IMAGES OF WAR

The Germans in Flanders 1917-1918

RARE PHOTOGRAPHS FROM WARTIME ARCHIVES

DAVID BILTON

'German soldiers have said of Ypres that it was "the worst of the hell of Verdun plus the horror of the Somme"'.

Pen & Sword
MILITARY

First published in Great Britain in 2013 by
PEN & SWORD MILITARY
an imprint of
Pen & Sword Books Ltd
47 Church Street
Barnsley
South Yorkshire
S70 2AS

ISBN 978 1 84884 650 0

Typeset in Gill Sans

Printed and bound in England by
CPI Group (UK) Ltd, Croydon, CR0 4YY

Pen & Sword Books Ltd incorporates the Imprints of Pen & Sword Aviation, Pen & Sword Family History, Pen & Sword Maritime, Pen & Sword Military, Pen & Sword Discovery, Wharncliffe Local History, Wharncliffe True Crime, Wharncliffe Transport, Pen & Sword Select, Pen & Sword Military Classics, Leo Cooper, The Praetorian Press, Remember When, Seaforth Publishing and Frontline Publishing

For a complete list of Pen & Sword titles please contact
PEN & SWORD BOOKS LIMITED
47 Church Street, Barnsley, South Yorkshire, S70 2AS, England
E-mail: enquiries@pen-and-sword.co.uk
Website: www.pen-and-sword.co.uk

Contents

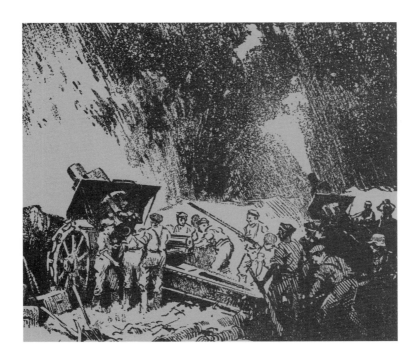

Acknowledgements

The book turned into three. Sorry to everyone at home, and thanks.

As with previous books, a great big thank you to Anne Coulson for her help in checking the text and to The Prince Consort's Library for all their help.

Errors of omission or commission are mine alone.

The 1917 front fighter.

Introduction

The purpose of this series of books, *The Germans in Flanders 1914*, *The Germans in Flanders 1915–1916* and *The Germans in Flanders 1917–1918*, is to chronicle the events that happened there during 1914 – 1918 and the impact of events elsewhere upon them.

This series is not necessarily a chronological photographic record: some periods were more fully recorded than others and, often, a photograph taken in 1915 was just as valid a record as if it had been taken in 1918; the books are essentially an attempt to provide a cameo of the experiences of the German Army in Flanders during the Great War. For most of the time an army does not fight, and the photographs portray life outside the trenches as well as in them. The photographs are from contemporary books and a private collection.

Included is a day-to-day chronology showing what was happening across the Flanders Front from the German point of view. Flanders is a coastal area so events at sea are included together with aerial activity, as it was the closest occupied territory to the British mainland.

The books are centred around Ypres and its immediate environs because that is where most of the fighting was taking place. However, most of Belgium was occupied and felt the effect of the war. The numerous cities and towns resisted the occupation actively or passively and many Belgians were shot for espionage. Belgium was also a ready source of materials and labour for the factories in Germany and many families suffered the heartbreak of losing a father, son, husband or brother to the war effort.

Mons was a typical town in occupied Belgium. After the war it was estimated that nearly seventy tons of copper, including its saucepans, had been taken from the town, including its saucepans. Other metals were also taken. Similarly cars, motorbikes and bikes were requisitioned. Livestock was taken: horses for the army and other animals for food. Even dogs were requisitioned. In 1917 all wine stocks had to be handed over. People too were also requisitioned. Civilians were deported on the grounds that it would help their livelihood and the economy if they were gainfully employed rather than unemployed and lounging idly around in Belgium. By the last stages of the war, many of the manual workers had been deported, leaving the middle classes to be conscripted into mobile labour groups who were used locally to load and unload coal wagons, package and dispatch goods to front-line soldiers and construct concrete underground shelters for the German Army.

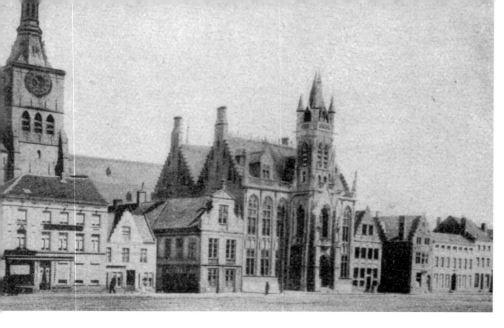

Dixmude town centre before the war.

Flanders also provided the German air force with numerous bases, some of which were used to attack England. 'Quite regularly since 1914, single-engined aeroplanes had braved the Channel, one or two at a time, to drop a few small bombs along the coast. Their favourite target was Dover Harbour.' They had become a routine nuisance.

Bombing was more often carried out by Zeppelins but in late 1916 an aircraft taking off from Flanders bombed London. Lieutenant Ilges (photographer and bomb aimer) and Deck Officer Brandt (pilot), both naval airmen, took off from Mariakerke near the Belgian coast in a single-engined LVG biplane; primarily a reconnaissance aircraft, it had the range to reach London and could be equipped with bombs. During the trip Ilges photographed 'aerodromes, factories, docks and other choice targets' and then, when over London, he took more pictures before releasing the load of six twenty-pound bombs. Brandt flew south and managed to evade the British squadrons at Dover and Dunkirk, but engine trouble ended the flight over French lines and the two were taken prisoner. Little notice was taken of the flight or the capture of its crew. The British 'were too busy exulting over the two Zeppelins' that had been shot down. However, *The Times* warned in an

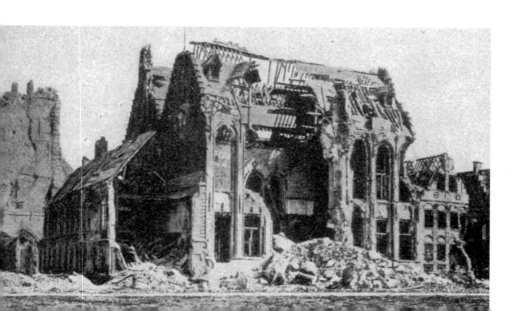

Dixmude town centre after thirty months of war.

editorial that it was likely that there would be further such visits on an extended scale. The following summer 'German bombers came to London in formation.'

Flanders was an important area for naval offensive operations and had to be guarded against Allied naval attack and the possibility of a naval-supported invasion. To this effect the sea-front was guarded by regiments of marine artillery. 'Thirty guns of the heaviest calibre had been set up there, among them five of 38 cm., four of 30.5 cm., and besides them a large number of quick-firing guns from 10.5 to 21 cm. calibre.' These fortifications and the coastal trenches required large numbers of men. Hence the *Naval Corps* was formed in September 1914, including garrison troops and regiments of naval infantry who fought in the great Flanders battles.

Similarly, taking the offensive to the Royal Navy required boats, aircraft and submarines. Of the latter, in 1916, a quarter of all available U-boats were assigned to the *Naval Corps* in Flanders. Initially they were small, relatively slow boats, but the later models were over three times the weight and half as fast again. However, their limited range meant that they could only operate from Flanders against the south and east coasts of England. Most mine-laying submarines also operated from the Flanders coast. Zeebrugge was an important base for the maintenance of these submarine types. 'When the U-boat campaign opened on February 1, 1917, there were already 57 boats in the North Sea' of which 'the *Naval Corps* in Flanders had at its disposal 31 U-boats of different types.'

Torpedo-boat flotillas were based at Zeebrugge; this was to be the scene of an attack by British Marines and the Royal Navy in April 1918. This St. George's Day attack was an attempt to block the port and stop offensive naval action. There were seaplane bases at Ostend and Zeebrugge; the facilities at the latter were used to overhaul U-boats for long distance work and as a base for short-range submarines. As Allied planes often patrolled the coast, many submarines were based at Bruges and along the canal to the coast. A repair and building shipyard for the Flanders Naval forces was situated in Ghent.

With the constant air and naval activity from the Flanders coast, the Admiralty regularly pressed for greater offensive action in the area. Haig also believed that more should be done to secure the Belgian coast. One possibility that was suggested was an amphibious assault. Clearing Belgium was often seen as a priority, but other events generally forestalled any action.

Flanders was indeed a strategically important area, but there is no need to list every day; as on every other front during the war, some days were very active but most were no more or less significant than the previous one. For an insignificant day, the GHQ report simply read: 'In Flanders today again only artillery activity' or 'In the West nothing new' – in English, the famous words: 'All quiet on the Western Front'.

Flanders is the ancient name for the mostly flat countryside that stretches from the North Sea coast in Belgium south to the French coast along the English Channel. Its name in Flemish means "flooded land". In the present day its size is classed as roughly equivalent to Greater Los Angeles. Its average temperature is around nine degrees Celsius and it rains practically every other day. However, the centuries old drainage system amply coped with the excess of water, producing a fertile land where farmers produced crops of 'beets, turnips and potatoes as well as flax, cotton, tobacco, grain, and fodder. They kept cattle, sheep, and pigs, chickens, geese, and ducks.'

For the purpose of these books, Flanders is difficult to define in geographical terms; it

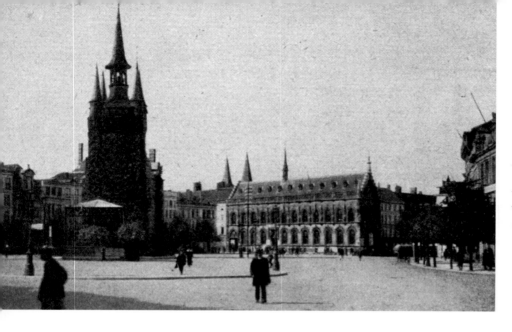

A photo of Kortrijk taken at the start of the war before it was in the front line.

has been in a continuous state of flux for hundreds of years. Originally covering a much larger area than today, the name Flanders during the war was seen differently by the various armies fighting there. To the Belgian army it was a defined area that covered the unconquered part of their nation and part of the conquered territory; to the French it was the area of Belgium where they were fighting; to the British it covered their Front from just north of Arras in France to their furthest left boundary at Boesinghe, north of Ypres. For the German Army, the Flanders Front stretched from Dixmude in the north to Frelinghien in the south, opposite the area held by the French and the British, but, to the General Staff at *OHL*, Flanders also included the conquered coastal regions of Belgium which were a base for their defenders, the *Kaiserliche Marine*, sea soldiers who guarded the coast and fought in the trenches. As this book is about the German Army, it is their geographical understanding of Flanders (Flandern) that has been used; activity in French Flanders is only mentioned in passing where it relates to the events in Belgium.

With the channel ports being a strategic German objective at the beginning of the war and with the Allied need to keep the ports open for the BEF, Flanders was clearly an area that would be fought over until one side won. A German success would enable them to strike at Britain and press southwards in an encircling movement against Paris.

Belgian Flanders lies at or just above sea level. This fact, coupled with the poor drainage caused by continuous shelling, meant that this war was often fought in a sea of mud. Its flatness made any eminence, even one as low as thirty feet, take on a tactical importance for both sides; holding the high ground gave the defender a view of his enemy. Holding 'a hill of 150 feet was priceless for the observation and artillery control that it provided over enemy lines and their gun positions'.

Ypres lies in a basin formed by a maritime plain intersected by canals, and dominated on the north, north-east and south by low wooded hills. The canals, of which the Yser is the most important, follow a south-east to north-east direction; a number of streams flow in the same direction, and there are three large ponds: Dickebusch, Zillebeke and Bellewaarde.

The hills that form the sides of the Ypres basin are very low and, at that time, were partly wooded. Their crests run through Houthulst Forest, Poelcapelle, Passchendaele, Broodseinde, Becelaere, Gheluvelt, Hill 60 and St. Eloi. Further south is the Messines-Wytschaete ridge, and to the south-west are the Hills of Flanders.

Houthulst Forest was the largest of the woods. Further south, after Westroosebeke, Passchendaele and Zonnebeke were other woods that were to become famous: Polygone, Nonne-Bosschen (Nonnes), Glencorse, Inverness and Herentage.

Surrounded by low hills, the numerous small waterways and the area's maritime climate gave the area around Ypres a character that was different to the rest of the front. The marshy ground, almost at sea level, is 'further sodden by constant rain and mists', forming a spongy mass that made it impossible to dig trenches or underground shelters. The water level is very near the surface, making parapets the only suitable and possible type of defence-works. Shell craters immediately filled with water and became death traps for the wounded, careless or unlucky. Such images create the iconography of the Flanders battles.

The geology and geography of the area meant that both sides centred their defence 'around the woods, villages and numerous farms, which were converted into redoubts with concrete blockhouses and deep wire entanglements'. Any slight stretch of higher ground was fiercely contested. The dominating hill crests 'were used as observation posts – the lowering sky being usually unfavourable for aerial observation – while their counter-slopes masked the concentrations of troops for the attacks.' As a result, the fighting was at its most intense along the crests and around the fortified farms.

Throughout the area 'were numerous scattered villages, clumps of woodland, a few nineteenth-century chateaux and occasional farms with thick hedges marking the boundaries of their largely open fields. On slightly rising ground in the centre' of the area was Ypres, 'a slumbering town with Gothic spires and towers'.

After centuries of being fought over by the French, Dutch and Spanish, the peace treaty after the fall of Napoleon allowed West Flanders and eight other Belgian provinces to be incorporated in the United Kingdom of the Netherlands. In 1830, an independent Belgium

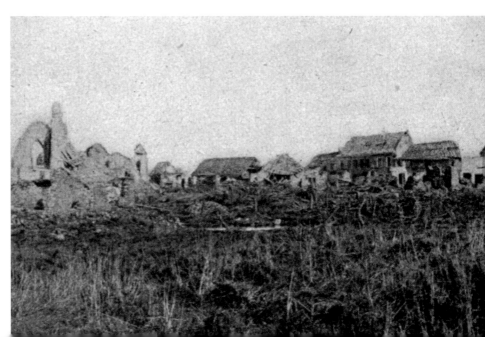

The ruins of Bixschoote in early 1917 before the battle had started.

was created, its neutrality guaranteed nine years later by the Treaty of London.

By 1914 Ypres numbered under 17,000 inhabitants. Its commerce was based on the manufacture of flax, lace, ribbons, cotton and soap. It was a minor tourist area because of its medieval Cloth Hall, the largest non-religious Gothic building in Europe. The newly arrived British troops found it to be 'a gem of a town with its lovely old-world gabled houses, red-tiled roofs, and no factories visible to spoil the charm.'

The *OHL* history described why the area was so heavily contested. The possession of Ypres to the English was a point of honour. For both sides it was the central pivot of operations. From the time artillery fire could reach the town, it became a legitimate target for German gunners as it lay so close to the front that the German advance could be seen from its towers, as the *OHL* history of the battle claimed. It also concealed enemy batteries and sheltered their reserves. Captain Schwink wrote, in 1917, that 'for the sake of our troops we had to bring it under fire; for German life is more precious than the finest Gothic architecture.'

At the start of the war Ypres did not even appear on newspaper maps. By 1916, not only did it appear but it had become a sacred place, like the Somme and Verdun. During the period covered by this book, the town was a ruin.

The Ypres salient was key to the fighting on the front which can be divided into three major battles known to the British as First, Second and Third Ypres, but there were many smaller battles between the major offensives as well as a final offensive by the German Army through Belgium that was not centred around Ypres. This was followed by the final Allied attack to liberate Belgium.

Essentially it was a British sector with Belgian and French troops at the northern end, while in September 1918 two American divisions were engaged. Most of the towns and villages were fought over again and again for each was key to the next piece. Casualties were consistently high and artillery barrages long, ferocious and expensive. By 1917 little remained of the 1914 landscape. A fertile land had become a moonscape.

Of the hundreds of thousands of men who served in Flanders, one is particularly notable – Adolf Hitler. A volunteer, he served throughout the war with *16 Bavarian Reserve Infantry Regiment,* in *6 Bavarian Reserve Division*, a division that served in Flanders on more than one occasion.

The Flanders front was never as quiet as some other parts of the Western Front, such as the southern Vosges sector. However, at times it was relatively less active and was used by both sides as a rest area. 'The Germans had a rest-house for their troops along the Yser in the woods of Praetbos, near Esen and Vladso.'

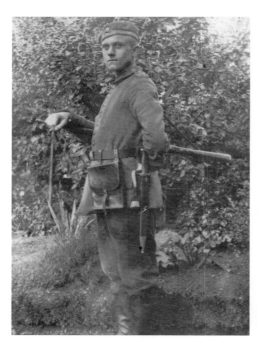

A youthful 1918 front fighter.

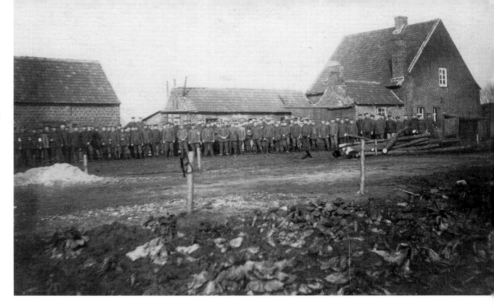

Out on rest in the Ypres sector during March 1917. Members of *12 Company, Reserve infantry Regiment 18*. Shortly after the photograph was taken it was moved to the Artois front where, as part of *18 Reserve Division,* it lost heavily during the British Arras offensive.

This was a quiet spot to raise spirits, where the men could play football and watch films.

'By 1917 the "front fighter" had emerged as the archetypal German soldier of the period, "with his steel helmet, bedraggled uniform, burning eyes and drawn face…imperturbable, toughened by the daily horror surrounding him, apathetic, resourceful, independent to the verge of insubordination; the man to whom the war had become daily, bloody, hard work stripped of all the gay trappings that formerly used to conceal its worst horrors".' The gasmask case was ubiquitous. The ever increasing use of gas shells made the wearing of a gasmask routine. To make certain of the best possible fit, the men were now clean-shaven. Gone were the beards of the early days of the war.

The major battle in 1917 was fought in the second half of the year, from June until November. The first five months are covered by the *British Official History* in two pages

with two footnotes. It sets the tone for a quiet period: 'Little need be said at this point concerning…the first five months of 1917. The earlier part of this period was uneventful; the later was distinguished by active preparations for the offensive.' It then characterised typical activity on the front: 'the use by both sides of trench mortars to compensate for their lack of heavy artillery, mine warfare with fairly frequent blowing of defensive camouflets to wreck the opponent's galleries, and great activity in raiding.'

To Ludendorff, the Ypres offensive was 'the second great strategic action of…1917; it was their bid for victory and for our submarine bases in Flanders.' He classed the period from 31 July to well into September as 'a period of tremendous anxiety' but *Fourth Army* had been able to check the hostile success and localise its effect. However, there was a 'loss of from two to four kilometres of ground along the whole front' as well as 'very considerable losses in prisoners and stores, and a heavy expenditure of reserves.'

During the Kaiserschlacht of 1918, major offensive operations returned temporarily in April before moving on to other sectors. They were to return later in the year during the Allied offensives that brought the war to a close. The next phase of the battle in Belgium would start on 10 May 1940.

Throughout the book German units are identified by italics and British and French troops by standard lettering.

1917 – Flandernschlacht (Passchendaele)

At the start of the year 'the *OHL* braced itself for the expected Allied offensives.' The previous year's manpower shortage had been partially solved; 'Ludendorff had increased the army by fifty-three divisions to its highest total ever of 238 divisions.' This had been achieved by pulling out 4,500 officers in administrative posts or in rear echelons for service at the front. On the Home Front 124,000 men had been 'combed out' and around 310,000 men born in 1899 were called up ahead of schedule. Returning convalescents made up one-third of the monthly need for 250,000 men.

'Numerous problems accompanied this mobilisation.' The Hindenburg programme for increasing production lost the army 300,000 men – all skilled factory workers. Many of the more elderly recruits were physically substandard while considerable numbers of the youngest recruits were undernourished. Even those who were fully fit were not of the

The road into Menin during October 1917. Above the soldiers' heads the sign reads 'Warning railway', drawing attention to the narrow gauge track through the village.

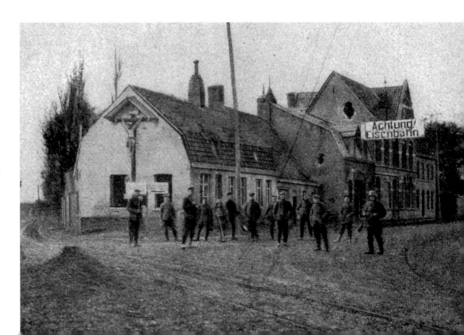

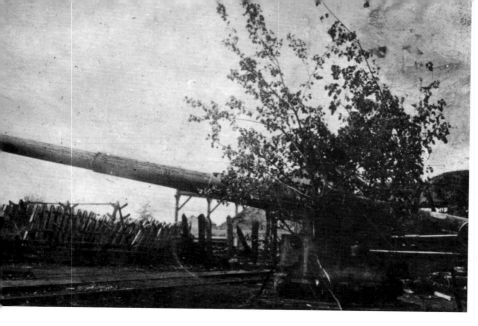

A camouflaged 15cm SK L/40 coastal artillery gun. In front is track for a narrow gauge rail system to move the shells quickly from the arsenal deep in the dune. This card was sent by Gefreiter Hofer of *8 Company, 11 Bavarian Infantry Regiment* while he was serving near Messines with *16 Bavarian Infantry Division.*

quality of previous years because their training had been cut to the bone in time and intensity. Desertion and acts of indiscipline were on the increase. In July, 'one-third of the 300 men dispatched to the Western Front by *Third Army Corps* in Brandenburg were arrested after refusing to board trains. Almost 18,000 soldiers languished in Prussian garrisons under arrest for indiscipline.' According to one source there were nearly 30,000 deserters on the streets of Cologne alone. And while the army was at its largest, German battalions were, on average, 250 men smaller than British battalions.

The quantity of shells expended on the Western Front was another cause for concern. In August 1916 643,000 shells had been used, the following month 907,000. During the year July 1915 to 1916, the number of artillery trains rose from 157 to 235 and the number of shells from 3.2 million to 4.5 million. The effectiveness of the expenditure of such vast numbers of shells was questionable. *VII Army Corps* reported firing one million shells a month during an offensive, calculating that it took 100 rounds to inflict one casualty.

A solution was needed to help solve the 'dire picture of manpower and material reserves.' In the 'middle of January, General von Kuhl summed up the situation at the principal General Staff officers' conference: "We can no longer reckon on the old troops; there is no doubt but that in the past summer and autumn our troops have been fearfully harried and wasted".'

British Fifth Army winter operations made the situation even worse and, by the end of January, it was acknowledged that the positions presently held by the German Army on the Somme 'were bad, the troops worn out' and that they were probably not in a condition to stand such defensive battles as 'The Hell of the Somme' again. After Ludendorff had toured Rupprecht's positions, he endorsed the strategic withdrawal.

January was very cold. The ground froze as did the water of the inundations – now no longer a barrier. With the presence of extra troops to guard against the possible entry of the Dutch into the war – because of unrestricted submarine warfare – the British set about strengthening their positions. Unable to entrench, they augmented the wire

obstacles despite the difficulty caused by the frozen ground.

'Operation Alberich became one of the war's greatest feats of engineering. For 4 months 370,000 German reservists, civilian workers, and Russian POWs toiled on the new defensive barrier.' The 300-mile-long "line" actually consisted of five major defensive positions.'

In February, work began on the Flanders Line between the English Channel and Lille. This was a defensive position for *Fourth Army* two to six miles behind the front. The Wotan line ran from east of Armentières and was ten miles behind the existing front north of Péronne. 'The Siegfried Line ran behind the left wing of the *Sixth, First* and *Second Armies* and the right wing of the *Seventh Army* from Arras to St. Quentin and the Chemin des Dames.' The Hunding Line began at Péronne and was to run to La Fère, crossing Siegfried near Verdun. Later in the year it was split into three separate defensive sectors. The final part was the Michel Line, running from the St. Mihiel salient to Metz. Only the Siegfried Line was finished on time.

While preparations were being made to withdraw in the south, the British kept up the pressure in Flanders with raids. One exceptionally heavy raid occurred at 1700 hours on 20 February. Just north of the Bluff, and half-way between the Ypres-Comines canal and railway, on a frontage of less than 500 metres, a British battalion surprised the garrison and took over 100 POWs and five machine-guns. Under the cover of a feint operation near Hill 60, which included a small mine explosion that drew fire on unoccupied British trenches nearby, the British managed to blow up two mine shafts and eighteen dug-outs, before returning to their own lines with less than eight casualties and only two men missing.

A further big raid was carried out the next day, followed by another on 24 February. Neither was as successful as that of 20 February. The first raid, by a New Zealand regiment, took forty-four POWs for a loss of thirty-nine of their own captured, while the second blew in a mine shaft, captured a machine-gun and took fifty-five POWs.

A retaliatory raid was undertaken against the New Zealanders on the night of 28

Taken behind the front line at St. Julien in March 1917. By the end of the year the conditions would be even worse.

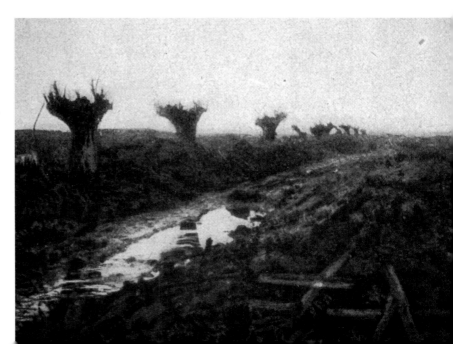

February. Following a heavy barrage of minenwerfers, a raiding party set out to enter the trenches held by the 16th Waikatos. Despite very determined attempts most of them penetrated no further than the wire. The Waikatos were on the alert, and for a quarter of an hour there was a very lively exchange of bombs. An officer was the only one to reach the trench. Badly wounded though he was, he stood on the parapet bombing, before leaping in to be bayoneted by the New Zealanders. Before dawn the raiders removed their wounded, but left thirteen dead men "standing up" in the wire. The Auckland casualties were ten killed and fifteen wounded. When the New Zealanders went out that night to identify their attackers there was no trace of the dead – they had been removed by their comrades.

'Operation Alberich formally commenced on 9 February and the first troop withdrawals came on 15 March. War material, tools, and food were removed at night by 900 trains hauling 37,100 carloads.' Only a wasteland would be left behind. By 5 April, the retirement was complete, reducing the amount of line to be defended and increasing the number of men available to counter any future enemy attacks; supply was also easier. However, it was a purely defensive move, an abandonment of Falkenhayn's principle of never surrendering a square foot you have won. The withdrawal 'surrendered 1,000 square miles of territory won with the blood of tens of thousands of soldiers.'

While the army withdrew, existing formations were reorganised. Divisions were reduced from twelve to nine battalions, each with four infantry and one machine-gun company. While this increased battalion strength and provided reserves – twenty new divisions were created in April 1917 – the number of machine-guns was still well below that of an Allied division. The withdrawal had little effect on the troops in Flanders, and the fighting continued.

While the planning for Alberich was being initiated, High Command 'was already contemplating the real possibility of a major attack against the Messines sector. In February, reports confirmed the reinforcement of British artillery batteries and improvements in the roads and other infrastructure in this area. The Arras offensive, which began on 9 April, did little to reduce Crown Prince Rupprecht's fears that the Messines-Wytschaete Ridge remained vulnerable.'

If an Allied assault in the area coincided with attacks around Arras and Vimy, there would be insufficient reserves for both fronts. However, intelligence reports to *Fourth Army* identified that any threat to the area would be purely diversionary. On 28 April 'a reliable German spy . . . reported that the British would transfer their main offensive effort to Messines within two weeks if they failed to achieve the desired breakthrough at Arras.' Other information sources suggested that the British would continue their attacks at Arras without French support. 'Ludendorff ordered that the necessary preparations to prevent a British breakthrough must be taken in the Messines-Wytschaete sector immediately.'

The preparations included reinforcements and the repositioning of troops and defences. North of Wytschaete *204 Infantry Division* was brought into the line, and *3 Bavarian Division* was positioned in the rear of the main defensive line near Warneton as a counter-attack division. The latter, highly rated, division had been heavily engaged at Arras, where it suffered 2,000 casualties. Command was unified and a division moved to strengthen the defensive garrison south of the River Douve.

In the period between Operation Alberich and the British Arras offensive, Füsslein's men continued their efforts to discover British mines. Tunnelling work at Spanbroekmoelen was heard in mid-February. The first camouflet caused little damage to the branch from the main tunnel, but a later camouflet damaged part of the main tunnel. Hill 60 was the next focus for raids and counter-mining. Here there were four galleries with British listening posts very close to the main German gallery. On 4 and 5 April two camouflets were detonated to remove the threat.

In the evening of the first day of the British offensive, 9 April, a large 'raiding party attacked overland, entered the British front line and threw portable charges into several mine-shafts causing casualties and damage.' In the *British Official History* this was the biggest raid faced during the period. Positions held on Hill 60 were attacked and 'enormous damage was done by the preliminary bombardment of four hours.' The defending troops suffered 278 casualties with fifty-eight missing, some of whom were buried by the effects of big trench-mortar bombs, while others were taken prisoner. The *204 Division* history states that over 500 men took part in the raid that caused extensive damage to the British mining operations. A sample of earth taken during the raid showed that the British were working at a much deeper level than their own Mineure. The British claimed to have taken two prisoners during the raid and killed forty of the attackers.

The next day a camouflet went off, causing further damage to the galleries damaged the previous day. However, the success was fleeting; most of the British mines lay un-discovered and intact. There were insufficient resources and manpower to combat the Allied mining, but Füsslein felt able to report that there was no longer a threat from mines.

'That same day the British opened their offensive at Arras taking the focus off Flanders once again. The British attack ruined Ludendorff's birthday and left him feeling deeply depressed, but, after talking to officers who had taken part in the fighting, he found that the new defensive ideas and principles were sound.

Then the French opened their offensives in Champagne and on the Aisne. Many years after the war when Ludendorff wrote his memoirs he could see little if any strategic point

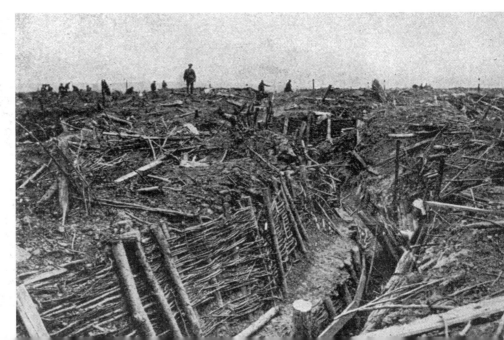

Troops inspecting the damage to their trenches caused by British shelling. As they are walking above ground, the trench must be some distance back from the front.

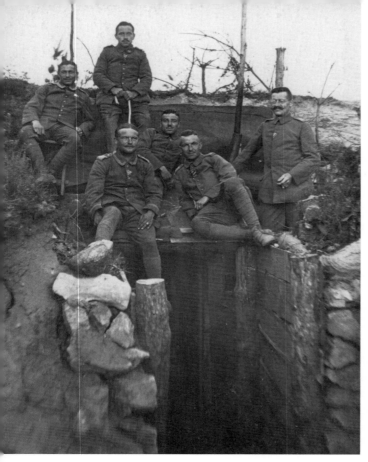

A group of decorated soldiers pose outside their deep dugout.

to the battle for Arras – a battle with a higher casualty rate than the Somme.' This was missing the point that the whole purpose of the British attacks had been to take the focus away from the main attack on the Chemin des Dames.

After the battle, German High Command claimed it as a victory because the French had not broken through, but the fighting men on both sides knew it was a victory for no-one. Regardless of the losses, the French offensive was continued for a considerable time with some large scale attacks producing only very limited success.

The failed Nivelle offensive had a major effect towards the end of May – mutiny. Unfortunately the German High Command did not believe the reports of a French troop mutiny until it was too late to use the information. Although the French troops were prepared to defend their lines, they would not attack. As a result of the unreliability of the French Army during this period, the British offensive at Arras would have to continue in order to conceal this problem, and when Arras finally did finish, the focus would move to the Flanders plain and a further British offensive – Third Ypres.

The *British Official History* recorded that "the campaign was fought by Sir Douglas Haig, on a front favourable on account of its strategic advantages, in order to prevent the Germans falling upon the French Armies, shaken and dispirited after three years of unceasing warfare and finally mutinous in consequence of the losses in and failure of the Nivelle offensive, upon which such great hopes had been set". However, *OHL* received information from a spy that there would be an attack in the Ypres area so that would be no surprise when it came. This was further corroborated by information from prisoners taken on the Arras front; "statements of prisoners proved conclusively that no further big attacks were to be expected in the Arras sector, and that a big attack was to take place from the Armentieres-Ypres front about the 7th June, after an eight-day bombardment".'

Although the focus had been on the Arras front, followed by Champagne and the Aisne, British preparations in Flanders continued. By the end of April, revised intelligence suggested a British attack against the Wytschaete-Bogen: an attack against the whole of the Messines-Wytschaete Ridge, from Mount Sorrel and St. Eloi down to St. Yves and Ploegsteert Wood. The British build-up of artillery and planes was such a serious cause

for concern that Rupprecht's Chief of Staff suggested a withdrawal from the southern salient to positions behind the River Lys.

Initially the idea was accepted. It would negate 'any mining threat and would preserve the hard-pressed infantry and artillery units, allowing time for rest, reorganisation, training and re-equipment.' However, Rupprecht's subordinate commanders rejected the plan and argued that there was no immediate threat and future attack would be held by the defence-in-depth tactics that had been adopted.

To the men at the front, staying alive was more important than strategy or tactics. In combat an enemy was to be killed, wounded or captured. For the dead there was nothing that could be done, but the wounded were a different matter. Despite being on opposing sides, medical staff helped their enemies. Medical Officer Westman's advanced first-aid station was near Kemmel (Hill 60). The valley near his small dug-out was filled with British and German casualties. The area was suddenly bombarded by the British with gas shells. As the fumes drifted in his direction, the alarm was given.

A member of a cyclist unit outside a concrete emplacement some distance behind the front line. He is armed with a Luger pistol and is carrying a message pouch. The shortage of leather is illustrated by the short boots.

Putting on their gas-masks, he and his men found that most of the British wounded were not carrying them. There were some spare masks but not enough. They were medics; their job was to save lives. So Westman and his men packed the British wounded sardine-like into the small dug-out. Closing the entrance with greatcoats and blankets, they wetted them with the only liquid available – urine.

Even though they were the enemy, Westman and his men were concerned for the welfare of these British wounded. 'After about half an hour, a breeze sprang up and drove the poisonous gases away. With heavy hearts, we removed the blankets and greatcoats, fearing that our Englishmen would have been suffocated, in spite of several improvised tubes which we had fitted with gas filters and introduced into the small cave. But they were alive and none the worse for their incarceration.'

Helping the enemy's wounded was not the only kindness shown. The New Zealand Auckland Regiment found this out when it went into the line near Romarin on the French-Belgian border. They took over a sub-sector which consisted of 'two gaps and three localities' and found their new home 'had been shockingly neglected.' The trenches 'were simply tumbling to pieces. Apparently no maintenance work had been done for months. The Germans in the line opposite had gained a decided ascendancy. Rumour even ran

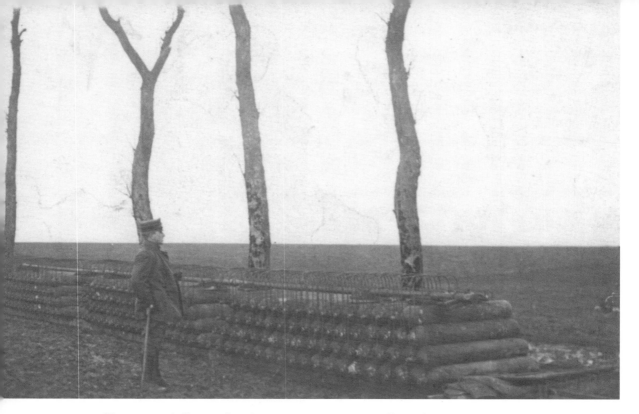

Observation balloons played an important part in artillery observation. They were inflated using gas stored in cylinders which were highly explosive. Here a soldier stands in front of gas cylinder dump.

that they were in the habit of coming over at meal times and taking the steaming dixies back with them. They were certainly active, both with snipers and minenwerfer guns.' Despite the open hostility, the New Zealanders discovered that their enemy were courteous, and the day 'after the Aucklanders took over the line the following notice was displayed over their parapet:—

"Engl. Oberleutnant Gefallen.
Er Ruht in Friedhof von Quesnoy."

Information about the whereabouts of the dead was always welcomed by both sides.

The naval and air war continued even when there was a break in major hostilities on the ground. On 23 April, an attack was made by a patrol of three Handley Page bombers on five destroyers off Blankenberghe. They attacked with 65 pound bombs and made a direct hit on one vessel, which immediately listed heavily to port and appeared to be severely damaged. The other destroyers dispersed immediately, although they later returned to help the crippled ship.

Much intelligence came from deserters and POWs, some from agents and from telephone intercepts, some from complex maths using gun flash and sound to calculate gun positions. Some of the signallers Westman visited had a far more dangerous job. They 'had to crawl at night on their bellies through the barbed-wire entanglements behind or

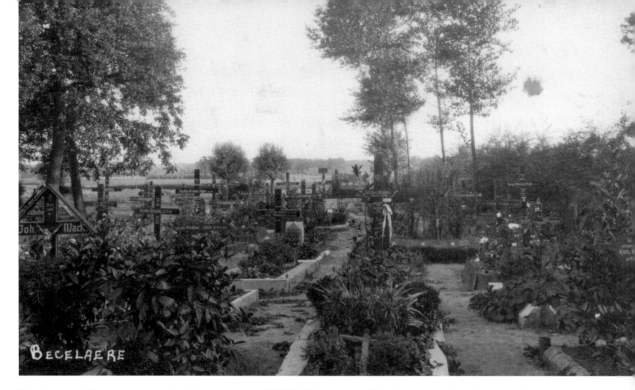

Becelaere military cemetery in the summer of 1917. The range of headstone styles denotes the graves of men from different units.

just in front of the enemy trenches and there bury copper plates about one square foot in size. These were connected by wires to special apparatus which recorded and amplified the aberrant electric currents which leaked into the ground from the telephone wires of the enemy. These nightly expeditions were by their very nature most dangerous, and I had to be in the forward trenches and to arrange stretcher-bearers to be available instantaneously. All kinds of devices were used to distract the attention of the enemy's sentries from the spot where the copper plates were to be dug in. Even mock attacks were staged to deceive him.'

Manning the listening posts for the buried copper plates was a dangerous and specialised job, requiring an understanding of the enemy's language and dialects. One listener had lived in France for many years and was stationed in the French zone. His most useful and regular provider of information was a French colonel nicknamed 'Chatterbox'. He talked openly over the phone to his counterpart in another unit, telling him of troop movements and the installation of new batteries. His idle chat provided much useful information. German signallers, in order to reduce message interception, 'used code words in their messages to and from the forward lines and the meanings of these words were changed daily.'

Air observation showed preparations behind the Messines-Wytschaete sector as early as 25 April. Flanders once more became the focus of offensive action as the British continued to take the pressure off the French. Under the lines at Spanbroekmolen, the British had been digging twenty-one horizontal mine shafts under Messines Ridge, in total over 7,000 yards of subterranean construction.

Army Group Crown Prince Rupprecht had wanted the area evacuated from the end of April but had acceded to the local theatre commanders' arguments to continue its defence. A major concern had been British mining operations but Lt. Colonel Füsslein had allayed this fear. In his opinion, the German 'counter-mining operations had been so successful, especially during April, that "a subterranean attack by mine-explosions on a large scale beneath the front line to precede an infantry assault against the Messines Ridge was no longer possible".'

Allied aerial dominance over the Messines front denied German commanders valuable intelligence. Aerial activity, while dangerous to those on the ground, provided the infantry with something to watch. 'The air battles continued to entertain us. The aircraft made a special effort to destroy balloons. If one of the latter was shot down, the observers used to jump and descend to earth by parachute. When the aircraft fired phosphorous [incendiary] bullets, they left long trails of flame and made a most interesting sight. Those of us on the ground were frequently the targets of enemy aircraft; the boldest of these came down to twenty metres to fire at us.'

It was not only the infantry who suffered from the attacks: 'Swarms of enemy aircraft enhanced the efficiency of the artillery. They interdicted the rear areas by day and night, attacking all manner of live targets with bombs and machine-gun fire.' However, the artillery were in a position to retaliate: 'Our artillery counter-battery fire also increased in intensity. Despite the high losses of our men and materiel in the batteries, we plastered enemy batteries and mortar positions industriously. Our Green Cross gas shells certainly silenced many a "Tommy" battery.'

At about this time, German seaplane units at Ostend and Zeebrugge began to increase their attacks on Great Britain and on British naval forces operating in the Straits of Dover and off the Belgian coast. This led to a strong but successful day and night counter-offensive by the RNAS from the Dunkirk area. On 26 April, a Handley Page bomber was engaged by a German single-seat Rumpler floatplane fighter piloted by Vizefeldwebel Müller. The German's fire ruptured the plane's petrol tanks. The pilot attempted to fly his crippled aircraft towards land at Nieuport, but was eventually forced to ditch in the sea nearly two miles offshore, where it immediately came under heavy fire from German shore batteries. Two French flying boats from a nearby seaplane station quickly took off and landed alongside the sinking bomber. One of the French planes rescued one of the crew and flew him to safety, but the other plane was shot into the sea as it tried to take off again; it was later towed into Ostend by a German destroyer.

By the end of May, the British had intensified their operations to include attacks on German bomber bases. From Coudekerque the bombers could easily reach any German-occupied port in Belgium and even more distant objectives within Germany, such as Duren, near Cologne. Throughout June 1917 the British bombers operated almost nightly, attacking key targets at Bruges, Ostend, and Zeebrugge and aiming especially at German bomber and seaplane bases to counteract the German bombing of London and South East England, which had begun at the end of May. Although German ground defences were usually fierce – they included batteries of searchlights, machine-guns and rockets – British bomber losses were light. Even the introduction of night fighter planes did nothing to stop the bombers.

Although the air war was intensifying, underground nothing had changed. The digging continued and on 10 May Füsslein reported the possibility of five deep mines at Hill 60, Caterpillar, St. Eloi, Kruisstraat and Spanbroekmolen, in front of or under the front line. By 24 May the situation was reported to be under control and the mine danger was downgraded.

The initial British Second Army preliminary bombardment was causing severe problems to the troops manning Wytschaete-Bogen. By the end of May, the bombardment had become so intense 'that dogs were brought into the line to deliver some of the rations, water, medical supplies and ammunition.'

Hans Fink, a twenty-year-old law student, wrote home on 27 May, describing what the British barrage was doing to his unit: 'On account of our continual losses the Company-Commander has the difficult, unceasing task of fitting reinforcements into the Company. There are no old, experienced men left – nothing but Deputy-Reservists and recruits.' Fink was to be killed in the fighting of 31 August.

Fourth Army reported to *OHL* that a strong British offensive was imminent from the Ploegsteert-Zillebeke sector and that the situation was serious. *Group Wytschaete* needed artillery reinforcements and air support. By 4 June it was doubted that the frontline units could hold against a determined attack, but withdrawal was not an option to be considered.

The continued British offensives on the Scarpe helped obscure British intentions. As *Sixth Army* continued to expect further attacks, few reinforcements were available for *Group Wytschaete*. Further information obtained from prisoners conclusively proved that there would be no further attacks in the Arras sector and that, about 7 June, after an eight-day bombardment, the British would launch an offensive somewhere between Armentières and Ypres. Any artillery would arrive only after the attacks had started.

Medical Orderly Scholl's diary described conditions under the bombardment. 'The English…are destroying all the dug-outs…they send over shot after shot…the casualties increase terribly.' So effective was the shelling that there was no shelter for the wounded who had to lie out and sleep in the open. A grenadier in the line at Wytschaete had the same experience: 'All the trenches are smashed in…we are forced into the open without any protection…our losses consequently are very heavy.'

The Allied troops were also under constant shelling. A New Zealander described in verse what was happening on both sides of the wire:

> "Day by day we dig new trenches,
> Bury war-created stenches
> Build up castles in the mud, and drain the floor.
> Night by night the big guns thunder,
> Trench and castle rend asunder;
> And at dawn we start to dig and build once more."

Battle-weary units were rested and sent back, luckier units were sent to quieter areas. Hitler's regiment, after fighting at Roeux, was sent north. In Flanders they enjoyed a 'splendid time of games and sport'. There, language and cultural similarities made them feel at home.

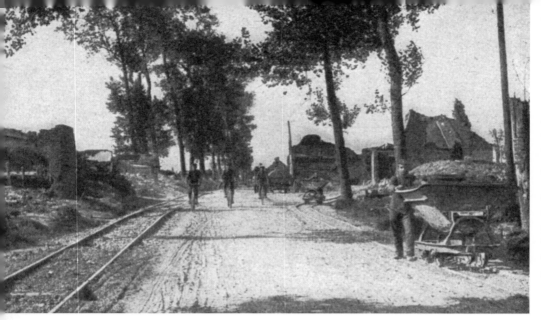

A town empty of civilians – St. Julien in June 1917. A scene showing the narrow-gauge track in use to move debris.

By the start of the attack, Wytschaete was a pile of powdered bricks. Wytschaete Wood no longer existed. It had been fired by the discharge of 2,000 oil drums on the night of 3/4 June. As well as the bombardment, the front-line troops had been subjected to raids by the British troops who captured seventeen men. The counter-battery work, especially on the day of the attack, had succeeded in destroying a quarter of the artillery of *Group Wytschaete*. There was a similar shortage of aircraft and anti-aircraft guns.

Facing the British attack were veteran Flanders units and men new to the salient. On the night of 5/6 June, and still on-going the next night, came the relief of *40 Division* by *3 Bavarian Infantry Division*. As they moved to the front, they found the barrage worse than what they had experienced on the Somme or at Arras and realised that they were taking over a real hot-spot. At first they thought that the initial violent earth movement was heavy artillery. Then it dawned upon them that the British had just blown the whole ridge. British artillery started to fire on them. Reports came in that whole companies had ceased to exist. Finally the British infantry arrived.

Rupprecht's concerns were proved correct. At 0410 hours on 7 June, nineteen mines, packed with 600 tons of high explosive, were detonated under the German front line. 'The earth moved visibly as far as 30 miles away and the furthest tremors were recorded 130 miles distant in London.' Thousands of German soldiers were killed, most instantly.

The short gaps between the explosions created a wave-like effect which profoundly shocked the defenders, many of whom thought it was an earthquake. Those who realised that it was a series of British mines were even more demoralised: they had been firmly assured that British mines were not a threat.

The attacking British quickly took the first line almost intact with 7,000 prisoners. Major Kranz, a geologist with the Württemberg Army, saw the explosion: 'One saw 19 giant "roses with carmine-red petals" or colossal "mushrooms" slowly and majestically rise out of the ground. They burst apart with a muffled roar; immediately thereafter brightly-lit multicoloured columns of fire and smoke shot up [and] dark material flew through the columns of fire towards the sky.'

As the last mine exploded, the British artillery barrage recommenced. Over 2,000 guns

fired at their maximum rate. Standing virtually axle- to-axle, the flashes from the guns gave the impression that the front was on fire. The bombardment focused on the first 700 yards of the defensive position and on known artillery positions.

Visibility was down to fifty yards because of the débris, dust and smoke from the mines and artillery barrage. Survivors and the less-shocked units sent up SOS flares in response to the attacks. Assistance from surviving artillery units was weak and ineffective; they too, like the front-line troops, had been bombarded.

The British attack, although successful, did meet with some opposition. Small groups of infantry and machine-gunners resisted until they were overcome by infantry or artillery. A typical example was Leutnant Diehl, who, only fifty metres away from the British infantry, and with most of the survivors having pulled back, held his position on the hill crest. He continued firing a machine-gun until he was taken prisoner.

The story was essentially the same along the front. In the north *204 Division* and *35 Division* faced the same British barrage: 'The English have completely smashed in the whole trench and all the dug-outs…a whole crowd of men were buried and burnt…soon there will be no hope for

Soldiers in a heavily camouflaged dugout under a farmhouse in Lombartzyde. A card sent by a soldier of *20 Landwehr Division* stationed near Dixmude. After a year's service in Flanders, the division was sent to Cambrai just before the British offensive.

us…our artillery doesn't speak.' *204 Division* was unable to cope with the British attack: 'The ground trembled as in a natural earthquake, heavy concrete shelters rocked, a hurricane of hot air from the explosions swept back for many kilometres, dropping fragments of wood, iron and earth…the effect on the troops was overpowering and crushing.'

In the centre, the defence had completely crumpled. Although their orders had been to hold these important positions, survivors ran away or surrendered. Some behaved like abandoned children, pleading with the attacking troops 'for comfort and assurance that they were not to be sacrificed in their sorry state.' The casualty rate is clearly indicated by the losses of *2 Division* which was ready to be relieved when the attack came: 'only one officer and three runners returned from the front and support battalions of the right-flank *44th Regiment*; a pitiful handful of men returned from the centre, *33rd Regiment*; and not one man returned from the left flank, *4th Grenadier regiment*.'

On the right flank the picture was the same. Although there was isolated resistance

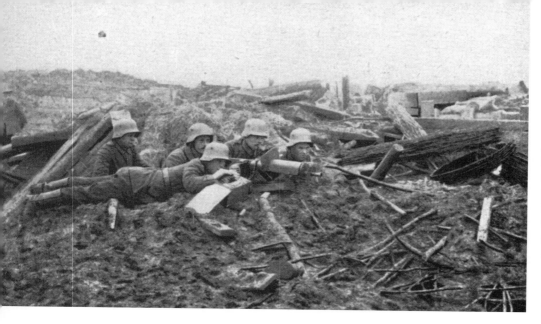

A well-hidden machine gun position in Houthulst village during the Allied offensive.

from positions like Petit Douve Farm, many of the stunned defenders were capable of little or no resistance to the attackers. However, Messines was to prove more difficult to take. A pivotal position that had to be held at all costs, it was a fortress of deep trench systems, heavy wire entanglements and fortified cellars. The defenders, *18 Bavarian Regiment,* fought in doorways, windows and behind the rubble and garden walls, using tunnels across the village to get around. The fighting was 'slow, methodical and desperate', all at close-quarters and hand-to-hand. Strong-point after strong-point fell until, finally, the commandant of Messines and his HQ staff were captured.

Operational and intelligence estimates had suggested that the forward divisions would hold until the Eingreif divisions could retake any lost ground. However, mining, artillery and the swiftness of the British advance had a profound effect on morale. Initially the army was unable to recover, as this captured letter indicated. 'This is far worse than the battle of Arras…What is taking place in Flanders at the present moment is no longer war, and borders close on murder…the sole object…(is to be) withdrawn as quickly as possible.'

By 0700 hours, the front-line regiments had been defeated and their support battalions over-run. Reserve battalions had either received no orders and stayed in position or had attempted local counter-attacks in which they had been practically annihilated. However, one garrison did not succumb to the Allied advance. On the Kanalkoffer or spoil bank, three companies of *61 Regiment* of *35 Division* were dug in. Close by was Battle Wood, held by units of *119* and *204 Divisions.* They held their positions until late evening and were able to provide heavy fire to assist the spoil bank defenders. The reinforced garrison was ordered to hold at all costs. Despite the best efforts of the British infantry and artillery, they were still in place the next morning when they were further reinforced by troops from a counter-attack division. The Kanalkoffer garrison proved to be the most tenacious fighters in the battle.

The speed of the advance took many of the defenders by surprise. Most were only too ready to surrender. A prize capture beyond the ridge was a complete HQ; 36 (Ulster) Division captured the Battalion HQ staff of *4 Grenadier Regiment*: thirty officers and men who were in the cellars of a house next to the Wytschaete-Messines road.

Tanks and cavalry were used to help clear areas. The former provided considerable assistance with demolition and strong-point destruction. Any heavy resistance encountered was generally brushed aside by the tanks and infantry, reducing the losses of the attacking infantry but increasing those of the defenders. The very presence of a tank was often enough to warrant surrender. At Fanny's Farm, after a tank smashed in the walls, the 100-strong garrison surrendered.

To add to the defenders' insecurity, the RFC, flying fast scouts, were strafing the ground wherever they found troops in front of the attackers. Some, flying as low as 100 feet, attacked troops, artillery and equipment. Their speed and total air superiority meant that they could get information back about new targets and the positions taken by the infantry. They were also shooting at the wounded who were making their way back. One soldier recalled: 'I leapt from shell hole to shell hole, pursued by enemy aircraft which kept firing at me. Diving down like hawks from one hundred metres, they picked off the wounded with machine-gun fire.'

There were such numbers of wounded to deal with that the few stretcher bearers that got through the barrage could do little for many of the men. For those close enough to hear, there were cries for help, shrieks of pain, and last gasps. Men had to make do with emergency first aid. *2 Company* of *Infantry Regiment 413* near Hill 60 were hit by the barrage, some taking cover in open trenches, others preferring concrete pillboxes. The latter choice was not always the safest: 'a direct hit on a crammed bunker by a delayed action shell collapsed the whole thing and buried everyone inside it.' Shortly after, the observer himself was partially buried by a shell but was pulled out by his men. Although his helmet had a large gash in it, he was unhurt and able to grab the company clerk, who was racing around like a lunatic with his left arm dangling. The wounded man was in a state of collapse when his officer gave him emergency treatment: 'I amputated his arm, where it was wounded just below the shoulder, with my pocket knife and applied a tourniquet made from the strap of my map case to the stump, to prevent him from bleeding to death.' The officer got him back to the aid post, where he died.

Most of the men opposing the British were the younger and fitter troops. Behind the lines there were the older men in Landsturm units who fought when needed but often provided essential labour. In some cases both father and son might be serving somewhere near the front. On 7 June, Landsturm Pionier Schneider was repairing shell holes in the roads to allow rations and ammunition to move forward. Shortly after the explosions, the wounded started moving back. As he mended the road, he heard his son speak to him. He had been badly wounded in the head and was moving to the rear for treatment. Having survived an air attack his son eventually got to hospital and there made a full recovery. The father survived the war, but his son was killed in the Champagne region on 30 September 1918.

The casualty rate for the attacking forces had been light. However, no plans had been made to reduce the number of men moving forward. As a result, British troops massed on the crest of the ridge in full view of the defenders in the relative safety of the Oosttaverne positions. In the warm sun, the troops began to dig-in to be met with concentrated machine-gun fire and artillery barrages.

No serious counter-attacks were mounted so the attackers had time to consolidate. Units were sighted but did not advance, regiments moved forward but turned back.

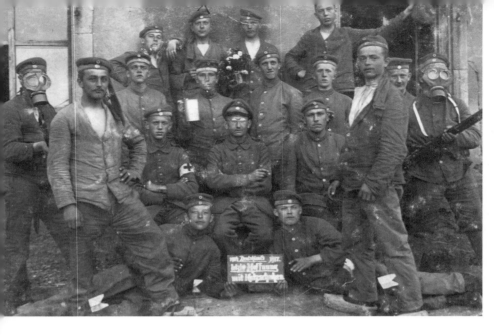

Soldiers relaxing in June 1917, little knowing what was about to happen on their sector in Flanders.

Localised attacks occurred but General von Laffert, commander of *Gruppe Wytschaete*, held back the two Eingreif divisions, which were new to the area, mistakenly believing that the British could not penetrate the defences for any longer than twelve hours. When the counter-attacking force neared the British positions, they marched in lines across open ground, a perfect target for the British Lewis and Vickers guns. Other counter-attacks met the same fate. The leading regiment of *1 Guards Reserve Division* (newly arrived from the Arras front and not trained as an Eingreif unit) was met by 'withering barrages of artillery, machine-gun and rifle fire'; the troops melted away and the 'survivors fell back to any available cover or shell-holes. The division had suffered over 70 per cent casualties.'

A similar fate befell *Fourth Army's* attempts to counter-attack. *7 Division* had only rudimentary Eingreif training and little or no experience of the terrain in which it was to fight. Slow in assembling, it started to cross the canal at Hollebeke and Houthem only to find the crossing points hit by British artillery barrages. The counter-attack order was cancelled and the division was used to reinforce hard-hit garrisons in the Oosttaverne Line.

One division that had thought themselves lucky to be relieved on 5 June was *22 Infantry Division*. They had been holding part of the line that disappeared in the explosion and were marching to a rest area near Lille after six months in the sector. Shortly after the explosion, the divisional HQ were informed of a change in plan: they were to return to Wytschaete immediately. On arrival they were thrown straight into battle. They were to reinforce the third position, halt the British advance and counter-attack. A lack of cover and heavy British artillery fire resulted in many casualties. However, the arrival of Eingreif divisions over the next few days meant they were able to hold the British.

There was continued Allied pressure as the British and Colonial troops passed through, ready to move towards the secondary defences of the Oosttaverne Line, although some stubborn pockets of resistance remained. The defenders of the first line, many of whom were crying like babes, were taken prisoner. Those who attempted to get away were shot down, killed by their own protective barrage or by the British barrage that was now targeting the next defence line.

Once the counter-attacks by *1 Guards Reserve* and *7 Divisions* had failed, General von Laffert 'conceded that any operation to regain the Wytschaete-Bogen position was doomed.' By the end of the day the British Second Army had taken 5,650 prisoners. 'Estimated German losses were 20,000, of whom half were missing. Between 21 May and 10 June the estimated casualty total was between 23,000 and 27,000. Over 10,000 were officially listed as missing.'

When these figures are balanced against total Western Front losses, they are not especially large. 'In the months April to June the Armies on the Western Front had lost 384,000 (not including lightly wounded), of whom 121,000 were killed and missing.' Despite all the losses, the army was now bigger than it had been at the end of the Somme offensive. However, the munitions available on the Western Front were only sufficient for the defensive.

That evening, a night withdrawal to the east was ordered – a withdrawal recommended weeks before, a withdrawal once dismissed as bad for morale and tactically unsound. The order was later modified to apply only to the artillery. What had been thought of as impregnable was now untenable. Morale had been shattered. Thousands had lost their lives. By 14 June the battle was over.

After a long hard day, *Grenadier Regiment 4* was ordered out of the line to join the remnants of its division assembling at Wervik. On 8 June it counted only forty-four survivors from its forward companies. Total casualties amounted to forty-six officers and 1,370 men killed, wounded or captured.

The Daily Army Communiqué from *Army Group Crown Prince Rupprecht* did not altogether reflect the views of the front-line soldier. 'Attacks launched by the British between Ypres and Ploegsteert Wood, north of Armentières, were beaten off yesterday southwest of Ypres by troops from Lower Saxony and Württemberg. At the same time the enemy succeeded after a series of enormous mine explosions along the line St Eloi, Wijtschate, and Messines, in breaking into our positions and driving forward, after a hard battle of changing fortunes, via Wijtschate and Messines. A powerful counter-attack by Bavarian troops threw the enemy back to Messines.'

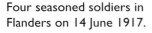

Four seasoned soldiers in Flanders on 14 June 1917.

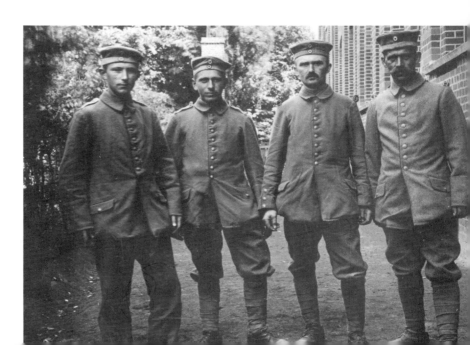

General of cavalry Maximilian von Laffert. 'When Germany mobilized for the First World War, von Laffert commanded the *XIX. Armeekorps* which was subordinate to the *Saxon Third Army*. Under his direction, the corps fought in the Marne campaign in 1914, at *La Bassée* in 1915, on the Lys and Somme rivers in 1916, and at WytschaeteBogen, Belgium in 1917. While commanding his troops in France, von Laffert suffered a heart attack and died later in Frankfurt on 20 July 1917. He is buried at the NordFriedhof in Dresden'.

After the war, Hindenburg wrote that: 'Violent attempts on our part to restore the situation by counter-attacks failed under the murderous, hostile artillery fire from all sides that converted the rear area of the lost position into a genuine inferno.'

'For the German High Command it was a psychological and potentially disastrous military failure.' Rupprecht expected further British assaults and doubted whether his defences would be able to hold them back. At the very least he feared a rapid British exploitation of their advance onto the vital area of the Gheluvelt plateau. To strengthen their defences, he wanted the troops to retreat to the Flanders Line. In fact, General Plumer was ready to continue the attack, but Haig was not.

The decision to move back was taken on 9 June. Intelligence reports indicated that the British could observe the Warneton Line. Its trench system was obsolete and vulnerable to attack and British artillery could sweep it at will. A retirement to the Flandern Stellung was the obvious choice but, before the troops could pull back, new defensive works were needed: an in-depth defensive position in front of the Flanders Line, 'with a bridgehead position known as the Kanal-Lys Stellung (Canal-Lys Line) which established a series of outposts between Houthem and Warneton and advanced posts forward of the Warneton Line.'

General von Laffert, commander of *Group Wytschaete*, was removed from his position two days after the battle. His mistake was using two specially trained attack divisions in the front line as relief units and employing two untrained divisions, new to the area to do their job. Laffert laid the blame on poor intelligence about the mining operations. His report stated 'that if any suspicion had existed about the magnitude of the mine danger, the front trench system would have been abandoned before the British assault' and a new line occupied.

Other reasons for the loss of the Messines ridge were given after the war by the *Official History*: two divisions were in the middle of a relief, 'the great numerical superiority of the British in artillery, aircraft and infantry and the thorough preparatory work; the effect of the mine explosions, both in number and size beyond any precedent; the unfavourable infantry position on the long forward slope; the cramped deployment area for the

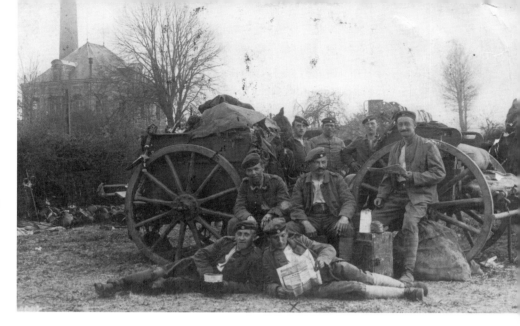

Early July 1917, and an artillery telephone line unit pose in front of their wagons.

supporting artillery within the salient which could be enfiladed from both flanks; and, lastly, the late arrival of the Eingreif divisions on the battlefield.'

No mention was made here of the state of the army, a state which was reported in the conversation of a soldier returning from the battle. He saw an enemy army in splendid condition, with ample reinforcements and well equipped. His own was tired and worn-out.

Fourth Army at the time justified the defence: 'the losses in men and material inflicted upon the British by making them fight for the Ridge was sufficient' reason to hold rather than abandon the position. However, in hindsight, von Kuhl, *Fourth Army* Chief of Staff, considered that Rupprecht had made a mistake; withdrawal would have spared the army one of the worst tragedies of the war.

The start of offensive action in Flanders gave the French Army time to recover sufficiently to take part in three limited offensives during the remainder of the year. The first was to support the British in Flanders from July to November. These attacks involved the French First Army, mostly men from the north unaffected by the mutinies. Supported by massed artillery, over 500 guns including 300 heavy, they crossed the Yser Canal at Ypres with minimum casualties. The other two limited offensives were equally successful.

Even after the Messines débacle, most of Flanders was still seen as a place to send units for rest. One new arrival in late June was Adolf Hitler and his division. After service at Arras, they were to convalesce well behind the front before returning to the trenches in late July.

British success and French failure gave Haig his chance for an unlimited offensive in Flanders; 'a general breakout, with Ypres as the fulcrum.' Admiral Jellicoe wanted the U-boat bases taken and 'Haig planned to break out of the Ypres salient, march along the Belgian coast, and roll up the entire German Army.' The three-stage offensive would strike south of Wytschaete, then between Diksmuide, and finally against Passchendaele. Lloyd George agreed to the offensive to relieve the pressure on France only after the failure of the Nivelle offensive. The offensive went ahead, ignoring Foch's warning about it being 'a duck's march through the inundations to Ostend and Zeebrugge'. On 21 July over 2,300 British guns commenced a ten-day bombardment on *Fourth Army*.

Hitler's regiment, resting near Bruges, knew of the Allied build-up from their newspapers. In his regiment were a few men like himself who had been there in 1914. They returned to Gheluvelt to find a landscape that had been explosively shattered, with 'freshly constructed positions, house ruins, rubbish tips and craters, splintered trees, decomposing material.'

By the start of the British offensive, General Sixt von Arnim's army had sustained 30,000 casualties including 9,000 missing. *16 Bavarian Reserve Infantry Regiment* would be one of the units to experience the barrage. Major Tubeuf calculated that the regiment lost 800 men killed, wounded or taken prisoner between 13 and 23 July.

'From dominating observation areas the enemy preparations for the battle could clearly be seen and indeed the British *Official History* called the Flanders campaign of 1917 the most clearly heralded offensive of the war. For two months observation and aerial reconnaissance showed the British troops constructing hutments, gun emplacements, roads and tramways and clearly indicated the arrival of new divisions, the supplies that would be needed and artillery reinforcements.' By 12 June Rupprecht, commanding the *Northern Group* of German Armies, described a British offensive in Flanders as certain. Its obviousness was an advantage. *OHL* had to focus its attention on the forthcoming British attack and send every available soldier north. There was no time to counter-attack against the failed Nivelle offensive. The French were safe to rebuild their morale.

In the period after the battle of Messines Ridge, the German Army had been busy preparing for the obvious assault. Colonel von Lossberg, the nation's defensive expert, was given free rein to improve the defences around Ypres. He had six weeks before the British attacked.

The new defensive position consisted of six lines in places with the first line being the weakest. Reverse strength meant that any British attack would meet the strongest defence when it was weakening. This would provide a killing zone which would cut off the attacker. Concrete emplacements were built to house strongpoint garrisons, headquarters staff, medical units and Eingreif troops. A shortage of labour and the priority

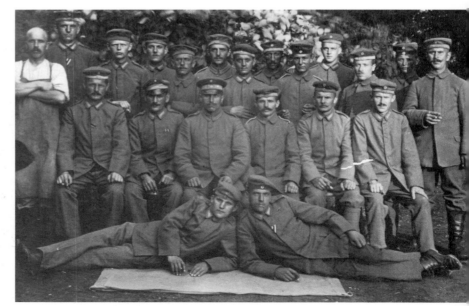

July 1917. Men of *235 Division* pose for a photo before leaving the St. Quentin area for Flanders. It arrived in the line during the British artillery preparation prior to the offensive.

given to the Siegfried and Wotan lines had limited work on the Flanders positions. By the time of the British offensive, the forward zone had been completed with concrete battery emplacements further back. Ruined farm houses in the battle zone had been converted into centres of resistance. Defensive lines further back had been planned and marked out by barbed-wire entanglements.

Behind each pair of front-line divisions was an Eingreif division with one regiment near the front with its own artillery, and two regiments further back as reserves. Behind them were reserve divisions. This was defence in depth, designed to break up and delay an enemy assault.

At the same time the number of artillery pieces was increased so that British superiority was only two to every one German field piece. Infantry units had time to reinforce and retrain. Changing deployment of units placed nine divisions as front-line units, with six behind as reserve. A mobile force of five divisions was deployed in two echelons behind the reserves. Twenty divisions faced thirty-four British divisions. In early July, Rupprecht recorded that he had 'ample forces and ammunition to meet the coming offensive.' He was confident that he could disrupt British plans.

Above the preparations, the air war continued unabated. On one day in late June, ground troops observed 139 aircraft in the sky at the same time. The dogfights provided a spectacle for those on the ground and, in one case, a macabre job. Watching on the morning of 27 June, the ground troops were pleased to see their own red single-seat fighters arrive and take on the British planes that had been harrying them for half an hour. As the fight dispersed one red plane was seen to be hit by anti-aircraft guns and small arms fire. As the plane banked steeply, a wing fell off and it plunged out of control to crash 100 metres from the British lines. There was nothing anyone could do for the pilot.

Later in the day, the company commander of the sector received a request from Baron von Richthofen to recover the body of Fliegerleutnant Allmenröder, holder of the Pour le Mérite, the coveted Blue Max. The first attempt failed, but the next night the soldiers were successful. The aircraft was deeply embedded in a battlefield cemetery from the previous two years. The ground was littered with decaying limbs and body parts; the smell of rotting corpses was so strong it slowed down their perilous work. Eventually they recovered the pilot and returned to their own lines. For this heroism, the three soldiers were notified by the Army Communiqué that they had received the Iron Cross.

'The Crown Prince wanted to mount his own offensive but was mindful of the shortage of artillery shells. However, the Head of Operations Staff suggested a small attack on the recently-arrived British divisions in the Nieuport Sector; this sort of attack he felt would help disorganise enemy preparations for the attack. A further attack south of the Menin Road to disorganise British artillery preparations was not allowed. Surprise was of the essence but a prisoner of *3 Marine Regiment* captured on 5 April, "stated that a British attack was expected shortly and that reinforcements of German artillery were being brought up. Two raids carried out on the night of the 9th/10th succeeded in capturing a prisoner, but he was killed by a shell soon afterwards, so this possible source of information of the German attack also failed". Aerial reconnaissance also failed to spot the intended attack.'

Between 6 to 10 July, an intermittent bombardment fell on the British positions, 'on the wooden pontoons across the Yser, on the trenches and dugouts on the sandy beaches

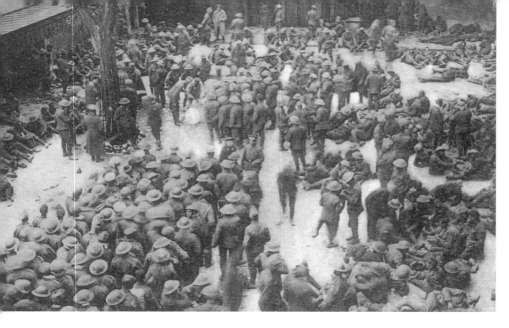

Large numbers of British soldiers were captured during the German attack near Ostend on 14 July 1917. They are being marshalled in the heart of the town Kommandantur.

and on the sparse gun lines in (the) rear' but it was not enough to arouse the suspicion of an attack among the British troops. On 10 July at 2000 hours, fifteen battalions, led by a storm unit of the *Marine Corps,* attacked towards the right bank of the Yser and rapidly captured it on the seaward side of Lombardsijde; to this point the carefully orchestrated attack had taken twenty minutes.

'The first wave, consisting of groups of a specially trained assault detachment advanced straight through to the back, or third, British breastwork, cleared it and, after a pause of ten minutes, pressed on to the bank of the Yser; the second wave cleared the dug-outs of the second breastwork and then occupied the third breastwork ; the third wave reinforced the first wave and established an outpost system along the river bank, placing machine-guns to command the river; the fourth, carrying material for consolidating the position, cleared the dug-outs of the first breastwork and followed on to the third; the fifth occupied and held the second breastwork'. However, a successful counter-attack by the British 32 Division succeeded in regaining all but 500 yards of its position. The attack cost the enemy defenders 126 officers and 3,000 other ranks.

Ludendorff forbade a further attack, this time against the Menin Road, because of a shortage of troops. This lack of manpower was caused by British feint attacks further south and by a suspicion that the British were preparing an amphibious landing on the Dutch coast. To defend against this alone took three divisions – two infantry and one cavalry. Facing the British were the five groups of *Fourth Army: Group Lille, Group Wytschaete, Group Ypres, Group Dixmude* and *Group Nord.* The offensive was expected to fall on the three middle groups; behind their front line were assembled Eingreif divisions, replacement divisions and finally *Group Ghent.* Of the twenty divisions, four had arrived in May from the Eastern Front, the remainder from France between May and July.

Rupprecht was aware that he did not have enough men to cover any threatened British diversionary attacks and defend Flanders. What had been possible last year was no longer so this year. Rupprecht's Chief-of-Staff described the situation they were in: 'During the battles of the Somme in the previous year it had been possible to contain the offensive – just – by weakening, to an absolutely dangerous degree, the other fronts – and put the

Josef Irlacher was killed by a British artillery barrage on 19 July 1917. The twenty-two-year-old was serving with *16 Bavarian Reserve Infantry Regiment,* part of *6 Bavarian Reserve Division,* the division in which Adolf Hitler served.

Zum frommen Andenken im Gebete
an den tugendsamen Jüngling und Krieger

Josef Irlacher,

Taglöhnerssohn von Teisendorf,
Soldat b. 16. b. Res.-Jnf.-Regt., 3. Komp.,
welcher am 19. Juli 1917 im 22. Lebensjahre
durch einen Volltreffer verschüttet wurde und
gleich darauf den Heldentod fürs Vaterland
gestorben ist.

O, Eltern und Geschwister mein
Ich kehre nicht mehr zu Euch heim
Der letzte Gedanke letzte Blick
Der eilte noch zu Euch zurück.
Als ich starb im Feindesland
Reichte niemand mir die Hand
Doch eh' mein Auge war gebrochen
Sah ich schon den Himmel offen.
Mein Jesus Barmherzigkeit! 100 Tage Ablaß.

Druck von Ed. Leopoldseder, Traunstein.
Zu haben bei K. Robels Nachfolger, Teisendorf.

forces collected into one major battle area. Even a light enemy attack against any other part of the front other than the Somme and Verdun would have been a most serious danger. But such secondary attacks were more greatly feared at the onset in the summer 1917 following the transfer of all dispensable men and materials to the *Fourth Army* in Flanders for the great defensive battle.'

While preparations were being made, infantry raids were carried out, protected by box barrages, and positions drenched with gas. On two separate occasions the whole of the front was shelled with gas and, for six nights before the assault, strongpoints, woods and the banks of the Steenbeek were the target of gas-shell bombardments. Raids were intended for the purpose of getting both prisoners and information. Prisoners taken before the offensive appeared to their British captors to be almost at breaking point from the continual bombardment of gas and explosive and harassing machine-gun fire.

In the days before the attack, the front-line soldiers worked day and night to make good their defences – only to have them destroyed by British artillery. As the shelling increased over the last ten days of July, it was obvious that 'the big struggle for Flanders was imminent.'

Prior to the British attack, some front line positions had been evacuated. On 27 July, air observers reported that the trenches in front of the northern sector of the British Fifth Army were unoccupied. Patrols sent out in the afternoon found empty trenches on a frontage of 3,000 yards to a depth of nearly 500 yards northwards of the Ypres-Staden railway. The French, further north, found the same had happened and were able to occupy the east bank of the canal. As British troops moved towards Pilckem Ridge, they met with strong opposition. The next evening the new British positions were bombarded and counter-attacked, but held.

The days before the Allied offensive 'were marked by intense air activity on both sides. At this time the combined strength of the RFC, RNAS, Aéronautique Militaire and the small Belgian Air Corps on the Western Front was 852 aircraft, of which 360 were

fighters; the German strength was 600 machines, of which 200 were fighters.' To bolster the Allied fighter strength in Flanders, two French fighter squadrons were sent to Dunkirk.

The air offensive opened on 11 July. On that day nine British planes were destroyed for the loss of fourteen German aircraft. 'A few days later von Richthofen was back in action, his head still in bandages, and a series of massive dog-fights took place between his Jagdgeschwader and Allied fighter formations. On the twenty-sixth, no fewer than ninety-four single-seat fighters fought one another at altitudes varying between 5,000 and 7,000 feet over Polygon Wood.'

Even before the battle, four divisions had to be withdrawn. This was due to Allied inter-arm co-operation. As the *Bavarian Official History* of the war commented: 'For a long time now the riflemen had cowered in the shell holes which covered the whole area – the deepest of which were full of ground water. Low-flying aircraft and reconnaissance patrols of the British infantry kept the men in the battle area at full stretch at all times…It is no wonder then that in both officers and men nervous energy was consumed and fighting strength quickly diminished.'

When the ground offensive began, Allied aircraft attacked German airfields and infantry columns with bombs and machine-guns. 'For the first time in the war, large-scale ground attack operations were carried out by the fighter units. It was dangerous work and casualties from ground fire were heavy.'

Although in general new defensive positions had been adopted, these were not effectively employed by Hitler's division. They were exposed, weakened and exhausted. The Commanding Officer of Hitler's regiment reported that his men were at breaking point: 'The troops were unable to sleep or rest at all. Due to the shortage of troops in the trenches, at night everyone had to carry out either sentry or sentry relief duty. Because of the constant gas and mine attacks, it was impossible to rest at any rate…The repeated gas mine and gas grenade attacks really shattered the nerves.'

Relieved on 23 July, they were given two days' respite before being sent to new posi-

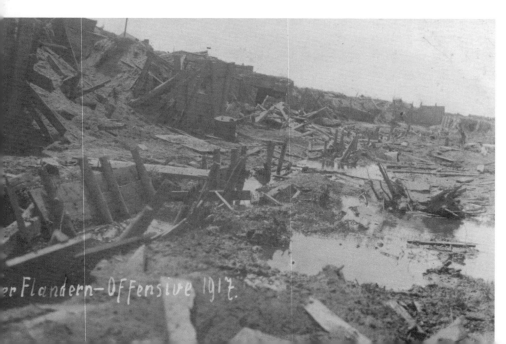

Destroyed by artillery: trenches after a barrage during the 1917 offensive. The picture was taken by a marine photographic unit and published by the *Marine Corps* library.

tions in a marshy wasteland. The bombardment here was worse than previously experienced, with the barrage becoming even more severe just before the attack. At midnight 30 July until 0350 hours 31 July, the German positions were drenched with gas. Then the British guns started a twelve-hour barrage to cover the attack.

Although deaths by gas were small in number when compared to deaths by shells, gas had a powerful effect on the men of Hitler's regiment. As a result of their experiences, they lost trust in the effectiveness of their gas masks. The Commanding Officer wrote: 'Various men claim that, despite having put their gas masks on in time, they still breathed in the gas and fell ill from it…The constant sight of horribly mutilated bodies, of the badly injured, of those sick from the gas, and of those killed by gas, had a very depressing effect on the men…The men of the regiment [are], at this time, both physically and mentally finished.' And this was before the British attack.

For the first time Hitler and his companions faced British tanks. Attacked from the air and on land by infantry and tanks, his regiment lost their first line of trenches, allowing the British to get 500 metres behind them. In comparison, on the Somme they had lost no more than a few metres of trench at any one time. Fortunately they did not have long to wait for relief. On the night of 1–2 August, 'crusted with mud, they tottered back, more like ghosts than men.'

In late afternoon the rain came in streams. 'The mutilated land became a morass.' Hitler and the other survivors were moved to a peaceful sector. The *Bavarian Official History* claimed that they had endured seventeen days in the position, been caught by the British during their relief, but had mown down English troops and only lost one kilometre of ground. In the seventeen days, they had lost forty officers and 2,900 men. Hitler's regiment was fortunate to be sent to Alsace to recover.

At the end of July an infantry officer recorded his experiences of the previous few days in the front line. After a barrage, he found that: 'three men were plastered on the walls of the trench or lying in fragments on the ground.' As the shelling continued the parapets disappeared. By evening the death total was forty-one. 'On the fourth day, one young soldier had had enough. He climbed out of the trench with two grenades…and told his comrades what he thought of the war. He was going

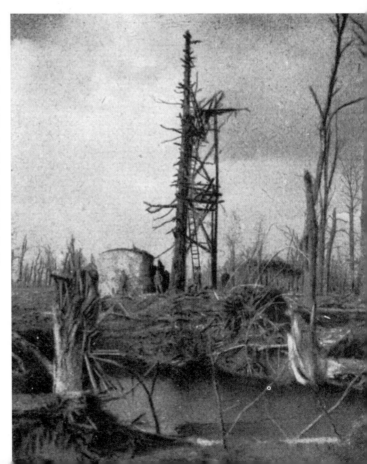

Artillery observation post in Houthulst Forest. The observation platform and support are made to blend in with the trees.

The Flanders
landscape in late
1917 – mud!

to run towards the British rifle fire and hurl his grenades at them, but he would throw them at his comrades if they tried to stop him.' Naturally they let him go.

At 0350 hours on 31 July, twelve British infantry divisions advanced, supported by 700 aircraft and 140 tanks, under cover of a creeping barrage, into thick mist and rain. *4 Guards Division* recorded the change in the barrage: It was 'drum fire no longer: it was as if Hell itself had opened.' Leutnant Bucher, commanding an infantry platoon, described his experience of the barrage and attack. With the bombardment in full swing he went to his shelter and tried to sleep but the noise was too much. Suddenly the duty NCO burst into his quarters, panting, his eyes rolling he reported the situation: 'The big offensive has started…already three men have been blown to bits.' The two then rushed up the steps into the trench. There they were met with 'an absolute downpour of earth and shell-splinters' and 'on every side the night was lit up by explosion.' There was a terrific explosion from the dugout they had just vacated and 'in a moment the dugout and four men ceased to exist: a 15-inch shell had blown the former heavily protected shelter to Kingdom Come.'

Up to about 0930 hours the British assault had gone according to plan, except south of the Menin road. The loss of the western edge of Gheluvelt plateau and the entire crest line of Pilckem Ridge was felt in two ways. No longer could observers look into the British lines and now British observers could see deep into German positions.

The forward lines, thinly held, inflicted few casualties on the British attackers but, although support and reserve unit counter-attacks had little success, the defence showed no signs of cracking. The opposite was true: as a result of their new defensive methods, the deeper the British penetrated, the stiffer the resistance.

Unreported until late in the morning, a large counter-attack force was moving behind the Broodseinde-Passchendaele ridge. The deteriorating weather conditions allowed the defenders to move unseen. About 1400 hours, an intense barrage fell on the British troops in their newly-occupied positions between the Ypres-Roulers railway and east of St. Julien. Shortly afterwards, counter-attack troops approached in waves from the front and flank. Unable to withstand the onslaught, the British troops fell back.

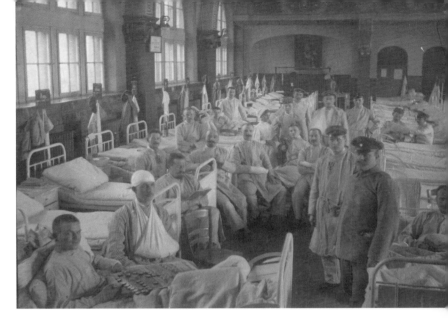

A public building converted into a temporary field hospital. The second standing soldier on the right is proudly wearing his newly awarded bravery medal.

The withdrawal exposed the British flank. As the British troops moved to provide a defensive flank, six waves of counter-attack infantry appeared over the crest of Zonnebeke spur. Their arrival was 'preceded by a barrage directed by Very-pistol rockets fired by the leading infantry.' Further aid for the counter-attack troops was provided by low-flying aircraft that flew along the British line, machine-gunning and dropping bombs. The British withdrew and eventually arrived at some newly-constructed defences.

The counter-attack slowed down as it approached the Steenbeek; British opposition was stiffening and it was raining heavily. Already marshy, the ground near the Steenbeek rapidly worsened. 'In many places the men were seen to be up to their knees in mud and water.' Movement became increasingly difficult and by 1800 hours they were still three hundred yards away from the British troops in the second line. Any further advance was halted by the British artillery and machine-gun barrage. The counter-attack troops pulled back, leaving many casualties. Although the barrage continued throughout the night, the newly-taken village of St. Julien was held.

At noon on the first day the rain started. It did not stop for seven days. The rainfall was double the normal average rainfall for August – 127 against 70 millimetres. Some periods were wetter than others, but during the month there were only three days when it did not rain. Even the few downpour-free days did not provide any sufficiently extended period when the ground could dry.

This did make life miserable on both sides of the line, but it also made it easier for the defence. The low cloud hindered Allied artillery observation from both the air and the ground. The poor condition of the terrain slowed down the attacking infantry and greatly hindered the use of tanks.

On the Allied side, the French enjoyed the most success. To the north of the attack they resisted a counter-attack, and they advanced beyond their original objective to gain a footing in Bixschoote.

Nearly two weeks later, on the day of German success (10 August), artillerist Gerhard Gürtler, a theology student from Breslau, wrote home to describe his experience on 30 July as his unit moved into its new positions just after midnight: 'We went straight on to

The well-attended funeral of an officer. His importance can be judged not only by the numbers but also by the presence of a band.

the gun-line – in pouring rain and under continuous shell-fire; along stony roads, over fallen trees, shell-holes, dead horses; through the heavy clay of the sodden fields; over torn-up hills; through valleys furrowed with trenches and craters. Sometimes it was as light as day, sometimes pitch-dark.' They managed to find a flat area, but everywhere around was devastated. The two nearby houses were in ruins. 'One is a mere blackened heap of bricks; the other has three shattered red walls still standing. The whole place is in the middle of arable fields reduced to a sea of mud, churned up to a depth of 15 feet or more by the daily barrage of the English 6- to- 8- and 11- inch shells, one crater touching another…Nothing can be seen far and wide but water and mud.'

After Gürtler had unloaded hundreds of shells, the British barrage reached a crescendo: 'the great Flanders battle started!...Darkness alternates with light as bright as day. The earth trembles and shakes like a jelly. Flares illumine the darkness with their white, yellow, green and red lights and cause the tall stumps of the poplars to throw weird shadows.' Gürtler's team was ordered to fire and keep firing: 'we crouch between mountains of ammunition (some of us up to our knees in water) and fire and fire, while all around us shells upon shells plunge into the mire, shatter our emplacement, root up trees, flatten the house behind us to the level of the ground, and scatter wet dirt all over us so that we look as if we had come out of a mud-bath. We sweat like stokers on a ship; the barrel is red-hot; the cases are still burning hot when we take them out of the breech; and still the one and only order is, "Fire! Fire! Fire!" – until one is quite dazed.'

By mid-morning the British barrage had moved on to new targets. As the troops re-stocked with ammunition and cleared up after the very active night, the wounded started their long journey to hospital; 'a long file of laden stretcher-bearers wanting to get to the chief dressing-station; large and small parties of slightly wounded with their field-service dressings – some crying and groaning so that the sound rings in one's ears all day and takes away one's appetite, others dumb and apathetic, trudging silently along the soft, muddy road in their low, heavy boots, which look like nothing but lumps of mud; others again quite cheery, knowing that they are in for a fairly long rest.'

Although not in the front-line, Gürtler and his men were in the firing line, and they

understood what the infantry were experiencing and feeling: 'those men who are still in the front line hear nothing but the drum-fire, the groaning of wounded comrades, the screaming of fallen horses, the wild beating of their own hearts, hour after hour, night after night. Even during the short respite granted them their exhausted brains are haunted in the weird stillness by recollections of unlimited suffering. They have no way of escape, nothing is left them but ghastly memories and resigned anticipation' and their possible death. 'The battle-field is really nothing but one vast cemetery. Besides shell-holes, groups of shattered trees and smashed-up farms, one sees little white crosses scattered all over the ground – in front of us, behind us, to right and left. "Here lies a brave Englishman" or "Bombadier____, 6.52". They lie thus, side by side, friend beside friend, foe beside foe.' Four days after he wrote this letter, Gerhard Gürtler was dead.

Heavy rain set in during the evening and forced movement onto the roads. Even with worsening conditions underfoot, a determined effort was made to regain the second line the next day. At 1530 hours, covered by a smoke screen and artillery barrage, groups of infantry maintained a footing north of Frezenberg until dislodged around 2100 hours by a British counter-attack. A similar attack the next day around 1330 hours was broken up by machine-gun and artillery fire. During 2 August, troops massing for a further counter-attack were dispersed by artillery fire. Later in the day St. Julien fell to the advancing British.

The rain had swollen Bassevillebeek, Hanebeek and Steenbeek, and constant shelling had damaged the drainage. The rain-softened ground, now a sea of shell-holes, was a semi-liquid, clayey mud. In places men were up to their waists in mud and water. Movement became extremely difficult. Further rain produced even worse conditions.

'The rain which had set in on the evening of the 31st July continued for three days and nights almost without cessation.' The new British front became a swamp. Any movement had to be made along well-defined tracks; moving off them was to risk death by drowning. The offensive had to be postponed.

In his diary Crown Prince Rupprecht described the conditions his men were living in: 'The rainfall of the past few days was so heavy that not only is the crater field occupied by *Fourth Army* full of water, so are the trenches in places. Most of the soldiers are taking cover behind their flooded trenches or in shell holes. In the latter case, they are attempting to protect themselves from the wet conditions by huddling under planks or sheets of corrugated iron, daubed with mud.'

Movement was restricted to night and, because only maintained roads could be used, British transport moving towards the front was an easy target. One especially dangerous spot was the bottle-neck on the road at the Menin Gate. Apart from the dangers of the mud, persistent barrages made life for the British troops uncomfortable; relief was difficult and the transport of supplies was hazardous.

It was no different on the German side. Prince Rupprecht recorded in his diary: ' It is proving very difficult to transport food, rations and trench stores forward because of the amount of gas which the enemy is using. The carrying parties are generally not in a position to mask up sufficiently quickly.' *6 Bavarian Reserve Division* recorded 1,200 gas casualties in the battle so far.

The explosive shelling during the battle also stopped supplies getting through. As food and water ran out, the defenders had to look for alternative supplies. One soldier

An artillery dump on 5 August 1917 after being shelled by the British.

recalled: 'Finally peace descended with the arrival of darkness. Some of us satisfied our hunger and quenched our great thirst by removing food and drink from the British haver-sacks which lay all around…The night passed slowly, but the artillery duel continued.'

After the war, Ludendorff wrote of the first day of the offensive: 'On 31st July the fighting caused us very heavy losses in prisoners and stores, and a large expenditure of reserves.' With further attacks imminent, other fronts would have to release troops.

In between the British attacks, the shelling continued. Each day the artillery barrage would presage an attack that never came, straining the nerves of the defending troops to the point of making them wish the British would come. A Reserve Oberleutnant recorded his experience of this period in the regimental history: 'A few hundred metres to our right we could see the remains of Langemark. I shall never forget seeing a constant stream of hellishly evil, flaming mortar bombs landing in the ruins and sending up jets of burning liquid into the sky. The British had a special way of ruining our nerves. Every morning towards 5.00 am the shelling was increased to a crescendo of drum fire. We were sure that the enemy were coming; we even wished they would come. We wanted to do some-

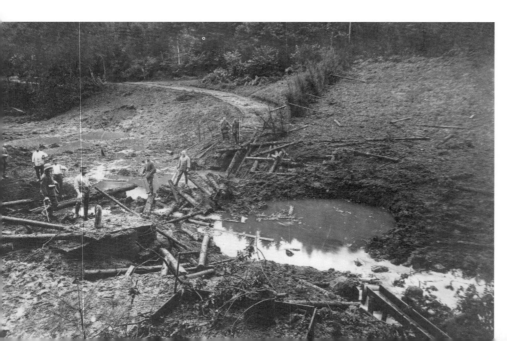

The results of British shelling on a track during early August 1917.

thing at long last; to fight, to defend ourselves, weapons in hands, anything rather than have to endure any longer this, which was slowly driving us all mad.'

The battle continued with a British attack on 10 August against a belt of strongpoints across Gheluvelt plateau, including Inverness Copse and Glencorse Wood. Although the ground was difficult for the British troops to cross, following the barrage, they took the forward line; little resistance was offered and many defenders 'came forward to surrender', including a battalion commander of *239 Reserve Infantry Regiment*.

Ninety minutes after leaving their jumping-off positions, the leading British troops were caught and boxed in by a machine-gun and field gun barrage. This cut them off from reinforcements and supplies of food, water and ammunition. Shortly afterwards, local counter-attacks were launched against the British troops, many of whom fell back under the pressure.

The failure of this British preliminary operation postponed the next assault by one day. More heavy rain added a further twenty-four hours' respite. At 0445 hours on 16 August, the British barrage opened. The British troops set off in a ground mist that cleared as the sun rose. Against machine-guns, artillery fire and counter-attacks, little progress was made by the southern flank of the attack. In the northern sector, the attack was not contained as successfully. In part this was put down to the poor quality of the replacements received. *79 Reserve Infantry Division,* having suffered heavy losses at Arras in April, had been brought up to strength with drafts of the 1918 Class. Post-war regimental histories claimed that these nineteen-year-olds were unable to stand up to the heavy continuous shelling. No large-scale counter-attacks were made to regain the lost territory but, still retaining the higher ground, the British were subjected to machine-gun and artillery fire which caused heavy losses.

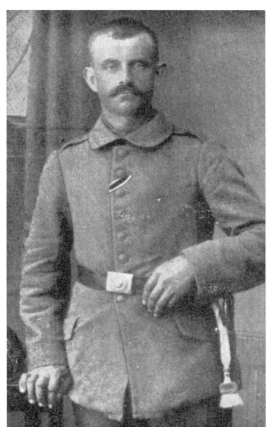

On the left flank of the northern end, the French were the most successful. Although delayed by prolonged fighting at several strongpoints, they did reach their objectives.

Both sides were under immense pressure to achieve in what had become a materiel battle with artillery as the king. Morale on the German side was not as high as the commanders wanted, and, although the British were technically winning, there were rumblings in their

Karl Eglmeier, holder of the Iron Cross Second Class, was a Landsturmmann in *3 Ersatz Regiment*. He was forty-two when he was killed on 19 August 1917.

ranks. It was common practice to interrogate prisoners and often useful information was obtained. Prisoner interrogation revealed a dip in morale among the attackers. 'British prisoners are saying – this has never been heard before – that they wished that they had shot their own officers who were leading them into the slaughterhouse. They have had enough of this butchery' Crown Prince Rupprecht recorded in his diary on 16 August. Later he noted that even captured officers were critical of their superiors.

For the next few days, the British launched only localised attacks. Attempts to gain ground on Gheluvelt plateau proved costly and fruitless as the defenders regained ground with bombs and portable flame throwers. After days of failure, the fighting now switched south from the British Fifth to the Second Army.

Although the British had won little in territorial terms, the battles had achieved what was intended: to keep the German forces tied up. Between 25 July and 28 August, the British attacks had resulted in exhausting twenty-three divisions that had to be taken out of the line, out of thirty involved on the front from Hollebeke to Weidendreft. Facing the French, seven divisions had suffered heavy losses. To provide replacements, nine divisions had to be brought from Alsace-Lorraine and, to feed the guns, seventy per cent of the heavy gun ammunition on the front opposite the French had to be transported to Flanders. The plans for the Russian front were postponed and the French sectors left alone.

General von Kuhl put the effect of the British attacks very simply: 'The first phase of the great struggle ended on about the 25th of August…But the fighting strength of the numerous divisions had been used up; and it was already proving difficult within the entire area of Crown Prince Rupprecht's Group of Armies to replace them promptly with fresh divisions.'

Ludendorff saw that the fighting on the Western Front was more serious than any that his army had yet experienced and that the battles of August imposed a great strain on them. 'In August fighting broke out on many parts of the Western Front. In Flanders the Entente attacked again on the 10th, although they must have suffered severely on the 31st July. The 10th August was a success for us, but on the 16th we sustained another great blow and, even with an extreme exertion of strength on our part, could only be pushed back a short distance! During the following days fighting continued with diminished intensity. The 22nd was another day of heavy fighting. The 25th August concluded the second phase of the Flanders Battle. It had cost us heavily.'

It also affected Ludendorff's plans for other theatres: 'The attack on the Duna [the Riga offensive] in Russia had to be postponed.' The Kerenski offensive was also a problem as it took four divisions away from the Western Front.

After the fighting on 28 August, Crown Prince Rupprecht wrote in his diary: 'Yesterday's attacks by the British were utterly defeated, thanks to the courageous resistance put up by the troops from Württemberg.' A field gunner from Württemberg had the same story to tell when he wrote home: 'Everywhere we wiped the floor with the British. No wonder that a sign appeared the following day in one of the British trenches: *We can wait until you Schwabians have gone.*'

Ludendorff, like his troops, was under considerable strain. While remaining confident that the 'West Front would stand even more battering' he was not satisfied with the performance of some of the units in Flanders. The August fighting had imposed a heavy

A propaganda card to show the British as villains: killing an innocent female worshipper during their shelling of Ostend on 22 September 1917. Nuns looking at members of the congregation killed during the British shelling of Ostend.

strain on the troops, who 'in spite of all the concrete protection…seemed more or less powerless under the enormous weight of the enemy's artillery. At some points they no longer displayed that firmness which I, in common with the local commanders, had hoped for.' A concern that would be voiced again during the offensive.

Many soldiers hoped for a wound that would get them out of the war for a while, a move to the safety of the rear. The dream was not always the same as the reality, as Musketier Lindelhof found when he was wounded. Having been transported to the rear on a narrow gauge railway, he arrived at a dressing station in a large building in Kortrijk which could accommodate hundreds of wounded soldiers. In a side room, with another soldier, he tried to rest, but the events of the previous day kept flashing in front of his eyes. Eventually he did sleep only to be woken by a dreadful scream: 'The room was lit up as though it was in flames. The bed next to mine was empty. I then felt pain and something sticking to my feet…I had injured my feet on broken glass.' There had been an air raid: 'An ambulance parked outside the door of the hospital had been hit…in the petrol tank, which had exploded, burning out the vehicle.' His missing comrade had been hit by a splinter and died. Finding shelter in a cellar, he sat out the remainder of the bombing raid.

Above the front the opposing air forces fought a different type of war. On 6 September Captain Georges Guynemer of Escadrille SPA.3, the Stork Squadron, shot down his fifty-fourth victim. Five days later he was dead, shot down over Poelcapelle by Hauptmann Wissemann. Nineteen days later, he too was dead, shot down by the French ace René Fonck. That same month the 'Hussar of Krefeld', Leutnant Voss, was also shot down and killed.

On most nights during the month, aircraft crossed the British 'line to bomb camps in the Ypres neighbourhood, and the communications as far back as St. Omer. A succession of aircraft, one at a time, bombed the crowded shelters, Nissen huts and horse lines in the back areas throughout the night, preventing sleep even if' little real damage was done. On clear nights more success was achieved; one raid killed nearly a hundred men. Squadrons operating from Belgian airfields also raided Britain.

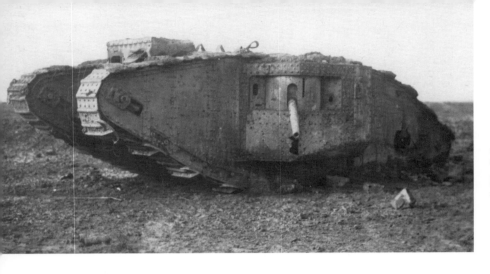

A British Mark IV male tank equipped with 6 pounder gun knocked out on 15 September 1917.

On the ground there were no major operations, but there was considerable minor skirmishing to gain control of No Man's Land, improve positions in the forward battle area and take prisoners. Both sides raided for information and to keep up morale. *Infantry Regiment 133* mounted a large raid on 1 September near Hollebeke. Writing home after the raid, Gefreiter Linke, who won the Iron Cross for his part, described the raid: 'We lay down about sixty metres from the enemy trenches. At exactly 11.00pm our artillery and mortars opened up suddenly and our machine-guns joined in too…At the same moment the assault groups launched forward at the enemy trenches. In the shock, about forty of them were killed, a great many wounded were lying around and we captured eleven prisoners. These poor lads had been just about to be relieved…an Unteroffizier and I recovered a severely wounded man who had been hanging on the British wire and brought him back. We had two men missing, two seriously wounded and fifteen lightly wounded.'

By the middle of September, the German defensive position was less secure than at the start of the offensive. In an un-posted letter, an unnamed soldier writing to his brother serving further south described his situation as worse than before Arras: there was no shelter; it was 'the devil let loose.' An officer in *Reserve Infantry Regiment 92* voiced the same experience: ' How was it possible to avoid the thousands of shells? I still go ice-cold when I think back to that small, water-filled shell hole in which we lay totally unprotected and acted as targets for the countless British guns…The length of the battle made Verdun dreadful; but so concentrated was the British fire in Flanders that it was incomparably worse.'

After the war, Ludendorff wrote of this period: 'From 31st July 1917 till well into September was a period of tremendous anxiety.' At home the press attempted to raise morale. Before the British mid-September offensive, the *Frankfurter Zeitung* told its readers that the British were running out of reserves, were making little progress and were trapped in the mud. 'These people (the British) know war in the swampy trenches of Flanders: they have made their acquaintance with German resistance, and they know that their storm tactics are prone to run their course.' Everything would be all right.

The quiet period was punctuated by trench raids probing forward positions. Reserve Leutnant Kümmel of *Reserve Infantry Regiment 91* recalled a trench raid on his positions during 14 September. 'At 4.00am, following a short, sharp bombardment on the positions

Johann Freimuth, a farmer's son from Pirka, was thirty-two when he was killed during a British artillery barrage. At the time of his death, 20 September 1917, he was serving with a Bavarian Ersatz (replacement) Regiment.

of our right hand neighbours, the British launched a raid, which succeeded in penetrating the forward positions and establishing a nest of resistance in the front line. Our 1st Company drove them off. Of twelve members of the British...division three men, including a sergeant, were captured. The remainder were killed in hand to hand fighting.'

Apart from the trench raids and – what was unknown to the defenders – practice barrages for the coming attack, the front had been relatively quiet, puzzlingly so. But by 17 September, *Fourth Army Headquarters* was convinced that an offensive in the Ypres sector was imminent. This was confirmed by the capture of an Australian officer who was carrying an operation order for the attack on the Ypres-Menin road. On receipt of a wireless warning, *Gruppe Ypres* and *Gruppe Wytschaete* warned their Eingreif divisions to be ready.

At 0540 hours, the next phase of the battle commenced. 'The British infantry suddenly came upon the defenders "like spectres out of the mist".' The day would not go well for the defenders. Massively supported by artillery, the attackers followed a barrage that lifted every two minutes and moved on fifty yards. It took the outposts and local counter-attack posts by surprise. 'Overrun in the mist, many parties were caught in their shelters, or on the point of emerging from them', to be met by hand grenades and phosphorus bombs.

Small British assault groups made their way in single file between the shell craters, deep into the defence system. The barrage had unnerved and stunned many of the defenders in the front line and even those further back. Little opposition came from the machine-gunners who sat inactive by their guns, even though few shelters or pillboxes had been destroyed. Some ran forward, waving handkerchiefs and pieces of white bandage. When opposition was met, the attackers slipped round the flanks in the mist; where the opposition was strong, casualties were heavy. Some defenders lay hidden in covered shell-holes and opened up on the follow-up troops, inflicting severe losses on them but sustaining heavy losses themselves.

Although counter-attacks were attempted, they were either stillborn or caught before they reached the attackers, due to the protective barrage put down by the British artillery. However, the British could not consolidate their positions in peace. Numerous snipers harassed their movements and slowed down the movement of fresh troops.

Troops in the northern sector restarted their attack when the barrage started at 0953

Alfons Vogel, a soldier in *11 Infantry Regiment*, who had served as a youthful volunteer from early in the war. He was nineteen when he was killed during a British artillery barrage on 20 September 1917.

hours and found more severe opposition. Pillboxes in ruined cottages, concrete dugouts and troops in hedgerows made the advance of even a few hundred yards costly. Further casualties were inflicted on the attackers by the artillery and aircraft ground-strafing.

41 Division met especially determined resistance from hidden machine-gun nests and from a mass of concrete dugouts and pillboxes on the Bassevillebeek spur. After several costly attempts to take the position, the British abandoned further effort. Casualties among the defenders were also high. According to their regimental histories, the defending battalions of *28 Bavarian Ersatz* and *395 Regiments* were practically annihilated. Their support battalions fared no better. When relieved on the night of 21/22 September, *395 Regiment* support battalion consisted of just seventy men.

On the southern flank, casualties inflicted on the attackers were heavy but the positions were eventually taken. The defence lacked artillery support because the observation posts were unable to see due to a four-hour smoke screen over them. Casualties among the defenders were again heavy in the under-sized battalions. *5 Grenadier Regiment* had an average company size of two officers, ten N.C.O.s, and sixty-five men; of the 280 that made up its front line battalion, only about twenty, mostly wounded, survived the day.

From their newly-captured positions, the attackers commanded a clear view in all directions. It was no longer possible for a counter-attack to form unseen. The defenders were completely disadvantaged and British machine-gun and artillery fire quickly dispersed any units forming up to counter-attack with heavy losses. *234 Division's* history records their losses for the day as sixty per cent of officers and up to fifty per cent of their strength. For the foreseeable future the Eingreif divisions were a spent force. Similarly, local attempts to improve their position at various parts of the line over the next few days were frustrated by machine-gun and artillery. During this period the British reported taking 3,243 prisoners.

Although the British were being checked, and many of the counter-attacks succeeded, it was certainly not a German victory. Ludendorff wrote in his memoirs that 'from 31st July 1917 till well into September was a period of tremendous anxiety. . .The fighting on the Western Front became more serious than any the German army had yet experienced...On 31st July the fighting caused us very heavy losses in prisoners and stores, and

Menen railway station showing little sign of real damage even though the photo was taken in 1917.

a large expenditure of reserves; and the costly August battles imposed a great strain on the Western troops…The state of affairs in the West appeared to prevent the execution of our plans elsewhere. Our wastage had been so high as to cause grave misgivings, and exceeded all our expectations'. He also complained that the counter-attack divisions arrived too late to catch the attackers when they were at their weakest, and that the enemy had quickly adapted to the use of the counter-attack division.

This being the case, it was necessary for *OHL* to review their defensive tactics. The failure of the Eingreif divisions was due to their lateness in attack; they needed to arrive during the enemy assault, when the British were at their most vulnerable and confused. Another failure was the artillery support. As the situation in defence was fluid, it was difficult to provide a protective barrage without visual contact. The decision was made to use Eingreif divisions in a systematic counter-attack on the following day. The positions of divisions at the front were also to be strengthened with extra machine-guns to prevent the Allied attack from advancing so far. To further reinforce the front positions, 'stand-by and reserve battalions were to move to the front as soon as, or before, the battle began, so as to catch the enemy whilst consolidating.'

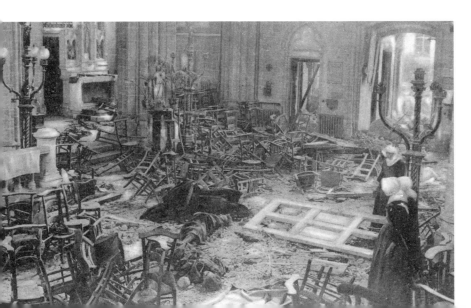

A postcard by a local printer sold to the public. Three nuns look at the effect of British shelling on the church of Saint Petrus and Paul on 22 September 1917.

From 22 September *OHL* stipulated 'that there must be:

Increased artillery counter-preparation before the battle, not only against the enemy's artillery but also, about half, against his infantry, massed behind a screen of outposts.

More offensive raids to make him strengthen his front lines and incur loss.

Strengthening of artillery observation in the German battle area, so that fire would be effective when he entered it.

Speeding up of counter-attacks.'

In his diary, Rupprecht recorded his fear that the British would complete the capture of Gheluvelt plateau in their next advance. In order to delay them, he ordered a counter-attack on 24 September, later changed to 25 September. He also hoped the British attack would be as far off as possible as he had insufficient reserves to contain it.

So, while the British made preparations for the their next attack, a well-organised counter-attack was delivered early on 25 September between the Menin road and Polygon Wood. As the British troops were being relieved, field and heavy artillery, using high-explosive, shrapnel and some gas shell, opened up on them. Fifteen minutes after the barrage had started, two regiments of *Fifty Reserve Infantry Division* moved to attack. Unfortunately for *230 Reserve Regiment,* its protective barrage fell on the assembly area and its troops had to pull back and wait for it to finish. Although new to the sector, the British fought stubbornly and the counter-attack was held with severe losses.

Prisoners captured on 25 September indicated that there would an offensive the next day. At 0550 hours, 26 September, the British attacked through mist, smoke and dust from the now dry ground. As on 20 September, the thinly held forward zone had been taken and once again counter-attack units moved into place. Unfortunately for them, the British had foreseen, with some accuracy, their assembly positions and upon reports of their movement brought down an artillery barrage. As the three Eingreif divisions moved through the front-line divisions, the intense barrages broke up their thrusts and made them fall back or at best dig in close to the new British line. Although supported by low-flying aircraft, the now disorganised counter-attack failed. By 2030 hours all efforts to regain the lost ground ceased. The night was quiet.

A company commander of *3 Battalion 34 Fusilier Regiment* recorded his experience that day. 'About 0600 hours a sergeant near the entrance shouted out that he thought the English were coming. I hurried out. The air was filled with smoke and this together with a ground mist made it difficult to see more than twenty yards or so…Then the shelling slackened only to move on and become stronger than ever behind us. Suddenly I heard shouts of 'the English' from in front. I called the men out and we took up a position in the mass of shell holes on either side. Almost at once figures appeared moving towards us through the fog. They were coming on at a steady pace bunched together in groups between the water-logged shell holes. We opened fire and threw hand grenades into the midst of them. For a moment the attack was held, but looking round I could see more English advancing past us to right and left, and realised that our only hope was to run for it. With the few men near me I started back towards Zonnebeke but, after a few yards, saw it was hopeless as the enemy had already closed in ahead of us in their advance. The noise of machine-gun fire from the village made us hope that a counter-attack would soon be made to regain the position and four of us ran back. We had scarcely time to slam the door of thick oak planks when it was ripped away by a hand grenade.'

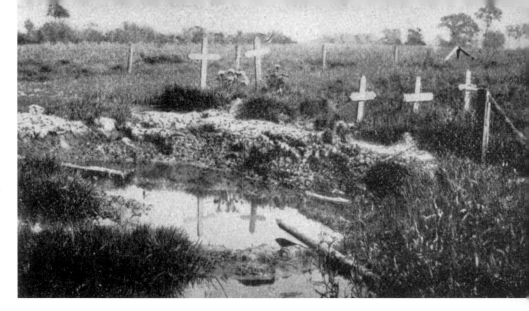

The soldiers' cemetery in Becelaere in September 1917 before the fighting reached the area.

A Leutnant in *Reserve Infantry regiment 231* recalled the aftermath of the attacks on his sector. He was ordered to move his unit slightly south where he saw 'utter chaos. Dead and wounded lay everywhere – many of them British. We established our strong-point…During the night a Scotsman blundered into our position. We kept him there to tend to his severely wounded countrymen, who were moaning terribly. One of them had lost both eyes to a flamethrower. I longed to shoot him and put him out of his misery, but such action was not permitted.'

Once again the British prepared for an attack. The chosen date was 4 October, the objective Broodseinde. Unlike the preceding attacks, there would be no artillery barrage until zero hour. As a deceptive measure, full-scale practice barrages were laid down at different times from 27 September onward. The deliberate targeting of strongpoints and counter-battery work continued throughout the period before the assault.

The *Official History* written after the war commented on the counter-attacks. 'The Eingreif divisions for the most part again struck against an already well dug in enemy, in some places against new enemy attacks…In the face of the British barrages they took 1½ to 2 hours to advance one kilometre, their formation broken and their attack power lamed.' Losses were again heavy during the day; the two attacking regiments of *4 Bavarian Division* together lost forty officers and 1,300 other ranks. No ground had been retaken.

The lost positions provided the Allies with important observation points but they were still denied the plateau north of Becelaere. Behind this, it was still possible to bring up and assemble troops under cover for further counter-attacks.

The Flanders losses impacted on other theatres. '*OHL* had intended to launch an offensive against Italy in September, in order to bolster up its Austrian ally and at the same time to ease the pressure in Flanders. Owing to the difficulty of mustering the required 9 divisions (6 only were eventually sent, and a seventh was improvised from *Jäger* battalions), mostly from the Eastern Front, to support the Austrian troops, the offensive had to be postponed till the end of October.'

The shortage of troops available on the Western Front is clearly shown by *195 Division*. Withdrawn into reserve at Cambrai, it was equipped and trained for Italy. On 1 October it was ordered to return equipment and proceed to Flanders. It eventually arrived in Italy

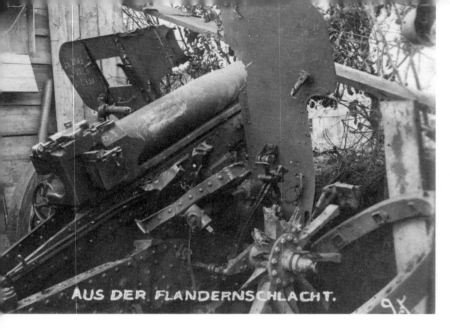

The results of British counter-battery work during the 1917 offensive.

during the middle of December. Such was the shortage that two divisions from the Eastern Front were stopped in transit to Italy and diverted to Flanders.

With the fine weather during the day and bright moonlit nights, the early mornings were enveloped in thick ground mist. At 0430 hours on 30 September, a heavy bombardment by artillery and trench mortars fell on British positions between the Menin road and the Reutelbeck. 'Preceded by assault groups using liquid flame throwers, smoke bombs and hand-grenades', the attackers rushed at the British positions. Even though they were aided by a mist, the withering fire from the British halted the advance and the attack force withdrew. A further assault at 0600 hours met the same end.

An attack on 1 October, after a hurricane bombardment, was initially more successful. Its objective was to retake the shelters and observation points lost on 26 September. Responding rapidly, a British counter-attack pushed the storm troops back to their original positions. A further attack was stopped by shell fire as the troops were massing.

As the Australian troops lay on the wet ground awaiting zero hour, they were caught by an artillery barrage. In the shell-holes in front of them were counter-attack troops. The three battalion attack by *212 Reserve Infantry Regiment* was intended to retake observation positions lost on 26 September.

Timed to start ten minutes before the German attack, the British artillery opened up on the ground where the assault troops lay. As they advanced into the barrage in the dim light they were met by advancing infantry with bayonets fixed. During the ensuing battle, *212 Reserve Regiment* lost thirty-six officers and over 1,000 men, many of whom were killed by the shelling. *45 Reserve Infantry Division,* of which *212 Reserve Regiment* was part, recorded total losses of eighty-three officers and 2,700 other ranks. The holding division behind them, *4 Guard Division*, suffered similar losses in each of its three regiments; its losses were eighty-six officers and 2,700 other ranks. One of its constituent units, *5 Foot Guard Regiment*, described it as the worst day of the war so far experienced. By the end of the day, the ANZAC Corps had taken their objectives and claimed to have taken 1,159 prisoners. However, this was achieved at considerable loss; the four divisions recorded just over 8,000 casualties during the battle.

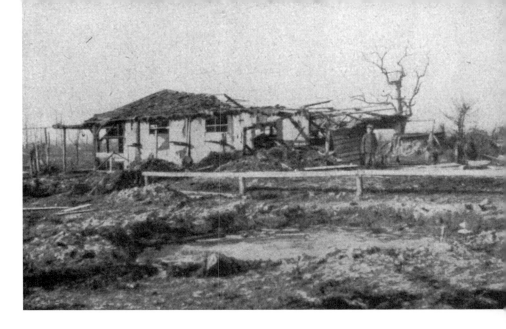

Camouflaged concrete dugout containing unit headquarters, defensive positions and first aid post. This building was known as the Wilhelmhof and was near Becelaere. The photo was taken in October 1917.

The capture of the Gheluvelt plateau on 4 October was described by the High Command as a "Black Day" on which the 'losses, particularly prisoners, were terrifyingly great.' Ludendorff wrote that 'the battle on the 4th October was extraordinarily severe, and again we only came through it with enormous losses. It was evident that the idea of holding the front line more densely, adopted at my last visit to the front in September, was not the remedy.'

With the defence line almost broken and a British attack imminent 'Rupprecht was expecting the German defensive dam to burst.' However, the next day he was able to praise the rain. Even if the British took Passchendaele there would be no further attacks. However, British and Canadian attacks did not stop until Passchendaele Ridge had been taken on 6 November.

Although *The Times* devoted a leader to the events of 4 October calling it 'The Victory of Broodseinde' and German losses were alarmingly high, especially in prisoners, the German press told the public that everything was going fine. 'Hindenburg was in full control, sucking British troops into traps where they were duly annihilated. The German people should not worry about the loss of hamlets.' The official explanation for the loss of the plateau was that 'the divisions were no longer what they had been, as a result of nervous exhaustion, fatigue and bloody losses.'

Once again the front line was reorganised because of the disaster of 4 October. 'On 7th October the commander of the *Fourth Army* ordered "the foremost line of shell craters, if no natural obstacle was available, to be occupied by a quite thin screen of posts with light machine-guns. A main line of resistance was to be constructed 500 to 600 yards behind this screen.".'

With losses mounting, and no sign of the British attack stopping, suggestions and preparations for a retirement were made. Such a movement, which would necessarily mean the abandonment of U-boat bases, would not gain the approval of Ludendorff.

The *Fourth Army* report for 4 October read: 'Once again the British attacked…(and) only gained a narrow strip of territory…totally disproportionate to the very heavy casualties.' In the *Army High Command* communiqué the troops were praised: 'The commander

and men of the *Fourth Army* have endured a day of battle of rare intensity, coming through it well…The bloody losses of the British divisions…are universally stated to have been very high. The excellent cooperation of all arms of our army combined to break up even this massively heavy blow by the British…Nothing can ever surpass the heroism of the German troops in Flanders.'

The next Allied assault on 9 October aimed at taking Poelcappelle; there was time before that to relieve the front divisions that fought in the 4 October battles. All nine divisions were replaced by the start of the next attack. The Allied intention was to capture the dominating position between Passchendaele and Westroosebeke. To counter the Allied attack, a fresh division was in place. The division chosen, 'The Iron Division' (*16 Infantry Division),* had orders to hold the foremost line, and outpost groups, with numerous machine-guns. To fulfil its task, its front line of troops was so close to the British jumping-off point that the barrage landed behind them.

The barrage that signalled the start of the assault at 0520 hours was weak and erratic. Some of the attacking battalions had not arrived on time, some had been shelled on their way to the front and both sides found the ground difficult to cross. After heavy rain, men struggled through mud above their ankles, often up to their knees. The defenders were much better placed to cause problems than in the previous attack. Protected by intact belts of low wire entanglements, hidden in shell holes and in concrete pillboxes protected by newly made apron fences of wire, the defenders were able to inflict considerable casualties and slow down the British troops.

Even so, the defence across the front offered a mixed resistance. Some units fought well while others surrendered readily during the advance. The British found Passchendaele deserted, while the Australians had to retire; they did not have enough troops to mop up the defenders hiding in shell holes and who were being reinforced by the arrival of new troops. *227 Division,* facing the British XIV Corps, made only slight resistance, having taken over the positions only just over an hour before the attack started.

Although the French attack had been successful, overall the loss of ground, except on the right flank, had been limited and was confined to Reutel, opposite Passchendaele and near Houthulst Forest. The defenders' losses had been heavy but on the whole the High Command was pleased with the outcome.

'Our orders came to embark for Flanders! – Flanders! The word flashed round the

A large calibre shell crater in a sea of mud. The Allied troops had to attack across such ground. The mud often deadened the effect of the explosion.

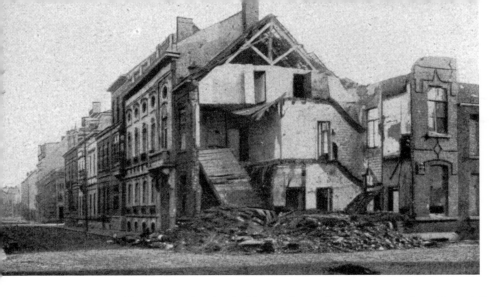

The effect of British shelling on Roselare during August 1917.

regiment like news of a death. Everywhere there were serious faces.' For newly-arrived divisions the almost incessant shelling was like nothing they had previously experienced, even for units from the Arras Front. Of course the barrage was always dangerous, but it could have a lighter side. The newly-arrived *220 Infantry Division* immediately found itself under heavy fire: high explosive in a random pattern. Hiding behind hedgerows, they watched a house disappear with one shell. Another shell landed on the other side of the hedge. A large puff of blue smoke was followed by laughter. The shell had landed in a deep trench latrine and exploded harmlessly, but it sent the evil-smelling contents of the latrine over 'the platoon, with the most generous allocation going to the platoon commander!'

Doubts, arising from a shortage of munitions and men, as to whether the British could be held, continued. In his diary entry for 10 October, Crown Prince Rupprecht wrote: 'There was a high wastage within the divisions of *Fourth Army* yesterday and we fired off the equivalent of twenty seven trainloads of ammunition. This time it is still possible to bring forward sufficient troops…but if…the French attack the *Seventh* and *Third Armies* simultaneously with the British continuation of attacks against the *Fourth Army,* the *Army High Command* will not be in a position to despatch sufficient fresh troops…to help us.'

There was a three-day gap before the next British attack, planned for 12 October, with the expectation of taking Passchendaele. The failure of the attack on 9 October had been blamed on the mud until 11 October, when Australian and New Zealand patrols discovered the two formidable and continuous belts of wire protecting the pillboxes of the Flanders 1 Line on Wallenmolen spur. It was these defences that had broken the British attack.

The Allied onslaught was steadily taking its toll. 'In the 3 months since 11 July, the 63 divisions of *Army Group Crown Prince Rupprecht* had suffered 159,000 casualties in Flanders.' Often divisions were taken from other fronts by *OHL* but this time none could be made available because of concerns that the French might make partial attacks to hold troops in other parts of the front, as happened at Malmaison on 23 October. With no reinforcements forthcoming, Rupprecht 'found himself compelled to consider whether in the case of his forces proving inadequate, in spite of the many disadvantages involved thereby [including the abandonment of the Flanders coast], he should not withdraw the front in

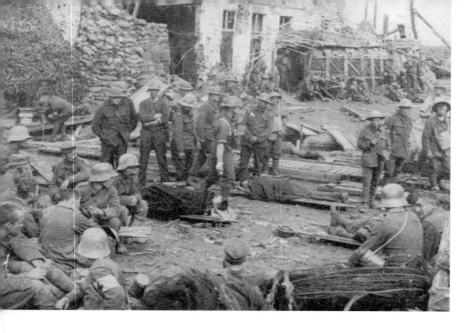

Taken at the start of Third Ypres, newly captured German soldiers at Hussar Farm, Potijze.

Flanders so far back that the Allies would be forced to carry out an entirely new deployment of their artillery. The time gained thereby could be used for the building of a new defence front, with a shortening of its length and consequent economy of troops. The loss of ground and the moral disadvantage of retirement would have to be accepted. Preparations were duly made for this operation.'

Accordingly, Rupprecht reported to *OHL* on 11 October that he was considering a withdrawal to save men and materiel. The order was not implemented. That same day he also expressed his concerns about the steady deterioration of the troops. A post-war memoir by a machine-gunner who fought in Flanders described the effect of the weather on the soldiers' health: 'Owing to the constant rain and the exertions of bringing up ammunition, rations and water through the mud, there was much sickness, and nearly everyone had diarrhoea.'

The effect of poor health on the men's fighting ability had been noted as early as September in a report written by *Reserve Infantry Regiment 19*. 'There has been a reduction of the fighting ability of the troops as a result of the numerous gastro-intestinal illnesses which have, without exception, affected every man stationed in the trenches. During the past eleven days five officers and 165 men have been evacuated to hospital through this cause…The cause is the wet conditions in the craters and dugouts and the stink of rotting corpses which is poisoning the air. Despite clearance of the area many corpses must be concealed in the mud and water-filled craters.'

The deterioration to which Rupprecht alluded affected more than just physical health. Troop behaviour was also impaired. Thieving and marauding were rife, and beyond the control of the field police. In his memoirs, an officer described what was happening: 'The old military discipline was gradually slackening…The unexpected prolongation of the war, constant shortage of reserves, poor food conditions and the inexperience of the younger officers and NCOs – all added to the discernible deterioration of morale.' Further evidence of lowering morale is given by Ludendorff: 'It must be admitted that certain units no longer triumphed over the demoralising effects of the defence battle as they had done formerly.'

Captured British fox-
holes in a wood near
Ypres.

But not all units were demoralised. Most knew why they were there. Fusilier Böhme serving in *5 Guards Regiment* knew exactly why he and his fellows were fighting: 'we are all part of the grey wall and we must protect the Homeland, our women and children against the bringers of death, because we are all German soldiers!'

The next day, 12 October, the relief arrived – rain. 'Our best ally' Rupprecht confided to his diary; about midnight a wind arose bringing drizzle. As Allied troops began their new assault, the wind increased in strength, the drizzle turned to heavy rain, and, apart from a brief respite during the morning, continued for the rest of the day. Few of the New Zealand troops were able to get past the belt of wire; those that did met the same fate as the previous attempts. Their casualties for the attack were 100 officers and 2,635 other ranks. The Australians on their right found the going just as tough but managed to get through to Passchendaele, finding it deserted. Moving over the same ground as the attack three days earlier they found wounded British soldiers hiding in shell-holes.

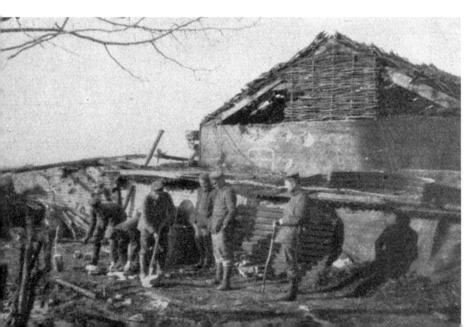

Pioneers at work outside a concrete blockhouse camouflaged to resemble a farmhouse. The photo was taken in October 1917 near Gheluvelt.

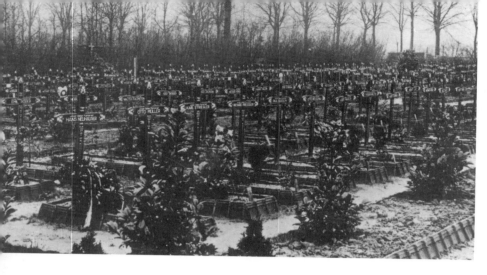

A neatly laid out cemetery somewhere well behind the front. Each grave is identical and all are cared for by men of *Reserve Infantry Regiment 245* in *54 Reserve Division*.

Continual machine-gun fire caused one brigade to pull back to the starting-line. Troops in the other attacking brigade had reached the summit where they were pounded by field guns firing over open sights and swept by fire from machine-guns and snipers. Faced with annihilation, they too withdrew, forcing the division on their right to abandon their gains.

The British attack to the north met with mixed success. The troops of XVIII Corps were unable to reach their allotted objectives due to deep mud, wire and machine-gun fire. At the end of the day they were slightly in advance of their starting-line. XIV Corps' barrage was more effective and, despite mud and considerable sniper activity, the defending troops gave way, allowing the British to move their line forward.

The infantry on both sides were now granted a reprieve. The Allies decided to 'postpone all further attacks until an improvement in the weather made the construction of roads practicable for the forward movement of the artillery'. This would allow a more effective and prolonged barrage for the next attack.

Scattered across the desolate landscape were concrete bunkers, constructed to provide cover as well as being armed strongpoints. They were theoretically safer than shell holes but they were not universally liked and were not always secure. Although they could withstand a direct hit, their foundations were not always strong enough to provide sufficient support. 'When a couple of heavy shells opened up a crater close to them, they would lean over, sometimes with the entrance down, with the soldiers trapped inside. There was no way of rescuing them.' The entombed men were doomed to a slow death.

The time of the recommencement was uncertain but there were three reasons why it definitely would come. The Allies needed to take Passchendaele ridge for observation; they aimed to take attention off the forthcoming French offensive in the Champagne; and they needed time for troop-tank training for the planned offensive at Cambrai.

It had not been a good start to October. The battering 'around Broodseinde on 4 October, the subsequent assaults on the 9th and 12th...did push the hard-pushed German defences back a further 2 kilometres across a 6-kilometre front and threatened Passchendaele ridge for the first time.'

Good weather favoured both sides, but poor weather assisted the defender. A few days after the Allies decided to wait, the weather improved. From the ridge, the defenders had a clear view of the Allies' intentions. To hinder the Allied preparations, artillery

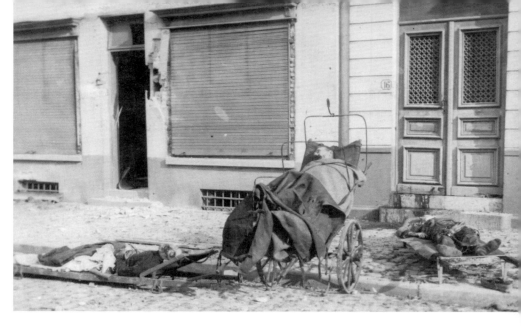

Casualties caused by the British shelling of Ostend in October 1917.

became more aggressive, hindering the laying of plank roads that were needed to move guns forward. From 14 October, almost nightly until mid-November, aircraft bombarded the Allied 'back areas with high-explosive, and drenched the low ground of the Steenbeck valley with gas shell. Sneezing gas (blue cross = diphenyl chlorarsine), which made it difficult to keep on the respirators, was followed by mustard gas (yellow cross = dichlorethyl sulphide) , which blistered the body and damaged throat and eyes.' While the gas killed relatively few, its effect was large-scale: it disabled thousands and saturated areas so they were unusable for a long time. Such was the effect of the artillery on the working parties constructing the plank roads that the casualty rate approximated to that of infantry in battle.

By mid-October, *Fourth Army* had suffered between 175,000 and 200,000 casualties. But, as Rupprecht had commented on earlier in the month, 'it was not just the troop losses but also the impact that the desperate fighting was having on German morale. The *German Official History* later admitted that Flanders was having a traumatic effect: "a deep mental shock" on both the soldiers who had survived so far but endured an increasingly desperate situation and the men of the fresher divisions that were destined to go through the experience of Passchendaele.'

Luck then favoured the attackers when they found that the road from Frezenberg to Zonnebeke had not been destroyed during the shelling. It had merely become covered in mud and was easily repaired once cleared. Thus speeded up, Allied preparations moved to systematic wire-cutting, counter-battery work and the bombardment of strongpoints.

In his history of the war, General von Kuhl described the situation of *Rupprecht's Army Group*. 'About the middle of October, the greater part of the divisions on the rest of the front of the Group of Armies [La Fère to the sea] had already been engaged in Flanders. On the whole front outside Flanders, even at the most threatened places like Lens and St. Quentin, we had no more than the very minimum of defenders to meet any diversionary attacks which might be attempted.'

The shortage of troops meant that there was no likelihood of the counter-offensive that the commander of *Fourth Army*, General Sixt von Arnim, suggested. He believed that

Leutnant Franz Wohlmuth, an artillery officer who had been awarded the Iron Cross First and Second Class and the Military Service Cross Third Class with Swords. He was killed at the age of twenty-one by British artillery on 22 October 1917.

such an attack would restore the shredded morale of the Flanders troops but, with every man needed to contain the British attacks, it was destined to remain no more than an idea.

At 0535 hours on 22 October the British, assisted by troops from the French 1 Division, feigned a full-scale attack with a barrage along the entire front. Although initially successful, early gains were lost later in the day. The next day, the Canadians did better and managed to push outposts closer to the top of the ridge.

The real battle started on 26 October when a Canadian battalion, following closely behind the barrage, advanced 400 yards in rain to gain their objective. Two counter-attacks failed to dislodge them but, after heavy and accurate shell-fire caused considerable casualties, a third counter-attack pushed them almost back to their start line. With two battalions of reinforcements, the Canadians pushed forward to regain their objective.

To the north, Canadian attacks, although suffering heavy casualties, pushed the defence back to capture Flanders Line 1 between Ravebeek and Wolf Copse. Added to successes further north, the Canadians had advanced 500 yards, half the distance to their objective, but they had secured drier high ground across Wallenmolen spur, south-west and west of Passchendaele. Counter-attacks by *11 Bavarian Division*, facing the Canadians, failed to dislodge them. By the end of the fighting, the Canadians had taken over 500 POWs.

Diversionary flank attacks by two divisions made only slow and laborious headway. The mud was so soggy that in places men sank to their knees. Stuck fast, they became easy targets for snipers. Any gain was lost later in the day. The defenders had inflicted heavy casualties on the attacking divisions: 119 officers and 3,202 other ranks. Successful defence had been bought at a similarly high price. *11 Bavarian Infantry Division* casualties were thirty officers and 1,469 other ranks.

On the northern flank of the attack, knee-deep mud checked progress and men fell back to their start line. The two French divisions attacking with the British Fifth Army made a little headway towards Houthulst Forest.

Werner Beumelberg described what it was like to fight in the mud. 'For half an hour a day in a major battle it was possible to fight – the rest unconsciousness, lying in puddles of mud, occasionally endeavouring to crawl into areas that were less fired upon; the

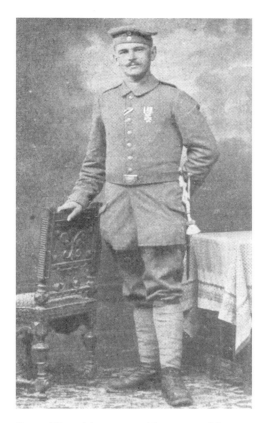

Michael Kronast was nineteen when he died in action. He was serving with *I Machinen-Gewehr Kompagnie* of *12 Bavarian Reserve Infantry Regiment* near Zonnebeke when he was killed by a British shell on 30 October 1917.

Franz Klasselsberger, a thirty year old soldier in a Bavarian Infantry Regiment. A brave soldier, he had been awarded the Iron Cross Second Class and the Bavarian Service Cross Third Class with Swords at the time of his death on 7 November 1917.

constant terror of being mutilated or killed.'

The improved weather the next day allowed aerial observation and gave the British the chance for some counter-battery work. During the evening of 28 October, British artillery batteries were heavily shelled with mustard gas. The next night, the British back areas were bombed, but the shelling was only intermittent.

At daybreak, 0550 hours, on 30 October, the Canadians advanced. Their objective was to capture a position on the southern edge of Passchendaele for the final assault. Although counter-attacked five times, they managed to hold on to their gains. On their left, the British troops, up to their knees in mud, were unable to follow the barrage and were caught in the German counter barrage, suffering heavy casualties. By this stage the British Army had 'lost its spirit of optimism and there was a sense of deadly depression among many officers and men.' The men on the other side of the wire had done more than could

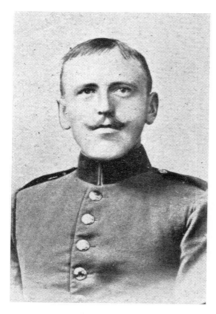

Unteroffizier Michael Maier had been at the front for thirty-nine months when he died in action. The thirty-six year old was killed in an artillery barrage on 6 November 1917 while serving with *Bavarian Reserve Infantry Regiment 2 (Kronprinz)* near Zandvoorde. He had been awarded the Iron Cross Second Class and Military Service Cross with swords.

reasonably have been expected.

To take the attack to the Allies, a local counter-attack was ordered for 3 November. Operation Hubertus was intended to push the Canadians back from the west of Passchendaele to straighten the line. The two-battalion attack was timed to start at 0550 hours. After getting the men into place, the Canadians launched a raid of their own that caught one of the battalions as it waited. Regardless of this, the assault was launched, but quickly lost momentum because of the high number of officer casualties. The story was the same further south where similar attacks took place.

In the medical report from *Infantry Regiment 132*, fatigue was added to the list of problems faced by the defenders. Lack of sleep was affecting the security of the line. To this could be added: 'colds and chills, gastro-intestinal problems, but above all skin problems caused by the plague of vermin and the total lack of means of caring for the body…all the officers and men exhibit the signs of utter exhaustion.'

The next Allied attack would be on 6 November to the east and north-east of Passchendaele. Preliminary barrages would be fired on 1, 2 and 3 November with all guns and howitzers on the Canadian front firing bursts on 5 November. Although strongly opposed, minor Canadian operations against specific strongpoints were successful, but later did meet with retaliatory attacks, one of which regained a wood in Reenbeck valley from the Canadians. A counter-attack to regain the main ridge north of the Roulers railway from the Canadians met with some success but within a few hours this had been lost.

By November the Passchendaele battlefield was seriously weakening the motivation of the defenders. In early October concerns had been raised about soldiers drifting back from the front during a battle. Now reports indicated that replacement troops from the Eastern front were disappearing on route, while some of the new arrivals were exhibiting poor discipline.

The assault against Passchendaele and the high ground to the north was launched at 0600 hours on 6 November; a fine but cold day to start, but later overcast and showery. After heavy fighting, the Canadians were into Passchendaele village by 0710 hours. By 0900 hours they had reached their objectives. On 10 November, in a rainstorm, the final Canadian push of the offensive took just one hour to reach its objectives.

For both sides, 'Third Ypres' had been a bloody series of battles. The cost in human terms alone for the Canadian success on Passchendaele Ridge was 271,000 Allied casualties and 217,000 Germans. Between mid-July and mid-November, *Fourth Army* had

brought in sixty-seven fresh divisions to replace fifty-one divisions. General von Kuhl described the effect of the Ypres battles: 'During the period 15th June–15th December 1917, 77 divisions were transported to the *Fourth Army* front (from the Lille-Armentières road to the Belgian coast), and 63 transferred from it…From the beginning of the battle on 31st July to the 20th August, that is in the first three weeks, 17 divisions were used up.' Six French and fifty-one British divisions, each nearly double the size of a German division, had fought against seventy-three German divisions.

The loss of Passchendaele 'merited a note in German papers and a collective sigh of relief on the British side.' Its loss was described by author Beumelburg in the *German Official History*: 'Attack after attack, clashing over the expanse of rubble, is textured into a jumble of bloody individual hand-to-hand combats…the artillery of both sides shoots indiscriminately into the ruins…At midnight, Passchendaele is lost.'

The Army Communiqué for 11 November reported a successful defence. The attacking British 'came up against counter-attacks from Pomeranian and West Prussian battalions which threw them back. They renewed their attacks five times but, in the face of our defences, most of them faded away forward of our lines. Wherever the enemy gained ground they were brought down by the infantry with cold steel.'

General von Kuhl judged the main Allied success had been 'the tying-down and drastic weakening of the remaining experienced and well-led German fighting troops.' The five-month campaign gave the French Army time to recover and also stopped the movement of troops to other fronts. Above all, Kuhl concluded, it 'had led to a vast consumption of German strength. Losses had been so high that they could no longer be replaced.' To him it had surpassed the Hell of Verdun and had been 'the greatest martyrdom of the World War.' In his memoirs, Hindenburg's comment on the battle was: 'It would have been better to have evacuated the ground voluntarily.'

The material cost had been high as well. During the offensive *Fourth Army* fired eighteen million artillery rounds 'and estimated that the British had expended six times that amount.'

The deepest penetration along the fourteen-mile front was five miles. Passchendaele Ridge had been taken, providing an observation post for another offensive, but the submarine pens were well beyond the grasp of the British. 'Rupprecht's defences in Flanders had held – but just', and not without help from the rain. For Crown Prince Rupprecht, the rain as he himself had noted had been his most effective ally.

Of course the wet weather affected both sides, but in different ways. It slowed the Allies down and stopped the advance, but they were able to retire to billets and recover. On the other side of the wire, the rain saved them from disaster, but they did not know when the next attack would come and so had to stay in the slime in a permanent state of readiness, living in, at best, primitive shelters that offered no protection from the artillery.

Grenadier Vizefeldwebel Zaske described what the German soldier had gone through during the battle: 'When we emerged from our holes, we looked like animals whose natural camouflage made them indistinguishable from the surrounding earth, even for the sharpest eye. Our grey uniforms were coated with mud and earth and it appeared as though every man was encased in terracotta from his steel helmet to the nails on his boots. Here we endured to the uttermost limit of that which is humanly possible; our

An aerial view of the Ypres battlefield in late 1917.

daily entertainment an endless stream of shells, most of them heavy calibre, which crashed down everywhere that the enemy suspected we earthworms were lurking.'

Here, a soldier explains that often trenches had ceased to exist: 'Our trenches have now for some time been shot to pieces...When attack and counter-attack have waged backwards and forwards there remains a broken line and a bitter struggle from crater to crater...The fight is carried on from clusters of shell-holes.' In many cases the best protection was a metal sheet placed over the side of the hole facing the enemy. General von Kuhl claimed that it was the conditions that wore the men out, not the incessant fighting.

While British and Empire troops were rotated and relieved, this was not possible for the defenders. Relief was often not forthcoming until a division had lost half or more of its initial strength. Two statistics clearly show the plight of some of the divisions: on 3 August, *2 Garde Reserve Division* had a strength of 2,208 (equivalent to three battalions at a time when a division consisted of nine battalions), of whom 600 were sick; *38 Division* requested relief as it had lost two-thirds of its strength.

To the British it had been Third Ypres; to the Germans it was Flandern 1917. Rupprecht summed up the battle for his *Sixth Army* : 'Eighty-six divisions, 22 of which made two tours of duty, took part in this most violent of all battles. Sons of all German tribes competed in heroic bravery and tenacious stamina to repulse the Anglo-French attempt [to]

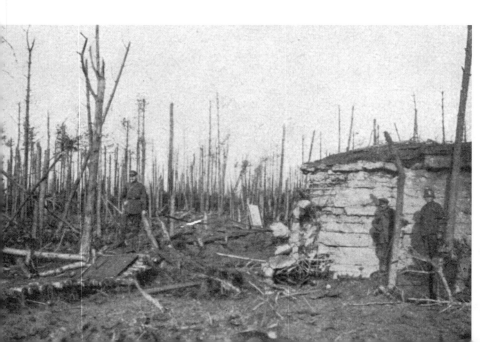

A damaged concrete pillbox in Houthulst Forest in November 1917.

conquer Flanders and seize our U-boat bases. Despite enormous concentrations of men and material, the enemy has not succeeded. A tiny, devastated patch of earth is his sole gain [won] with extraordinarily high casualties, while our losses were far less... So the battle of Flanders was a heavy defeat for the enemy [and] a great victory for us.'

More truthful than the official comment was Otto Dix's view that Ypres was nothing but "Lice, rats, wire entanglement, corpses, blood, schnapps, gas, guns and rubbish".

Although German losses were less, both sides could lay claim to victory. Despite Allied superiority in numbers and materiel, the German Army had managed 'to...inflict grievous casualties in a battle of attrition.' However, the attacks had weakened the Germans, brought Germany near to certain destruction and helped bring about the offensives of 1918.

After the war, von Kuhl described the effect of the battles in terms of replacements and their effect on the German war machine. 'The supply of reinforcements was bound to become even more difficult in the ensuing years, so that in the end the conduct of the War was definitely influenced by it.' He also agreed with Field Marshal Haig's interpretation of the effect. Although the attack did not break through the German front, 'the Flanders battle consumed the German strength to such a degree that the harm done could no longer be repaired. The sharp edge of the German sword had become jagged.'

General von Kuhl also praised his own army: 'It would be quite wrong to deny the British credit for the courage with which they fought...It would be equally wrong to suggest that there was any possibility that they might have broken through.' Ludendorff in his memoirs also praised his men: 'That which the German soldier performed, experienced and suffered during the Battle of Flanders will stand for all time as a brazen monument to him: one which he himself constructed on the territory of the enemy!'

That the fighting had often been vicious and heavy is evidenced by the casualty figures and the reactions of the commanders. On a human level, what it was like is eloquently described by a letter written by an officer who was killed during the battle: ' After crawling through the bleeding remnants of my comrades, and through the smoke and debris, wandering and running in the midst of the raging gunfire in search of refuge, I am now awaiting death at any moment. You do not know what Flanders means. Flanders means endless human endurance. Flanders means blood and scraps of human bodies. Flanders

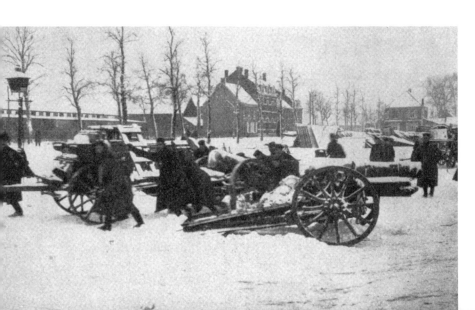

Moving field guns in the snow during December 1917.

means heroic courage and faithfulness even unto death.' Another soldier wrote that the Flanders campaign was 'suffocated in swamp and blood.'

A soldier, who had served there in 1914 and 1915 and had returned in 1917, wrote home: 'I have always had a horror of the name "Flanders".' Writing after the battle Carl Zuckmeyer described what it meant to him: 'We were stigmatised, marked, either to die or live with the burden of a scarcely bearable, non-communicable memory that plumbed the darkest depths of our tortured souls.' A grenadier, who had served in the worst conditions so far on the Eastern and Western Fronts, compared Flanders with the primeval earth, and then gave his opinion that, in describing Flanders, words failed everyone.

General von Kuhl described the campaign as 'the greatest martyrdom of the World War. No division could stick it out in this hell for more than fourteen days. It must then be relieved...Foot and bowel complaints ravaged the troops.' In contrast the *British Official Medical History* paints a different picture for the British and Empire troops. The sickness rate was comparatively slight and 'was less than in any year of the war except 1916, when ground conditions were worse.'

According to Captain Schwink, writer of the *OHL History of Ypres 1914* 'the fighting in 1917 was perhaps more severe than that of those stormy autumn days of 1914'. However, the objective was the same: to keep the enemy away from the Fatherland. Like the Somme, Flanders had a special meaning to both soldier and civilian. 'Flanders! The word is heard by everyone in the German Fatherland with a silent shudder, but also with just and intense pride.'

The *German Official History,* summed up the Flanders campaign as protecting the French, reducing German involvement elsewhere, and causing an enormous loss of men. 'The offensive had protected the French against fresh German attacks, and thereby procured them time to re-consolidate their badly shattered troops. It compelled *OHL* to exercise the strongest control over and limit the engagement of forces in other theatres of war...But, above all, the battle had led to an excessive expenditure of German forces'.

The casualties were so great that they could no longer be covered, and the already reduced battle strength of battalions sank significantly lower, from 750 to 700 men.

Between the Arras battles and the latter half of the year, battalion strengths had fallen

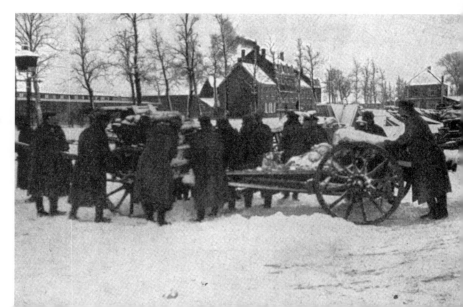

Even in the worst of conditions the field guns needed ammunition. Filling ammunition limbers in the snow of December 1917.

General of infantry, Hermann von Kuhl, served as the capable chief of staff for several different commanders during the war. Hermann was born on 2 November 1856, the son a of a high-school teacher from Koblenz. He retired from the Army at war's end with the rank of General der Infanterie, publishing a number of texts on military science. He was also awarded the *Pour le Mérite* for Arts and Sciences in 1924. Kuhl received his title of nobility in 1913 during Wilhelm II's 25th anniversary as Kaiser of the Prussian Empire.

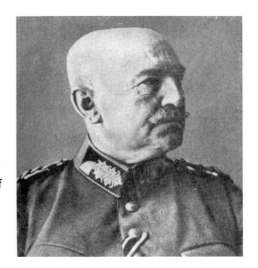

from 750 to 640. The number was low because of a shortage of replacements: 'all reinforcements have been used up except the 1899 Class of 18-year olds, and recovered wounded sent to the front.'

There was even a grim song about being a soldier in Flanders. 'In Flanders there are many soldiers. In Flanders there are many dead.' A line that went through the mind of a wounded soldier as he lay in a ditch filled with dead British and German soldiers.

Losses on both sides had been high but both sides could claim it as a victory. The British losses were more easily replaced and they had taken Passchendaele, but the British advanced only five miles and had achieved few of their original objectives. For some of the defenders there would soon be a relatively peaceful time: they were being transferred to the Cambrai sector – "The Flanders Sanatorium" – where little ever happened. However, their new-found peace was soon shattered as the British launched the last offensive of the year.

Generalleutnant von Moser, commander of *XIV.Reserve Corps*, described the falling away of morale. 'In millions of letters from the Western Front from April to November came the ever-rising bitter complaints of the almost unbearable hardships and bloody losses in the scarcely interrupted chain of battles: Arras, Aisne-Champagne, Flanders, Verdun and the Chemin des Dames. A hundred thousand leave men told the Home Front by word of mouth the details of the ever-growing superiority of the enemy, particularly in weapons of destruction.'

Writing in December, General von Kuhl summed up the battle: 'The sufferings, privation and exertions which the soldiers had to bear were indescribable. Terrible was the spiritual burden on the lonely man in a shell hole or trench, and terrible the strain on the nerves during the British bombardment, which continued day and night…The hell of Verdun and the Somme was exceeded by Flanders.'

Lessons had been learned: defensive tactics were changed, reserves were to be held in rear areas for swifter counter-attacks and more use made of mustard gas. The battle now moved on again, this time to Cambrai, where on 20 November a British offensive was launched to break through the Hindenburg Line and capture Cambrai.

A platoon marching through Biebuyk in December 1917 after the battle had finished.

This did not mean that the Flanders battle was over; it dragged on into December. German units patrolled No Man's Land pushing on one occasion as far as the church in Passchendaele. Artillery on both sides remained extremely active as did the Royal Flying Corps. Bombs were dropped on troop formations and on moonlit nights low-flying planes bombed and machine-gunned at random.

The final throw of the battle commenced during the night of 1/2 December when the British artillery bombardment rose to drum-fire.

At 0300 hours on 2 December, this increased, and, fifteen minutes later, two British brigades attacked. After initial success, by the end of the day the defence had prevailed and the battle was at an end.

On the opening day of the Cambrai offensive the commander of *Gruppe Wijtschate* sent a personal communication to his battalion commanders about discipline. 'Recently, the standard of saluting by officers in the Group sector has left a great deal to be desired. It is a rarity to come across junior officers who consider it necessary to salute senior officers first. Some gentlemen do not consider it necessary to take their left hands out of their pockets and others salute, riding crop in hand or with a cigarette between their fingers... The dreadful discipline on the street of the men is caused to a large extent by the bad example set them by their officers.'

'Although the offensive had finished, there was continued fighting; part of *16 Bavarian Division* had a limited success in a local attack on 12 December near Bullecourt and there were further successes at Messines and Polderhoek.'

As the British Flanders offensive finished, the High Command met to consider their plans for 1918. On 11 November 1917, Ludendorff presided at a conference in Mons to discuss how a decision could be forced in the west. The conclusion that was reached was that neither the Russian nor Italian front would affect the ability of the army to deliver a major assault. The attack should be at the end of February or beginning of March. Most importantly, it must be against the British. If the British Army was broken, the French Army would capitulate. During the meeting a massive offensive was devised that would split the British and French forces in two.

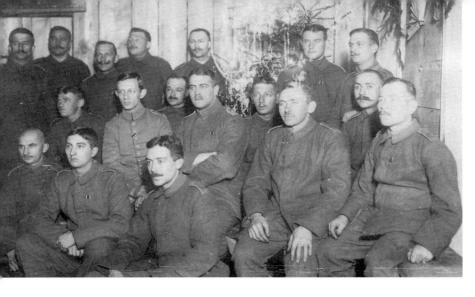

A group of soldiers pose with their officers during the Christmas 1917 celebrations. Six of them have been awarded the Iron Cross Second Class.

At a meeting on the day of the Cambrai offensive, von Kuhl pressed for an attack in Flanders – Operation St. George – against the River Lys front between Festubert and Frélinghien. Another option was the similarly weak front near St. Quentin although that would require more resources than Flanders. With the British sending insufficient reinforcements to the Western Front, while sending divisions to help the Italians, and as Russia was ceasing hostilities, it was clear that the number of German troops available for an all-out offensive was the largest it was ever likely to be again. Against this, on the enemy side there were increasingly high numbers of Americans arriving every week.

Although the original idea was one single knock-out blow, General Wetzell proposed a series of offensives. These would hold the French at Verdun, pull in British reserves from Flanders to contain an attack near St. Quentin, then strike the main blow in the direction of Hazebrouck 'before rolling up the rest of the British line.' Such a series of attacks 'called for courage, superb staff work and excellent logistics'. It would stretch resources to the limit but, nevertheless, on 27 December Ludendorff ordered plans for a number of offensives to be ready for 10 March: '"George" in Flanders, with a secondary operation known as "George 2" near Ypres, "Michael" on both sides of St Quentin, flanking operations near Arras and south of the Oise, and further attacks at Verdun on the Champagne front.'

Operation George was to be an attack in the direction of Hazebrouck on a twelve mile front. George 2 was more complex; it consisted of three operations: Hasenjagd against Messines Ridge, Waldfest against the line north of the Ypres salient, and Flandern at Dixmude much further north.

'The die was cast. With the release of first-class troops from the Eastern Front, 1918 would be the final throw of the dice: a gamble that had to be taken. Germany must win the war before the full entry of American forces onto the Western Front, and before grim despondency turned into defeatism.'

An NCO reads mail from home in his rear echelon billet during Christmas 1917. On the table is a small Christmas tree decorated with paper flowers and postcards from home.

A 1917 photograph which clearly shows the state of the roads in Flanders after heavy rain.

Feldgottesdienst in Flandern.

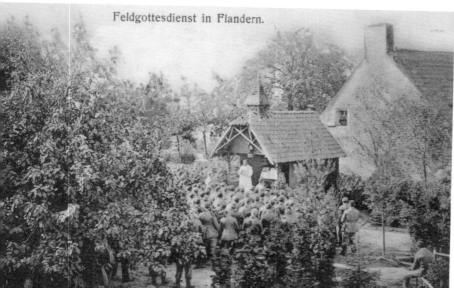

While out of the line, there was time to take care of spiritual needs – a field church service.

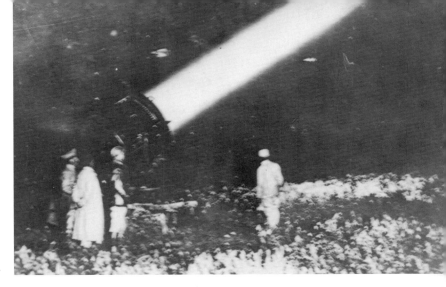

A searchlight scans the sky for British bombers which regularly bombed the rear areas.

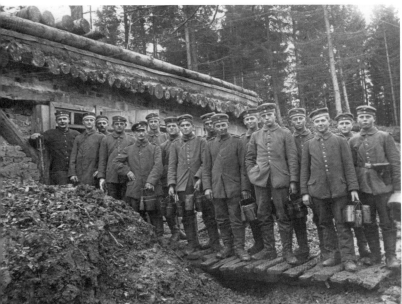

Mostly youthful soldiers queue for the meal at a well-constructed field kitchen in a rear area somewhere in Belgium.

A posed photograph showing the personnel of a hospital carriage provided by the state of Württemberg.

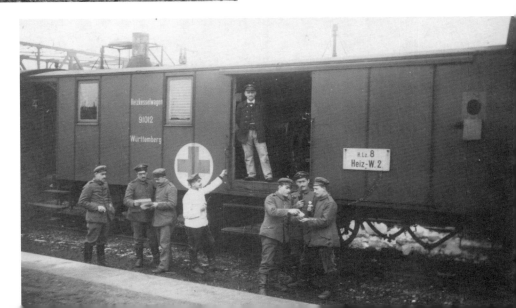

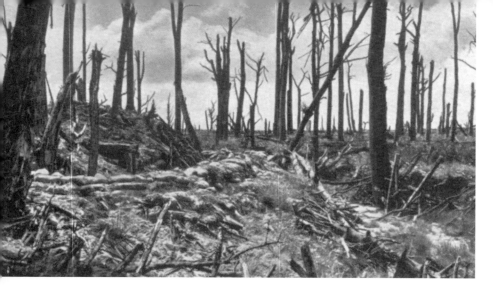

Houthulst forest after the British artillery barrage.

A platoon of Landwehr infantry in late 1917. The notice board is damaged so the men could be from *Regiments 363* or *383,* probably the latter.

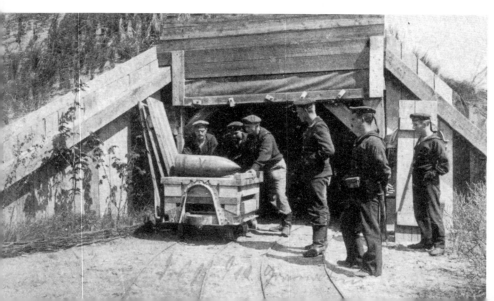

Sailors pushing large calibre shells out from an underground munitions room below the dunes.

An Stelle des Tümpels stand ein Haus.

A large puddle and a group of Landsturm mark the remains of a house near Pilckem.

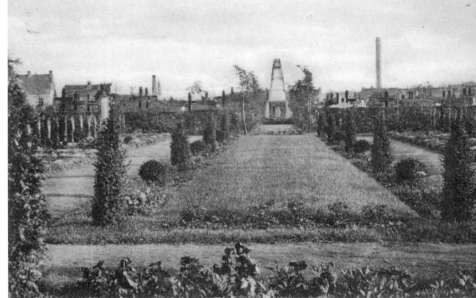

The dutifully tidy military cemetery at Roulers. As was common in most, there is a stone-built regimental memorial.

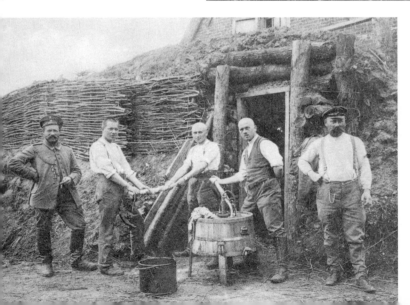

A portable laundry run by soldiers of the Lines of Communications, in this case Landsturm men. The soldier on the left is wearing a proficiency lanyard showing they are well behind the front.

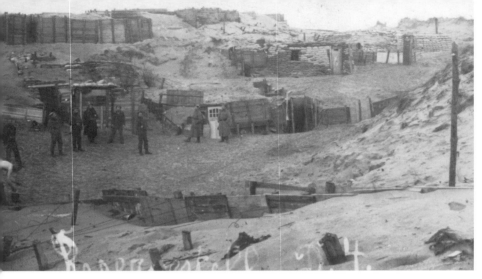

Dugouts in the dunes made of sandbags, scrap wood, and doors taken from damaged houses. In the centre-ground is a group of marines. Three of these are either going on or coming off guard duty.

Officers carrying map cases taking a rest somewhere in Flanders.

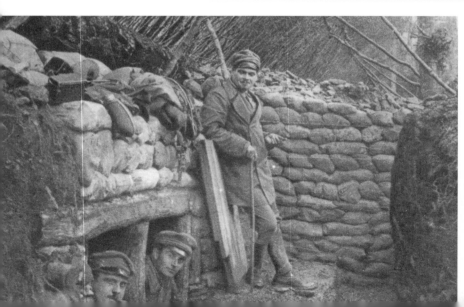

A West Flanders trench showing the entrance to the sleeping area. The trench is dug into the earth and strengthened with sandbags. Protection from enemy grenades is provided by the branches which form a roof over the trench. A charity card sold to raise money for a veterans' organisation.

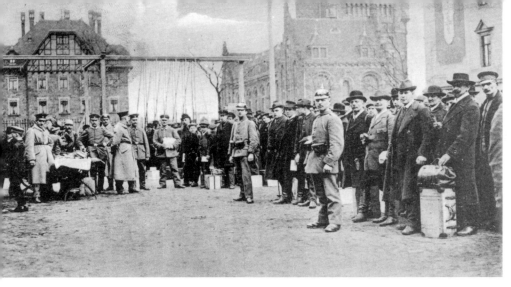

Middle-class Belgian males waiting their turn to be enrolled for war work in Germany.

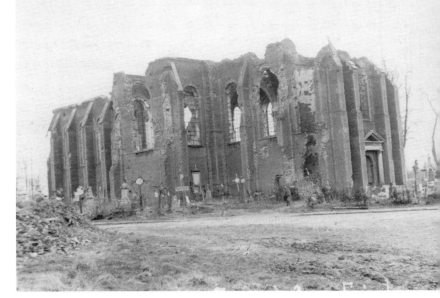

Zonnebeke church during the 1917 offensive. A propaganda card to show the damage caused by British shelling.

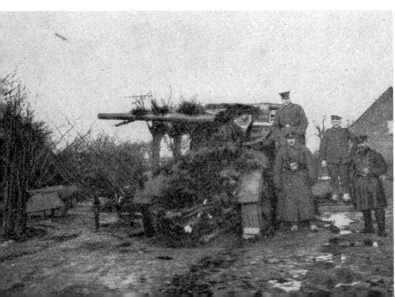

A camouflaged anti-aircraft gun; photograph taken in December 1917.

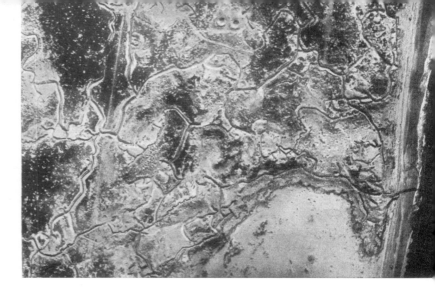

An aerial view of the trenches in the dunes near Ostend.

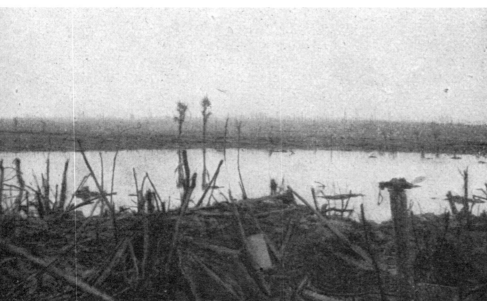

Becelaere battle front between Polderhoek and Baden Haus, showing the wet conditions endured by soldiers.

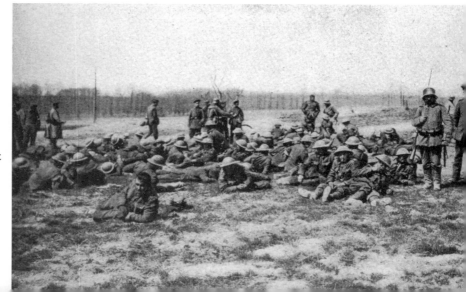

British POWs taken during the fighting in and around Houthulst Forest.

Becelaere battle field taken from the air. The photo clearly shows the number of shells fired and the poor conditions that resulted from the damage caused to the drainage system of the area.

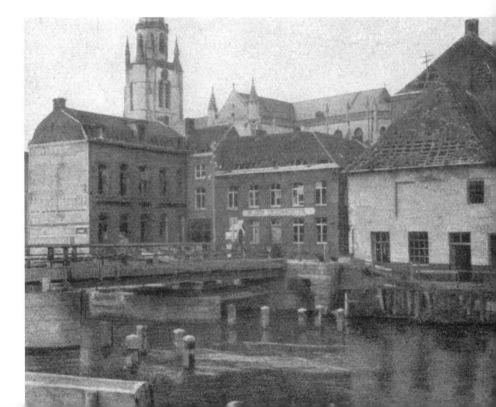

Despite the war, a border still existed between France and Belgium. This is the Border at Wervik in October 1917.

Entrance to a Flanders cemetery. The wording reads: 'They were loyal unto death'.

A concrete defensive position at Wervik in September 1917.

Building barracks on Commerce Street in Ledgehem.

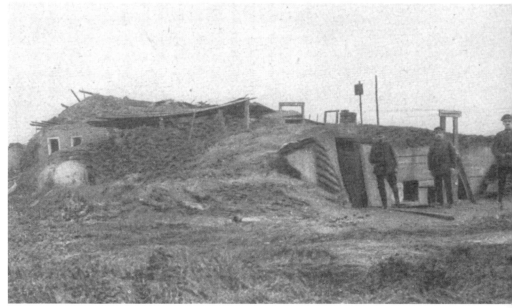

A concrete communications centre near Zonnebeke during 1917. It is camouflaged with soil and grass and built into the side of a damaged farmhouse.

Dadizeele railway station in November 1917. Such railheads were often the target of light British bombers.

The rapid expansion of the army required the construction of numerous temporary billets. Pictured are some of these on the road between Menin and Wervik in October 1917.

A tethered observation balloon in a sea of mud. Flanders is very flat and, without any area of rising ground, artillery observation relied upon these balloons. They were obvious targets for Allied planes so the observers were provided with parachutes.

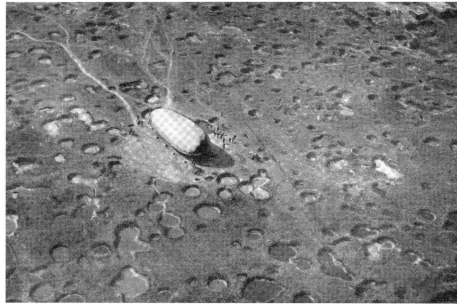

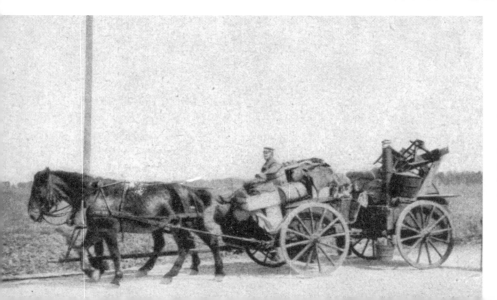

Both sides used horse-drawn transport, the German Army more so. This is a general purpose wagon transporting a mixture of objects.

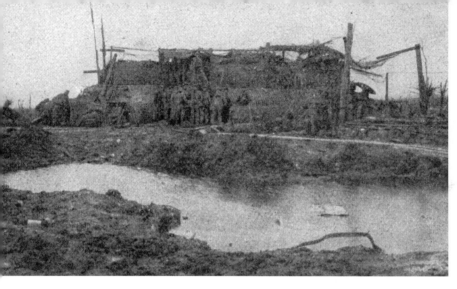

A fighting troops commander's headquarters behind the lines near Becelaere in late 1917.

Although used only irregularly, flame thrower attacks were terrifying to the defender. In the direct line of fire there were few survivors. This is a fixed Flammenwerfer with a fixed range. Portable ones could be carried during an attack.

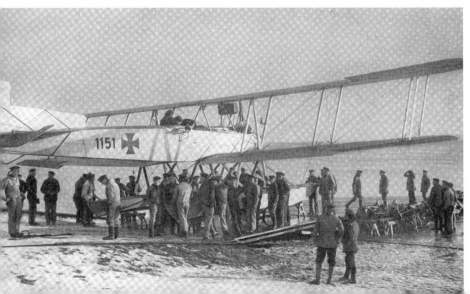

Sailors of the Flanders Naval Corps manoeuvring a Friedrichshafen F. 44 into position for take-off.

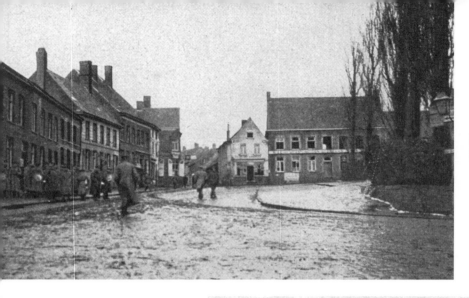

Hooglede market square in December 1917.

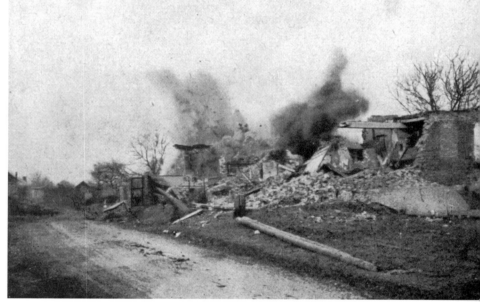

Houthulst village under fire during the 1917 offensive.

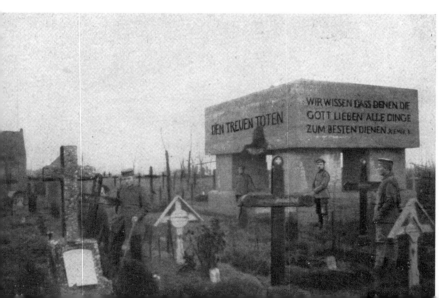

The German military cemetery at Houthulst. The memorial reads: 'The loyal dead'.

A Jäger cemetery at Broodseinde. The sixteen regiments and forty-two battalions of Jäger troops were regarded as some of the best troops in the German Army.

Most Jäger units were attached as divisional troops so they were relatively independent. These Jägers are guarding the Belgian coast against British invasion.

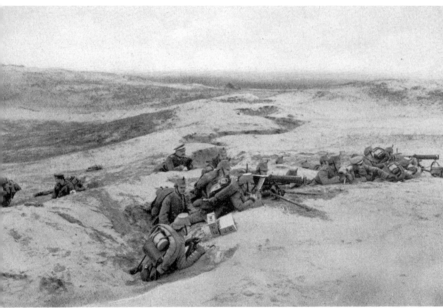

Marching past the Kaiser: a troop review on 23 December 1917.

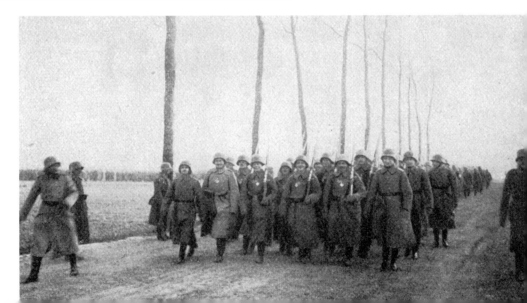

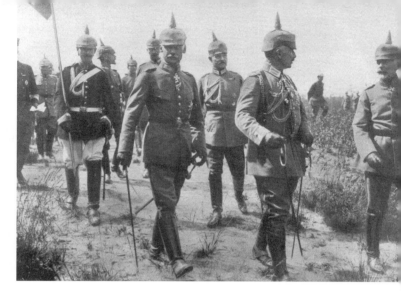

The Kaiser, accompanied by
Crown Prince Rupprecht, at
army manoeuvres in Flanders
during 1917.

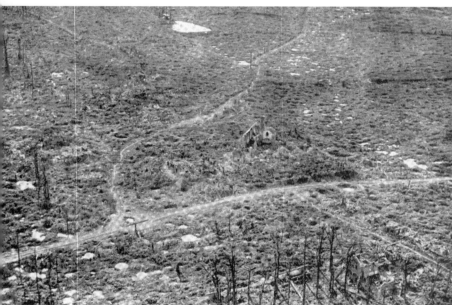

The ruins of Kemmel after
the battle had moved on.
In the centre is the
church.

A local horse and cart
travelling along the Kezelberg
road in December 1917.

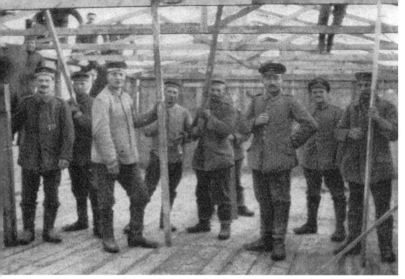

With the arrival of more and more troops during 1916 and 1917, new accommodation was needed. Here a construction unit is building barracks to house the new arrivals and provide dry shelter to those on rest.

Sint-Petrus kerk on the outskirts of Ledegem in November 1917. On the left, the noticeboard directs traffic into the centre and to other directions.

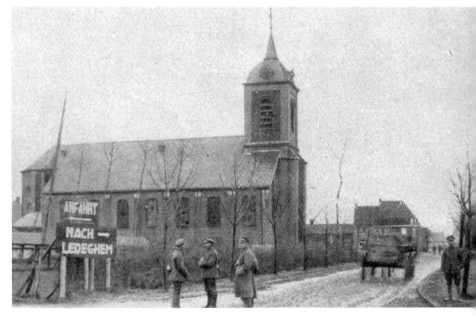

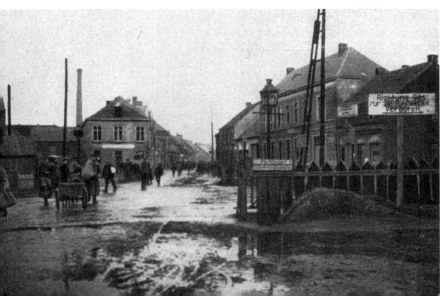

Lichtervelde station in December 1917. This town was some distance behind the lines and still had civilians living and working in it. The very indistinct wording on the sign prohibits traffic from turning right.

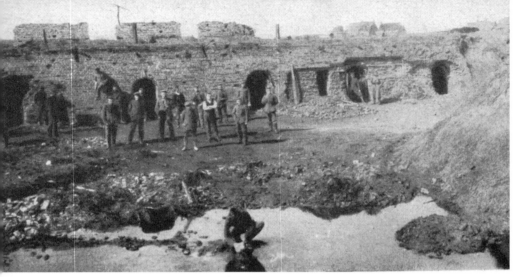

Anything that could be adapted for living quarters was used. Here a damaged brickworks near Zonnebeke provides dry and probably quite safe accommodation.

Even in the coastal dunes there were problems with water. Here, soldiers are cutting a drainage ditch to move water away from their positions near Lombartzyde. Naturally the officer looks on as the ratings work.

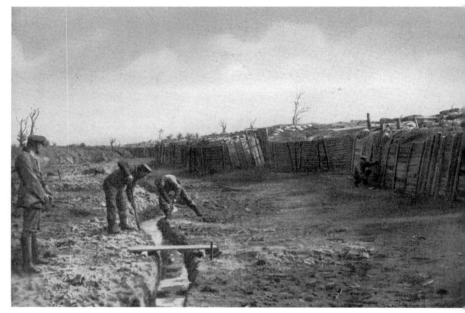

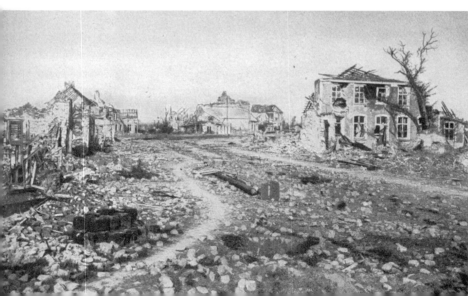

Lombartzyde village in early 1917.

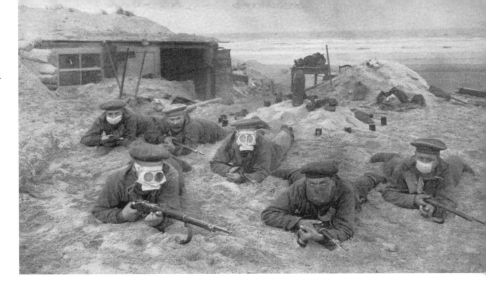

Unlikely to suffer from a gas attack, ratings serving on the coast did not receive the most up to date equipment until the needs of the army had been met.

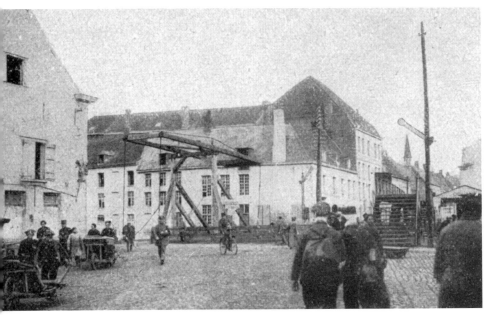

In October 1917 Menen was a thriving town complete with civilians. This shows a busy corner near the canal bridge.

Soldiers in Moorsele town centre during 1917.

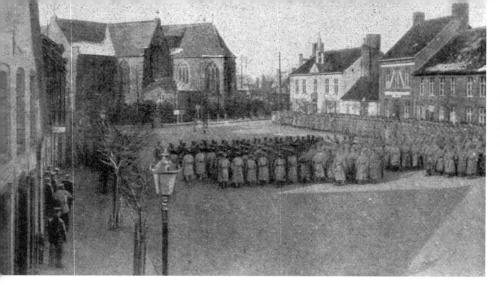

Parade in Moorslede in honour of the Kaiser's birthday on 27 January 1917.

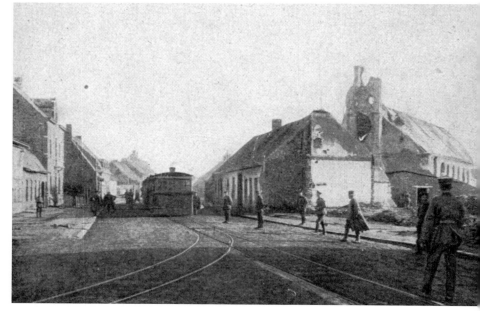

The end destination for the narrow-gauge train was the town of Poelcapelle. This photo was taken in 1917.

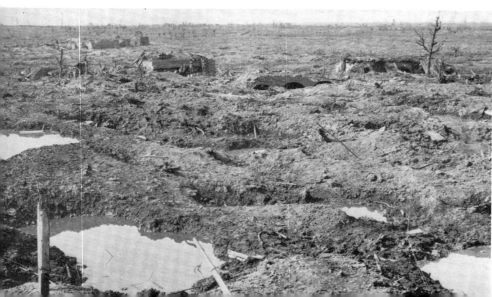

Nonne Boschen on 1 October 1917 after the battle had moved on: a scene of total devastation.

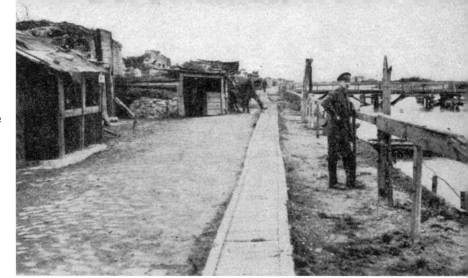

A northern position on the Yser river in October 1917.

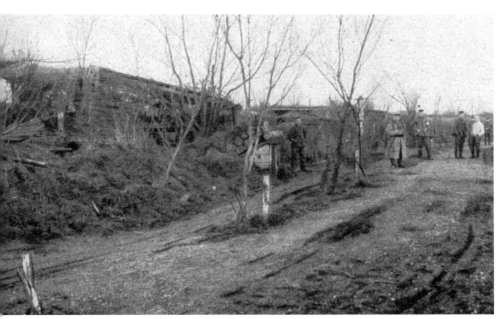

A hidden mortar position in a wood near Zonnebeke.

An isolated dugout on the Passchendaele Front during November 1917.

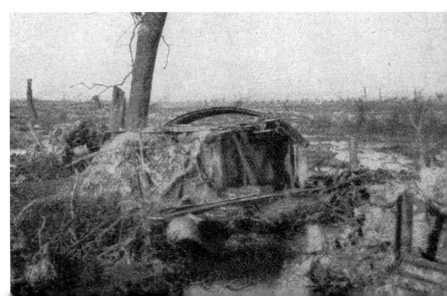

The damaged drainage system and heavy rains resulted in large areas of flooding which were impassable.

Aerial view of Passchendaele in 1915.

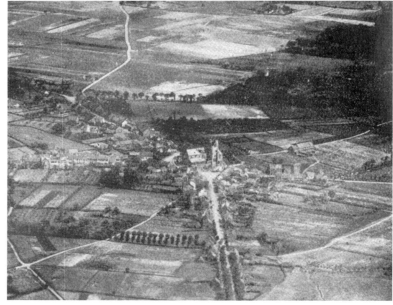

Nearly the same view of Passchendaele two years later.

Passchendaele Ridge after the battle was over: complete devastation.

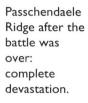

(Right:) A regimental cemetery in Poelcapelle.

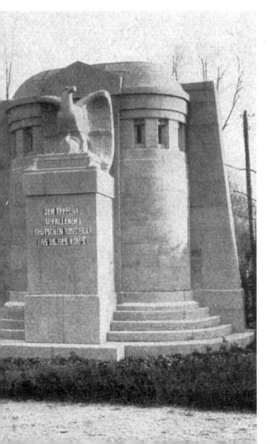

(Left:) The memorial to the fallen buried in Poelcapelle cemetery.

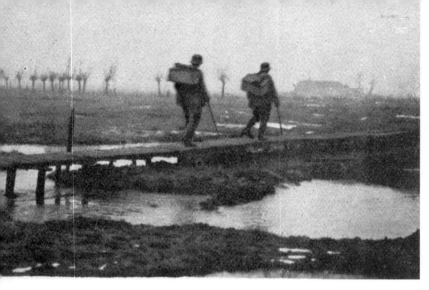

A ration-carrying party making their way across raised duckboards: the only safe way to move across the mud.

A camouflaged above-ground regimental headquarters in Houthulst Forest before the battle.

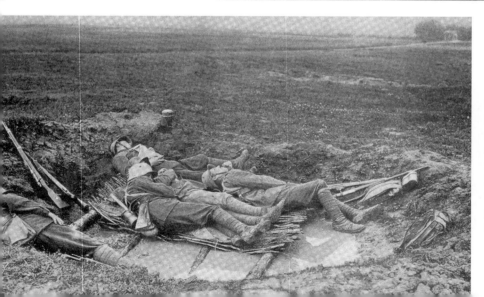

Such was the strain of battle that sleep was taken any time and anywhere. Here five soldiers rest in a shell hole. Three are lucky enough to have a platform to keep them out of the mud.

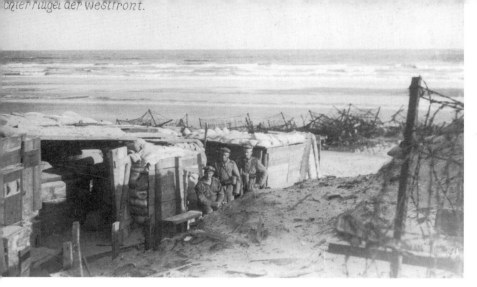

The last soldiers on the right wing of the German Western Front. Three Marines in the bunker among the dunes on the edge of the North Sea.

The Scharnhorst Stellung during the early months of 1917. Above much of the trench are structures to stop surprise attackers and their hand grenades from getting into the trench.

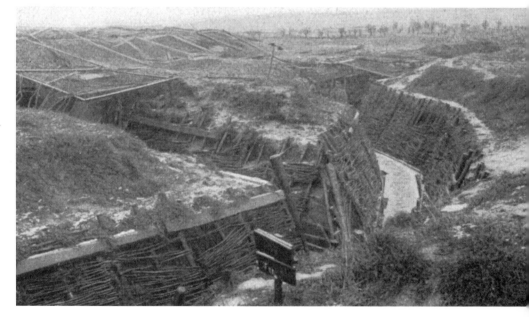

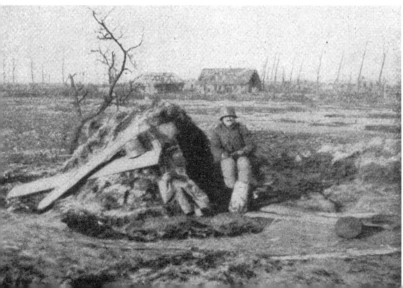

Schwabenheim dugout in November 1917.

Loading a naval aircraft with small bombs for an attack on the English coast. Quite what the pigeon is for is unclear – unless it was to be used if the plane came down in water away from its base.

A large calibre shell hole in Houthulst Forest in 1917. As the water table was very close to the surface, such holes quickly filled with water, and with continued shelling the area turned to a mud moonscape.

The battlefield at Gheluveld before the rain turned the ground into mud.

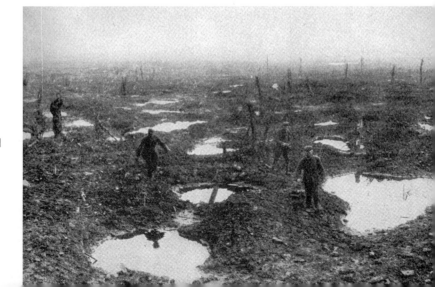

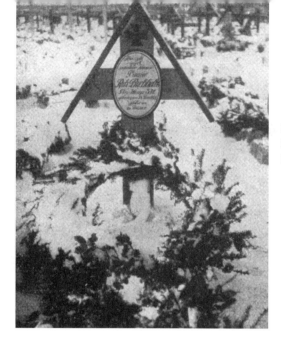

Pioneer Burbbalis' grave, one among many in a snow-covered soldiers' cemetery in Flanders.

A street corner in Ingelmunster in September 1917. Civilians obligingly pose for the cameraman. During the war Ingelmunster castle was commandeered by the Germans as a headquarters. On the left is the ubiquitous direction sign.

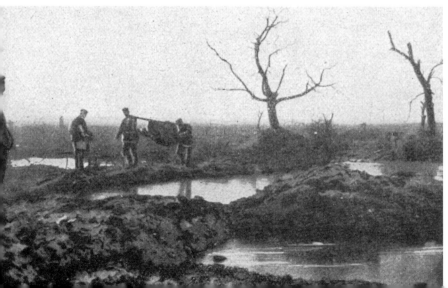

Transporting the wounded out of the front lines was arduous and dangerous. Here two stretcher bearers carefully pick their way along the crests of the shell holes, slowly making their way back.

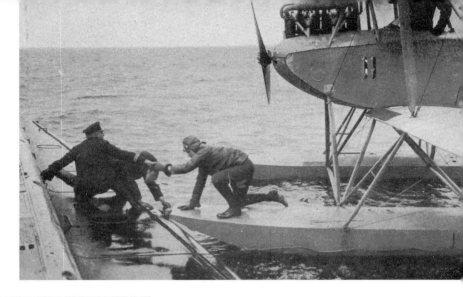

In the middle of the North Sea a naval aviator is given a helping hand onto a U-boat. The original caption gives no further clues as to the reason for this.

With poor drainage many of the trenches filled with water during the January snow melt of 1917, becoming unusable. This shows a deserted water-filled trench in Flanders.

The Wilhelmhof Stellung near Becelaere in October 1917 after considerable British shelling.

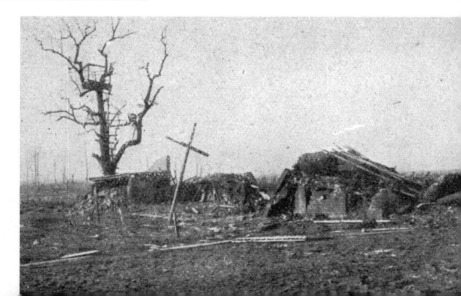

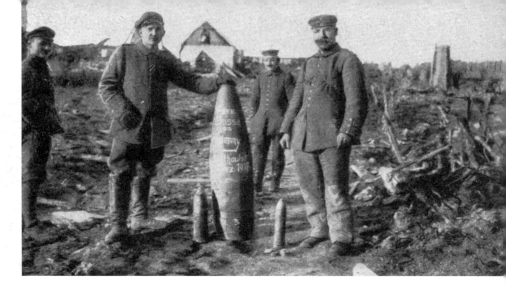

Unexploded British ordnance, large and small, exhibited in Houthulst Forest during December 1917.

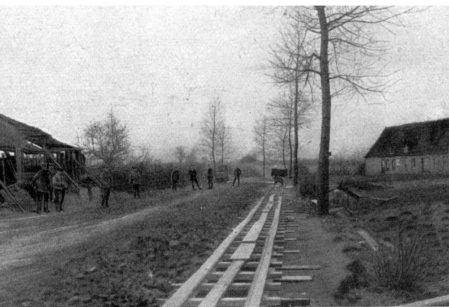

A temporary wooden trackway to facilitate the movement of materials. This track ran through the centre of Zonnebeke on the road to Ypres.

A substantial bridge to link both sides of the Yser canal near Dixmude in October 1917. As there was relatively little fighting in the area, the wooden buildings are starting to look permanent.

An attempt to camouflage positions on the Yser using fencing screens made with tree branches.

Even where the ground looked solid, in many cases it was no more than a grass covered swamp. The photograph shows a wooden walkway over such ground. This is the Hanebeek stream near Zonnebeke in February 1917.

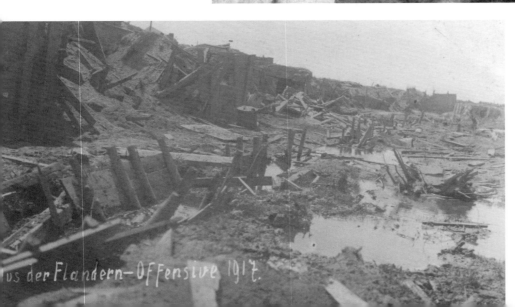

The effect of artillery on the positions in the dunes on the Flanders coast.

Typical winter's fun.
Snowballing in Houthulst
Forest around Christmas
1917.

In the trenches at Frezenberg during
March 1917.

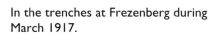

Badly damaged in the November 1914 fighting, Langemarck was again attacked in early August 1917. This photo, taken before the second battle, shows the earlier damage. In the foreground is the ubiquitous narrow gauge rail track.

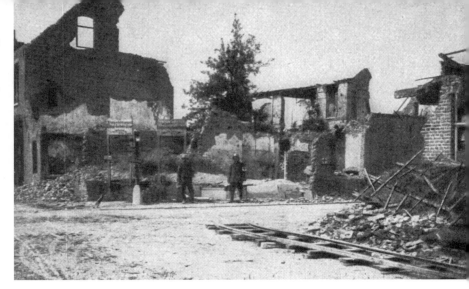

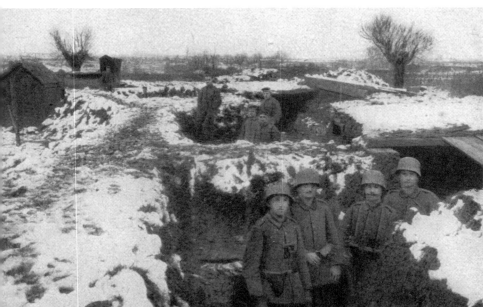

January 1917 at Scharnhorst position near Frezenberg.

Chapter Two

1918 – Georgette, Hagen & 100 days

When the so-called impregnable defences of the Siegfried Line had been broached at the end of 1917 it was obvious that defence was no longer the best option. The offensive had to be taken to the Allies on the Western Front. Ludendorff later noted that 'the interests of the army were best served by the offensive.' 1918 was a make-or-break year.

With Russia out of the way now was the time. Initially there would be no shortage of men, but there were problems with other resources. Germany could not match Allied industrial output, neither did it have an endless stream of manpower available. 'German triumph had to be assured within a week of the opening of the great offensive.' The alternative was disaster.

The original plan was to drive a wedge between the British and French armies, a strategy similar to Falkenhayn's attacks of October 1914. Separated from the French, the British would be pushed back to the coast whence they would, it was hoped, evacuate to Britain. What had been proposed before the new year was to be changed. Operation George was too dependent on the weather and George 2 relied upon the success of George. The focus would now be on Operation Michael, supplemented by Operation Mars near Arras and Operation Archangel to the south of Michael. George or Roland in the Champagne area would follow later.

'The attack, code-named Operation Michael, was to fall on the British front. After considerable deliberation, Ludendorff decided upon the fifty-mile sector south of Arras down to La Fère because, after the winter, the ground would dry out quicker than in other British areas; also, very importantly, the British defences and forces were believed to be weak. After the initial onslaught, the troops would wheel right and move north, taking British positions in the rear. This was not to be one battle, but a whole series, to destroy the British army, or push it back to the sea. Just in case the French decided to help their allies, there were attacks scheduled against them.'

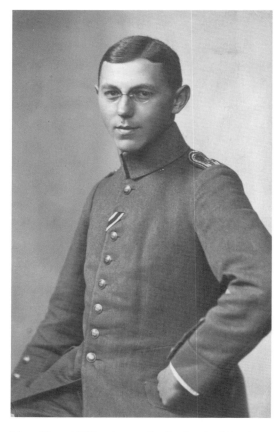

New Year 1918, a keepsake for family friends, the Hoffmans. A photo of officer Erwin Eisner, holder of the Iron Cross Second Class.

'The assault troops were brought up to the front on 20 March without serious difficulty, even though the British artillery shelled the front line trenches during the evening and night. At 0440 hours, on 21 March, nearly 10,000 field guns and mortars opened fire on the British positions on a front between the Oise and Sensée rivers, shelling the area between the forward positions and the battle zone; four hours later the first wave of infantry charged out of the trenches and moved quickly towards the British lines through thick fog. Preceded by the Sturm-abteilungen, forty-three divisions of *Second* and *Eighteenth armies* assaulted the British Fifth Army, while a further nineteen divisions of *Seventeenth Army* attacked the British Third Army. The well-trained attackers were in excellent spirits and confident that they would win the war. Outnumbered and hampered by the thick fog, the British forward zone of defence fell apart in many places.

'Operation Michael was suspended on 5 April, with the Germans finding themselves in defensive positions on the muddy Somme battlefield that they had voluntarily left a year earlier. Although the

Rest and relaxation in the trenches – Flanders 1918

Safe, some distance from the front, members of 2-405 telephone detachment pose for a keepsake during March 1918.

assault had cost them more casualties than they had inflicted, they had captured 90,000 Allied soldiers and 1,300 artillery pieces. In terms of distance, *Second Army* had advanced forty-five kilometres and *Eighteenth Army* up to sixty kilometres. The plans now being adopted were tactical rather than strategic; the casualties could not be replaced in either number or quality.'

As a result of the setbacks, St. George I, its original name, would proceed but St. George II could not due to insufficient troops. Ludendorff ordered that St. George I and Hare Drive were to 'go forward rapidly on both sides of Armentières towards Hazebrouck, and simultaneously "Wood Feast" should cut off the Ypres Salient from the north-west.' Rupprecht's plan was for *Sixth Army* to attack against Hazebrouck on a reduced front, again on account of a shortage of troops. *Fourth Army*, with between twelve and fifteen divisions would launch George II in three directions: Hare Drive would assist George I by attacking the Wytschaete-Messines Ridge, Wood Feast would cut off the British troops in the Ypres salient, and Flanders 3, by attacking from Dixmude towards the Loo Canal, would pull in troops needed to defend the rest of the front.

The initial advances were indeed spectacular – but not spectacular enough. Ludendorff revised his plan when the north-westerly drive foundered around Arras. The thrust changed to Amiens which by 9 April could be clearly seen on the horizon. While the High Command trumpeted the success, the *Kölnische Zeitung* was more cautious. It informed its readers that 'the fighting is terrible and the task we must achieve is enormous' and that the British were fighting with extraordinary courage. At Villers-Bretonneux the advance stalled.

The *German Official History* agreed with many of Ludendorff's senior officers that there was no clear centre of gravity in the attacks. 'Tactics had become an end in themselves'. Reserves went wherever a crack appeared in the front. The attacks quickly wore out the 'mobile' and 'attack' divisions which were not replaced with reserves, even though these were available. During the Michael offensive, seventeen fresh divisions had been held behind the three attacking armies and six un-blooded divisions remained in reserve in Flanders.

As Michael progressed, plans continued for George but on a reduced scale. With fewer

A photo of seven friends taken late Spring 1918 in Houthulst Forest. The reverse reads Father with friends (serving) in *2 Battery of 8 Bavarian Field Artillery Regiment.*

divisions allocated, it became Georgette. Before it started, Operation Mars against Arras commenced against such staunch British resistance that it was halted.

Operation Mars was launched with the aim of trapping the northern British armies by attacking northwest from Arras, and to prepare the way for a breakout towards the channel ports. 'However, unlike 21 March, there was no fog to hide behind and the British knew what to expect. In addition the attack had been planned hurriedly. After three hours' bombardment, the attack was launched at 7.30 am on 28 March. Unfortunately for the German attackers, casualties were very heavy for little territorial gain.'

'The offensive continued, but huge losses, exhaustion and the lack of a decisive break-through, linked with an ever increasing length of supply chain and a shortage of supplies, even food, were taking their toll on morale. After months of shortages and falling quality of goods and material, the German troops were amazed to see how well provisioned the British troops were – a direct contradiction to the propaganda that the submarine attacks were starving Britain.' At midnight on 28 March, the Mars offensive was cancelled, but the general attacks did continue along the front with minor success.

'The final result... is the unpleasant fact that our offensive has come to a complete stop'. Ludendorff later wrote that 'the enemy's resistance was beyond our powers'. Operation Michael was called off on 5 April but, before then, plans to continue the Spring offensive were being put into action.

Flanders 3 was amplified to become Flanders 4, extending from Dixmude to the coast. *Sixth Army* promised seventeen divisions but only eleven were provided. The attack would be executed after Georgette and would 'confine itself to capturing the coastal area south of Nieuport if the forces at its disposal seemed insufficient to do more.'

On 3 April, Rupprecht's forces received operational orders for the attack to start with *Sixth Army* on 9 April, Ludendorff's birthday. This was to be the main thrust. Orders for *Fourth Army* to attack on 10 April did not arrive until 8 April. 'Sixt von Arnim was determined to pinch out the "salient" where his *Fourth Army* had suffered so badly during the Messines and Third Ypres/Passchendaele campaign.'

This would not be the first assault of the year in Flanders. On 6 March 1918, 2 Belgian

Mounted regiment had withstood an attack at Reigersvliet and executed a counter-attack together with other units of the Belgian Cavalry Division.

Operation Georgette, along the Lys River between Warneton and La Bassée, was a scaled-down version of Operation George with the object of capturing Ypres. Its key tactical objectives were Hazebrouck railway junction, the heights of the Flemish hills and the Cassel-Poperinghe-Ypres road. With these taken, the continued occupation of Messines Ridge and the southern part of the Ypres sector would be extremely difficult, and the British supply lines to Ypres and Béthune would certainly be adversely affected, and at best choked. The Lys Offensive or the Fourth Battle of Ypres was intended to push the British back to the ports. It would be preceded by Operation Archangel, an assault on the Amigny heights, crossing the Oise at Chauny, and the advance to the Oise-Aisne canal from the 6–9 April 1918. This was to be a most successful operation.

The offensive resulted in protected flanks for the southern wing of *Eighteenth Army* in its new positions while *Seventh Army* had shortened the length of frontline it needed to defend. As Archangel wound down, Georgette kicked off. The signs looked good.

The British saw the Lys sector as a backwater and therefore suitable to rest divisions from the Somme. It was important to maintain this quiet during the rapid build-up of men and materiel. German artillery was quiet and refused to be drawn into counter-barrages; trench mortars only fired during localised raids; there were no trench raids and outposts and saps were empty. Behind the lines, four times the number of Allied artillery pieces was being amassed.

The two attacking armies had swelled in size. *Sixth Army* was now twenty-eight divisions and would push forwards in the direction of Hazebrouck. With thirty-three divisions *Fourth Army* would attack from Armentières to the coast. Not all of the divisions consisted of fit, well-trained and well-armed men. More than half were ordinary divisions.

Although many of the attacking units were 'attack' and 'trench' divisions, with fewer horses and inferior equipment, they made good progress. They quickly infiltrated the British 'positions to a depth of five miles and seized Kemmel Hill.' On the first day they advanced six miles and crossed the River Lys the next day. In a short period of time they had retaken their lost positions from 1917: Armentières fell on 11 April and a day later they were within five miles of Hazebrouck – a strategic point in the offensive that was never taken.

Control of the air was seen as an essential part of the operation. As with Operation Michael, local air superiority for the assault and breakthrough would be assured by the nearly 500 aircraft of the two attacking armies.

During the night of 8/9 April, assault troops quietly filed into the front-line trenches as the Lys Valley became blanketed in fog. The Portuguese sector was seen as a weak link. They were under strength, lacking ammunition and transport; they had little combat experience – in fact some had never fired their rifle in anger. Nine German divisions were available to attack the two Portuguese holding six miles of front in the most thinly manned part of the British front in Flanders, four for the attack, three in reserve and two cavalry divisions. All the divisions were fresh and most were hardened to the Western Front. A further unknown lay in the fog. Ten captured English tanks had been assigned to *II.Bavarian Corps* and a number of the new AV7 tanks were brought up, but proved too heavy for the soft ground.

'At 4.15am on 9 April, 2 hours before dawn in thick fog on a cold, raw morning…The batteries of the *Sixth Army* opened as one…A deluge of high explosive and poison gas destroyed strong-points, killed men and horses and shattered the nerves of many.' A shell landed on Portuguese headquarters destroying communications and making it difficult to summon the reserves. The attack also caught the British by surprise near Armentières.

The main attack did not start until 0845 hours but by then much of the Portuguese front-line was already taken. There had been little resistance: 'they ran away faster than we could run towards them' reported one officer while other soldiers declared that they ran away in companies. British troops on the Portuguese flanks reported seeing them run away as early as 0730 hours. By early afternoon, General Costa, the commanding officer, reported that his division was lost or scattered. 'No fewer than 6,585 officers and men' were taken prisoner, most in the forward zone.

The same was true on the German left, but not all the Portuguese battalions withdrew at such speed. Facing *42 Division,* 4 (do Minho) Brigade resisted, suffering losses of over 500 men before pulling back. '3 and 29 Battalions also performed creditably when they came into action', but the defences had been broken. However, gas and fog hampered the attack, and the advance fell behind timetable. Guns and materiel were slow to get through, bridge-making pioneer units came under fire and, just as important to an advancing army, no field kitchens arrived so there would be no hot food.

While the centre was making some progress, the defenders of Givenchy in the south were causing more serious problems. Facing the British 55 (West Lancashire) Division – whom the Germans thought were Scottish! – were three divisions: *4 Ersatz* recently arrived from Galicia, *18 Reserve* from the Ypres front and *43 Reserve* newly arrived from Russia. In reserve were a further six divisions. German intelligence informed the divisions that the British division was tired and fit only for holding the line. That was true after Cambrai. By April they were in good physical condition, confident and well-rehearsed in manning their defences.

As on the Portuguese front, shelling started at 0415 hours. Even against stout British resistance, the attackers pushed forward. However artillery fire stopped reinforcement

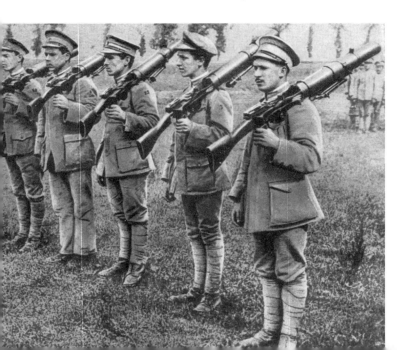

Lewis gunners of the Portuguese division that was defending a quiet sector on the River Lys when the German attack of 9 April started.

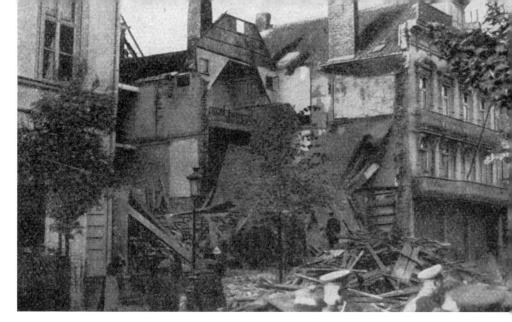

Although some distance from the front line, towns like Kortrijk were important assembly points, rest areas and home to many supporting troops. This photograph shows the damage caused by British bombing in July 1917.

and counter-attacks pushed the attackers back. As escape routes were cut, many German detachments were captured. By nightfall the British troops had retaken the forward posts and saps. *4 Ersatz Division* had suffered a serious defeat.

Although its units were much depleted, 55 Division had established an almost continuous flank by evening. This division had caused serious problems to the German attackers. Along with the heavy toll of dead and wounded, over 600 troops, including two battalion commanders, and a band (with its musical instruments) were taken prisoner when they were caught in the British wire and had no choice but to surrender; also captured were more than a hundred machine-guns and automatic weapons. Crown Prince Rupprecht noted that this failure was due to the obstinate resistance of a particularly good Scottish division; as noted before, in fact the British troops were from Lancashire.

The picture was different to the north of the Portuguese where a 7,500 yard front was held by 40 Division. In this area, the defences were inadequate. Its nine tired battalions faced *32 Infantry Division* with one regiment of *38 Infantry Division* with *11 Reserve Division* behind them. They were all experienced divisions from the Ypres area.

As the attack progressed British defences were overwhelmed. 18 Welsh Battalion was all but wiped out and 21 Middlesex coming from reserve met a similar fate. 20 Middlesex were almost surrounded, but managed to pull back to form a defensive flank with 13 Yorkshires. The British had one battalion left, 12 Suffolk. Although this battalion resisted, it too was forced to withdraw under the pressure.

With the British 40 Division scattered and many units destroyed, German infantry closed in on the bridgehead. Unopposed, they managed to take the British batteries that had not got across the river. Unknown to the attackers, the two newly-arrived British Army Corps had formed 'the basis of a plan for an early deployment of reserves in the event of an emergency.' When the shelling had started, they put their reserves on alert.

Moving forward, they rallied some of the retiring Portuguese, but the majority of those sent to reinforce the British vanished into the fog. Following on quickly behind the Portuguese were troops of *8 Bavarian* and *35 Division*. Although they put tremendous

A large-calibre shell crater at Zaren. While such shells were feared, their overall effect was often minor because of the cushioning impact of the mud.

pressure on the British defence, it did not break. However, to the north of the village, positions were systematically taken and their garrisons killed or captured. Many gun positions were abandoned with their guns in place. The British retired fighting, leaving behind guns, ammunition and supplies intact. Troops moving in the opposite direction passed stores deserted many miles behind the front.

The focus was now on the bridgeheads. As the attackers drew closer, the fog started to lift and the RAF were able to recommence spotting for the artillery. However, with the Germans closing in on the river line, engineers began the destruction of the bridges across the Lys, though not always successfully.

While the British withdrew over the bridges, some of the attackers were already over the river having used pontoon bridges. Defending the western bank, the British were being outflanked. They faced strong fire from the eastern side where the Germans had managed to bring up field guns. Those Germans who had got across the river were not large in number and were already experiencing supply and transport difficulties.

Although German forces were still making progress, sufficient British troops were being assembled to halt them. These new arrivals managed to make a more-or-less continuous flank which the German attack could not turn.

Assisting the defence were Camels and SE5As that were ground-strafing and bombing from low level against the roads that led to the bridges and also against reserves. One unit that did not help was 208 Squadron: they destroyed their planes in the belief that the Germans were closing in as the fog stopped them flying out.

The northernmost assault was against the Armentières front. This was held by another tired British division, this time from Arras. It escaped the worst of the fighting on the first day but had been heavily shelled with gas for nearly twenty-four hours just before the attack and suffered 900 casualties.

Facing 34 Division was a regiment from *38 Division,* the same division that had just broken 40 Division to the south. Despite terrific pressure from the German attack the defenders made a fighting withdrawal and eventually formed a new line, fragmented and frail but one that held. To provide assistance, further British units were detailed to move south to join them during the afternoon.

With half the army being classed as non-combatants, the rapid movement of the British front backwards meant that there was much equipment to move if it was not to be captured by the advancing Germans. The roads were blocked solidly with casualty clearing stations, field ambulances, labour units and more heading rearwards.

Ludendorff's verdict on the day: 'In the evening we were advancing towards Armentières , had reached the Lys and we were approaching the Lawe. In the direction of Béthune we made little progress. On the left, at Givenchy and Festubert, we were held up. The result was not satisfactory.' He made no mention of the losses.

'The reports which came in towards evening to Crown Prince Rupprecht sounded so favourable that the *Sixth Army* was ordered to push as far as possible over the Lys during the night.' Later reports showed that less had been achieved than had been at first believed.

Phase two of the offensive started the next day against British positions north of Armentières. The plan had been devised by General Sixt von Arnim and his Chief of Staff Generalmajor von Lossberg. The assault would be made by two corps of four divisions, with two divisions in reserve and two in *OHL* reserve. All were rested and were used to conditions on the Western Front.

The night was quiet although the British were aware of the sounds of activity. At 0245 hours the German bombardment commenced. The British held positions on the 'forward slope of a line of high ground along which the Armentières-Ypres road ran – Messines Ridge. Positions they had taken in June 1917. Positions that were not easy to defend. Behind lay nearly three miles of devastated and waterlogged ground crossable [only] by duckboards.'

Again it was misty and the gas fired at the British batteries and key points lingered. The attackers were largely unseen in the fog and quickly infiltrated around difficult positions. The speed of the advance meant that not all guns could be withdrawn in time; nineteen heavies were taken and tons of ammunition and stores were left behind.

The infantry of *31 Division* began their attack at 0330 hours, inflicting numerous casualties on the British but suffering heavy casualties in return. Front posts were lost and by mid-afternoon the attack was moving in the direction of Hill 63.

17 Reserve Division did not attack until 0600 hours but within minutes had taken front and support posts and advanced north along the Warneton road. By the time British reinforcements had reached Messines on the way to their Corps Line, the attackers were already in the village. Continued German pressure pushed the British troops back in many places, but not in all.

As night fell the battle died down, probably as a result of exhaustion, and only weak German patrols were encountered. 'The British line had been pressed back and the crest of the Messines-Wytschaete Ridge reached', but insufficient progress had been made. Aggressive defence meant that outflanking the British in the Ypres salient would not be an easy task.

Freshly re-stocked with artillery and ammunition, *Sixth Army* resumed the offensive from 0600 hours the next day. Overnight the British 55 Division had improved its defences but to little avail – the heavy and almost continuous bombardment obliterated much of their work. The fighting was severe but again little progress was made. The British line had cracked, but it still held.

A fake gun. With increased British counter-battery firing, a fake gun emplacement spotted from the air was indistinguishable from the real thing. This deception saved many guns and lives.

The German troops had crossed the River Lawe on both flanks. Their advance threatened to encircle the British troops at the bridgeheads they still held. Parties from *8 Bavarian Reserve Division* had crossed the river, and, supported by field artillery that had been moved under cover of darkness to the opposite bank, brought down on the British positions such enormous volumes of fire that no movement above ground was possible. The British return fire stopped further reinforcement and, after a counter-attack and the arrival of a further British unit, no further progress was made.

To the north, *8 Bavarian Reserve Division* had managed to get more men over the river and push forward making good progress. The attack was halted by midday; not until the attackers had managed to get enough artillery forward did they restart the attack at 1800 hours. Advancing under cover of the artillery barrage, the German troops spread north and south, moving past Vieille Chapelle. Estaires was heavily shelled during the night.

The next day troops from *35 Division* crossed at Pont Levis and pushed forward, entering and advancing through Estaires until pushed back by a strong British counter-attack. The arrival of further German troops pushed the British battalions back but did not clear them completely out of the town.

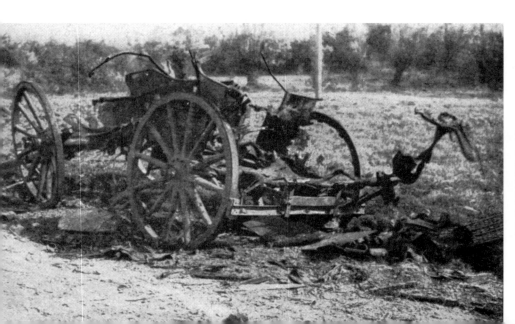

Sometimes death or survival were just luck. The remains of a horse-drawn wagon struck by random shell.

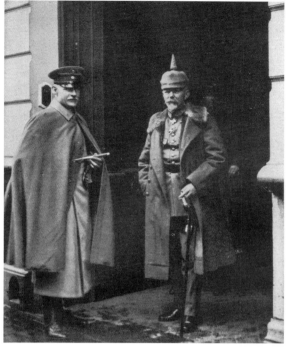

General Sixt von Arnim (right), commander of *Fourth Army* with Crown Prince Rupprecht of Bavaria. Rupprecht achieved the rank of Generalfeldmarschall in July 1916 and assumed command of *Army Group Rupprecht* on 28 August that year, consisting of the *1st, 2nd, 6th* and *7th Army*. He was considered one of the best German commanders of the war.

By late afternoon, *10 Ersatz Division* was at Steenwerck and involved in hand-to-hand fighting. At Bac St. Maur a British counter-attack was met with severe machine-gun fire and pushed back. As the fighting see-sawed, further British units were starting to arrive.

Renewed attacks the next day by *II.Bavarian Corps* and the German troops converging from Ploegsteert and Steenwerck posed grave danger to the British. With weight of numbers on their side, the German force pushed forward. They were on the edge of Erquinghem-Lys and with continued pressure pushed the British out of Armentières, a town they had held since 1914. But the advance was far behind the targets set for the offensive.

The Army diary recorded that pontoon bridges had been successfully swung across the Lys and that *17 Reserve Division* had captured Messines and advanced to within 800 metres of Wytschaete. During the evening the division had successfully held its positions against violent counter-attacks. *31 Division* had been held in front of Ploegsteert Wood but *214 Division* had taken the village and held it against several counter-attacks. The intention was to continue the attack in the morning and orders to that effect were issued just after midnight, but Rupprecht wanted more. He wanted an attack on the Belgians to be made from Houthulst Forest because the British troops in the salient were now worn out. This plan was rejected by the local commander who wanted three more divisions for the purpose.

With the advance only miles from Hazebrouck and few defenders in front of them, the attackers nevertheless faced other problems. *OHL* was concerned that the attack was not being pressed home with enough vigour. There were also concerns about transport and supply; neither Ludendorff or Rupprecht knew that the French were not prepared to help the British or that the British were stripping the Somme of troops to hold their attack.

First light on 11 April revealed an even thicker mist. Behind the mist, thirty divisions from two armies were ready to renew the attack. *Sixth Army* would move northwards and link with *Fourth Army* around Nieppe. They were also to capture Wytschaete and

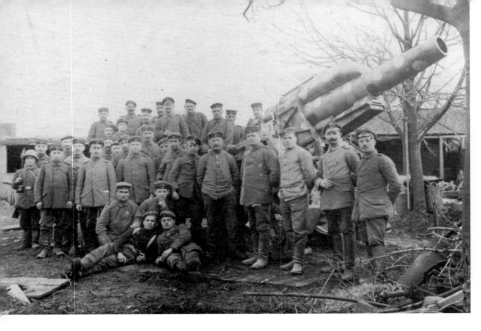

A Flanders souvenir. A battery crew pose in front of a camouflaged Lange 21cm Mörser (21cm long mortar). This artillery piece was a super-heavy mortar firing a 113Kg shell a maximum range of 11,100m

Wulverghem and had seven fresh divisions in close support for the attacks. This was the last day on which they would be able to use their *Schlachtstaffeln* and low-flying fighters to assist the infantry.

In response to the German advance, thousands of civilians were fleeing back from the fighting front. 'Farmhouses and villages were abandoned, the animals left in their fields. Above their heads flew the heavy shells, killing soldiers and civilians alike.' Throughout the day attack was followed by counter-attack. Slowly the British pulled back. By the end of the day, although Estaires, Merville, Messines, Ploegsteert and the wood, Hill 63 and Neuf Berquin had been taken, and despite the fact that the British had been dislodged along the entire line of the Lawe and the Lys, Wytschaete remained in British hands. Ludendorff, Rupprecht and the two army commanders viewed the day with disappointment; neither army had reached its objectives.

On 12 April a raid was made on Zeebrugge. Coastal Motor Boat 33A ran aground off Ostend, drifted ashore and was captured. All the crew were killed.

The day's fighting shows that truth is often a grey area in war. An official account stated that 'the *Sixth Army* met with great success, as the pressure from north and south against Armentières resulted in the capture of the town with 3,000 prisoners and 40 guns.' An *OHL* bulletin stated that the British had put up a brave defence before laying down their arms. On the other hand, according to the British, they had evacuated the town and the number of prisoners taken was minimal. Only two guns were lost, both to fire.

'At 11.45 A.M. the Kaiser visited *Fourth Army* headquarters and during the day the Army commander issued an order announcing his arrival and conveying an Imperial message to the troops. In this, the Kaiser expressed his best wishes and thanks for the efforts made hitherto, also his firm conviction that in coming days each individual would do all he could to ensure a decisive victory over "our British enemy".'

After the war Ludendorff described the day. 'The enemy's machine-guns continued to give our infantry much trouble. It should have grappled with them more seriously.' He also expressed concern about the lack of fighting quality shown by some of the divisions: 'certain divisions had obviously failed to show any inclination to attack in the plain of the Lys.' He qualified his concern by blaming it on the terrain, which made it difficult to bring artillery up.

During the day, German aircraft flew low over the British lines, providing accurate artillery spotting for the forthcoming attacks. As a result further British withdrawals were made, often hindered by refugees. *OHL*'s concerns about troop determination were not unfounded, as illustrated by troops who attacked Neuf Berquin and occupied it when the British left. The British dug-in but no follow-up occurred; instead the British heard singing. It has to be assumed that wine cellars had been found and were being enjoyed by the German soldiers.

Even with the arrival of new units, the number of troops available to the British was rapidly falling, forcing further withdrawals. As on previous days as much as possible was destroyed as dumps and camps were vacated. The large quantity of materiel that was not destroyed placed the attacking troops in a dilemma: continue the advance or enjoy the spoils. Ill-discipline became an issue again, as in Operation Michael.

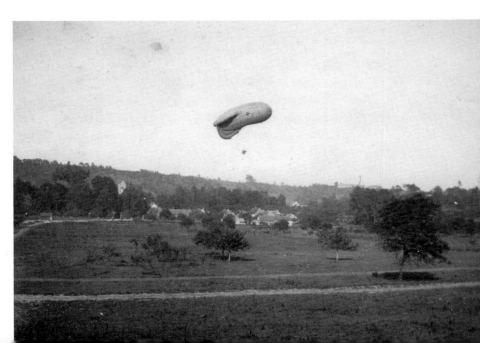

The clear skies of early July 1917 gave the observers in observation balloons such as this a clear view of the Allied build-up for the Flandernschlacht.

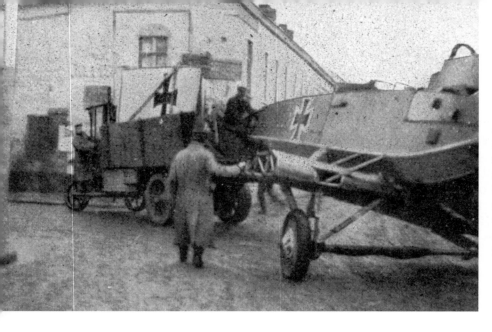

As well as ammunition cases, aircraft could also be recycled. Here a shot-down plane has been retrieved, dismantled and put on wagons to allow its return to a workshop for repair.

Even so, by the end of 12 April they were within six miles of Hazebrouck. That evening, *Fourth Army* was on the line Hollebeke-east edge of Wytschaete- east edge of Wulverghem-Le Romarin. After hard fighting, *Sixth Army* 'reached a line which ran west of Le Romarin-southern edge of Bailleul- southern edge of Merris-Vieux Berquin-Calonne-Locon. Considerable progress had been made, but the troops had not yet reached the objectives given for the 11th April, and west of Merville were unable to hold all the ground they had won.'

The sky above and behind the battlefield had also been very active. There was no fog and the RAF put up a maximum effort. 'One hundred and thirty-seven aircraft from I Brigade attacked German troops and transport around the important junction of Merville between 0600 and 1900 hours.' Two day-bomber squadrons were also involved. Air fighting was continuous, with ten British planes shot down against five German. Five German observation balloons were also shot down.

As well as being tired, the men were also always hungry and thirsty. Captured enemy supplies resulted in the attack stalling while the troops ate and slaked their thirst. The craze to plunder often spurred soldiers on. *Sixth Army* recorded repulsive scenes of drunkenness. Enemy supply depots were emptied and, when they ran out, there was always the bounty to be found in the backpacks of the dead, although to rob the dead or wounded was expressly forbidden.

For the Allies the situation was now so serious that a repeat of the Belgian inundation of 1914 was considered by the British. Damming the River Aa and letting sea water into the canal system would create a lake a mile across and shorten the British line by twenty miles. Like the Yser flooding, it would be impassable and stop any advance. The decision was not to be taken lightly, as such action would force the Belgian Army to vacate the last Belgian territory they held and pull back into France. Similarly the British would have to give up Ypres and Dunkirk.

If the advance continued at the speed it had achieved since it started, Hazebrouck and the high ground around the town would be lost. With Haig calculating that he was facing over 100 divisions, things looked decidedly good for the German Army. However, the

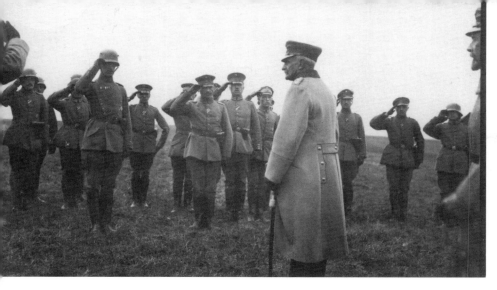

General Sixt von Arnim taking the salute from a be-medalled group of middle-ranking officers. Taken in Flanders by another officer, on an unknown occasion.

fleet-footed troops were now miles from their start line, tired, with no cavalry and suffering from the shortage of transport. 'According to the observation of British prisoners, the Germans were in serious transport difficulties owing to artillery fire, bombing, and congestion on the few roads available; the regimental transport consisted of anything from a landau to a hand-barrow, the condition of the horses was dreadful, and there was no sign of march discipline.'

On the British side, fresh troops had arrived and were ready to take up positions, but there were still fresh troops available on the German side. Although his troops had moved forward it had been a disappointing day for Rupprecht – little of value had been achieved – and even the breakthrough would be held by the British.

Foch had also released French troops to assist the British. One division had arrived in Dunkirk, Tenth Army was nearly with the British and a cavalry corps was on the way. Further north in front of Ypres, it had been quiet enough for the British to shorten their line and release another division to combat the Georgette Offensive. This withdrawal had been so stealthily accomplished that it was not even noticed, although troops in advanced positions had been observed moving from Zonnebeke and St. Julien south-westwards on Ypres. On hearing of the withdrawal, Rupprecht's Chief-of-Staff informed *Fourth Army* that the attack by *Ypres Group* should be launched immediately – but no order to that effect was issued.

It was not only the shortage of transport and resources that deleteriously affected the advance. Thousands of prisoners had been taken, but the organisation ready to deal with them or to transport them to Germany was inadequate. There was little food or medical care available; many were kept to assist with the removal of the wounded. Others were used as labourers, unloading trains, clearing the battlefields, burying the dead and repairing roads.

By 13 April, although there were some signs of chaos and collapse, no far-reaching result had been achieved. With British resistance stiffening, and the arrival of French troops, Ludendorff was looking at other options: a number of small attacks in different sectors across France, again favouring the Somme. However, *Fourth* and *Sixth Armies* ordered further attacks in Flanders, with the former launching an attack to gain the high ground between Neuve Eglise and Bailleul whilst the latter had as its objectives Bailleul,

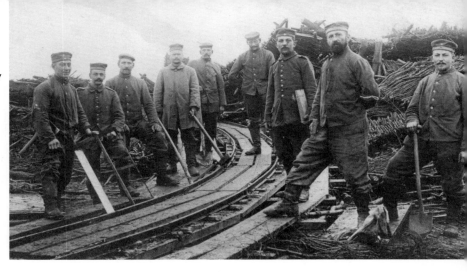

Once materiel had left the rail-head it was essential that it was moved as quickly as possible to where it was needed. An efficient method was the narrow-gauge railway. Here Landsturm soldiers are being used as labourers to build and maintain the transportation system.

Meteren, Strazeel, Nieppe Forest and the capture of the crossings over La Bassée Canal between Guarbecque and Mont Bernenchon.

Twenty-three divisions were poised to launch an attack against fifteen British and Australian divisions, and a French division on the way. Fortunately for the defenders, their attackers were tiring and did not always push forwards with their usual vigour. Some were even prepared to surrender and be taken prisoner. Many attacks were halted by continued British machine-gun fire, but the advance did make some slow progress. Again *Sixth Army* had achieved little and even lost ground. On the other hand *Fourth Army* had taken Neuve Eglise and moved closer to Bailleul after very heavy fighting. The offensive was moving towards Ypres. On the British side the decision was taken to pull back to the eastern slopes of the Ravelsberg and Mont de Lille.

At this point the Australians joined the front line, covering the withdrawal of the remnants of three British divisions assisted by the artillery of three other divisions. In this sector the attack suffered a severe reverse. Near Méteren, the attack went better but, nevertheless, the important town of Bailleul was not taken. Neuve Eglise was initially lost to a British counter-attack but retaken later in an effort that once again pushed the British back. However, it was not enough to launch an attack on Ypres.

Although only partially successful, the calibre of the British troops involved drew praise after the war from an officer in the *Alpine Corps*. 'To us, the 13th April 1918 was a disappointment. We were accustomed to definite success in attaining our objective everywhere, in Serbia, in front of Verdun, in Romania and Italy. For the first time…we succeeded in gaining only a few hundred metres of ground. I think I may say that the defenders of the British front in April 1918 were the best troops of the many with whom we crossed swords in the course of the four and a quarter years.'

Again there was the problem of moving the guns forward especially across a battle-field. After a three day rest, *12 Reserve Field Artillery Regiment* started to move to the front at 1445 hours on 11 April, having waited on parade for nearly six hours. They marched for nearly eleven hours under extreme difficulties with no road control and hour-long blocks on the road. After a rest of just over two hours they set off again, this time over shell craters. Engineers who had gone on ahead tried to repair the roads and attempted to make bridges over the trenches. Even so the history recorded that 'it was most troublesome to get forward.'

Everywhere the regiment went, there were signs of fighting. 'In the peasants' cottages…foodstuff was still on the table, and in the fields were scattered guns with the shells still in the bore.' By midday on 12 April they reached Estaires to find it still burning and blocked with soldiers. It was too much of a target for the RAF to ignore. Flying low, they dropped bombs that caused many casualties. *38 Reserve Infantry Regiment* lost sixty men marching through Estaires while *12 Reserve Artillery* recorded a similar loss in just one of its batteries.

But the advantage was still with the attackers who now had forty-eight more divisions than at the opening of the offensive, with the freedom to strike anywhere from Arras down to Noyon against troops with few reserves. Foch would not spare more French troops to aid the British. To create reserves, the Belgian Army needed to hold a greater part of the line and the British withdrew to a shorter front. The British Second Army would secretly retire along the front Kemmel-Voormezele-White Chateau-Pilckem Ridge giving up the gains of 1917. This would also have the effect of disorientating any attack.

During 14 April, *Sixth Army* reported to Ludendorff 'that its offensive had, to all appearance, fizzled out, and that the troops were completely exhausted: each day the divisions were ordered to attack but would not do so.' *Sixth Army* Chief-of-Staff wanted the offensive to be postponed until the artillery and trench mortars could be deployed. Ludendorff agreed to a postponement until 17 April. While *Fourth Army* was attacking towards the high ground Kemmel-Dranoutre-hills east of Bailleul with a final objective of Poperinghe, the army headquarters were visited by the Kaiser.

Again the lack of progress was attributed to the artillery. Although a British report commented on the excellent coordination between the artillery and the infantry and on the accuracy of their shooting, the Chief-of-Staff of *X.Reserve Corps* did not agree. To him it was 'really scandalously bad artillery preparation; the batteries were too far back, had no observation posts to follow the course of the battle, and fired without knowing where the enemy was.'

A lesson was learned. 'Ludendorff laid down two principles for the employment of

A quiet time during the summer. During periods of rest, activities were organised to keep the soldiers active. In the warm months a popular pastime was the swimming festival.

artillery: "(1) thorough artillery preparation before, and creeping and sweeping fire during an attack; (2) allotment of batteries for the special purpose of destroying, either by fire over open sights or from covered positions with observation well to the front, obstacles which threaten to stop the infantry".'

While *Sixth Army* was quiet, *Fourth Army* was to attack. It was assigned the capture of Bailleul using a corps newly arrived from Russia. The *Guards Reserve Corps* and three other divisions would launch their attack on 15 April. That day 'Bailleul fell into German hands, the British army retired from the Neuve Eglise high ground…and the withdrawal in the Ypres salient was completed.'

Rupprecht's main objective for the day was Bailleul. Original plans for the two armies to encircle the town were dropped and the task was given to *Fourth Army*. The army diary recorded the day's events: 'During the morning, the left of the *49th Reserve Division (XVIII.Reserve Corps)* captured Wulverghem and the hostile positions north-east of the village…At 1500 hours, under the orders of the *X.Reserve Corps*, the *11th Bavarian, 117th* and *32nd Divisions* attacked in order to capture the line of hills, Zwartemolenhoek [a mile north-west of Neuve Eglise, Sebasto [the high ground about Crucifix Corner], Ravelsburg, Mont de Lille. The attack was highly successful; all along our front we got within 300–800 metres south of the Bailleul-Wulverghem railway, and during the night the *32nd Division* even managed to push some troops across the railway. The enemy resisted desperately.'

The *Guards Reserve Corps* now planned a large-scale attack on 20 April. Eight divisions would be available, with four for the attack. Assembling in the Houthulst Forest area, it would move in a south-westerly direction with the aim of crossing the Yser Canal. This would coincide with an attack from Kemmel. Heavily supported by artillery, the overall objective was to take Ypres. A major problem faced was the lack of roads, making re-supply difficult. On the Allied side, French reinforcements were arriving.

When patrols discovered that the British line was being held by only a few outposts, the attack was brought forward to 17 April. The problem would be in launching a simultaneous assault three days early. Occupation of Bailleul also opened up the possibility of an attack in the direction of 'the Steenvoorde-Poperinghe road, the key supply route to the Ypres salient' as well as other options.

On 16 April, with no special orders given to either army, *Fourth Army* continued the offensive from Bailleul to beyond Wytschaete and the *Sixth*, while standing fast, captured Meteren. There was no major action, but the shelling of British positions continued. They were minor actions for tactical reasons, two of which were important: Méteren and Wytschaete were captured. Allied casualties were high and included a company of New Zealand troops taken prisoner. As a result the French divisions moved towards the front; a front so frail that Haig wanted to start the inundation of the Dunkirk area. In fact, Foch had already ordered the damming of the River Aa.

Tannenberg was a flanking operation north-east of Ypres. Fresh divisions would assault the Belgians who now held the line between Nieuport and Langemarck. The Belgian plan was to hold their territory as long as possible and then retire on the Loo Canal. Three divisions with a regiment of the *Marine Corps* assaulted three Belgian divisions in positions on a 7,000 yard front 'from the Dixmude road crossroads at De Kippe down to Langemarck.' After a day of hard fighting the Belgians were back in their original lines, having taken over 750 prisoners.

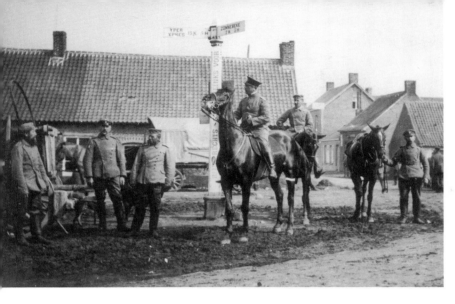

1918 – Landsturm soldiers in the centre of Westroosebeke: their uniforms suggest mounted troops. This crossroad still exists today: Ypres is 13km away and Zonnebeke 7km.

The position was becoming clear to Foch; he now ordered two more French divisions north and created the Detachment d'Armée du Nord. Unknown to *OHL* the British and French were reconstructing behind the line. 'As well as the inundations between St Omer and Dunkirk, several new lines were mapped out and construction begun over a belt several miles deep.' Working feverishly, the Labour Corps dug and carried, and transport units moved dumps and stores. New headquarters were constructed, hospitals moved, communications tested and – possibly the greatest difficulty – French forces were assimilated into the structure.

In the British sector, Tannenberg yielded little. The British force was still in place and the troops of *Fourth Army* were worn out. It was not possible to continue unless fresh troops were available. General von Lossberg, *Fourth Army* Chief of Staff, pointed out in a telephone conversation to his counterpart at Prince Rupprecht's headquarters 'that the situation was very critical', Kemmel and Mont Noir could not be taken without fresh troops, 'seven divisions of the *Fourth Army* were exhausted and urgently required relief, and a minimum of five

A youthful Iron Cross winner, Arthur Michl, poses next to an unexploded British heavy calibre shell and a shrapnel shell. The card was sent to his uncle in February 1918.

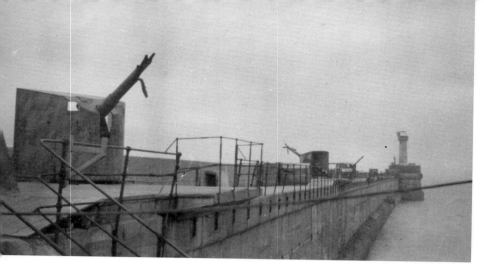

While the Zeebrugge raid achieved little, the attack on the mole was successful. An old submarine, containing explosives, destroyed the mole connecting the bridge to the shore when it was detonated. The photograph shows the spiked coastal guns on the Mole.

new divisions were needed: tactically, the position of the *Fourth Army* was unsound, clinging precariously as it did to the foot of the slopes held by the Allies. If the *Guards Corps* were not successful the next day the attack must be called off.' Ludendorff decided to await the outcome before committing any troops.

The German troops had an added difficulty: many held positions from which any further assaults would prove too costly. Manpower was now an issue. Further troops would be available after 21 April; in the meantime the only fresh troops were the *Guards Reserve Corps*, and at Givenchy *IV.Corps* were available and ready for action. What happened the next day was of the utmost importance for the continuation of the offensive.

'On the evening of the 17th the *Sixth Army* ordered the attempts to advance near Bailleul to be stopped, on account of the arrival of French reinforcements. On the left wing, however, on the 18th, after four days' rest during which a great concentration of artillery had been effected, the *IV.Corps* (four divisions in front line and one in reserve), with the support of *IX.Corps* (three divisions in front line and one in reserve), on its right, was to gain possession of Givenchy and Festubert and the line of the La Bassée canal as far as Robecq, in order to ensure the protection of the left wing.'

At 0100 hours on 18 April, German artillery started a bombardment as severe as 21 March and 9 April. The shelling lasted seven hours near La Bassée Canal, slackened off near Festubert after four hours, and then increased as the attack started. The Givenchy-Festubert front had been reasonably quiet so the assaulting troops were rested. Their deep objective was Béthune.

Visibility was again limited by fog and gas. Three divisions assaulted two British divisions. Initially successful, but eventually held up by determined resistance, the attack on Givenchy was over by mid-day. Casualties had been very heavy, the village had not been taken and the target of Béthune had not been reached. The failure was blamed on the British counter-attacks and the concrete machine-gun nests which were not captured. In another sector, although some key posts were taken in other attacks, no breakthrough was achieved.

OHL had previously voiced concerns about the lack-lustre performance of some units. *18 Reserve Division* was withdrawn from the battle the day after its failed assault. However, failure did not necessarily mean that it had made a feeble attempt. *239 Division,* although it eventually achieved little, had initially made good progress but was held and did not

cross the canal. To the north the attack produced only a minor advance, while, in front of Ypres, the assault was a total failure.

Fourth Army, under the misapprehension that its *Guard Corps* had reached the Steenbeek, ordered it to continue its attack on the Belgian positions. On the rest of the army's front the general offensive was stopped to prepare for an assault on the line Kemmel-Mont Noir. Even though its divisions were exhausted, only three reliefs were authorised.

As with *Sixth Army,* the day was not to be one of good fortune. 'From early morning, things went wrong for the *Guards Corps*. The *6th Bavarian Division* proved to have been very badly shaken on the 17th and to be almost unfit for attack.' *83 Division* was so delayed by the difficult country which it had to pass through that it could not get up in time to assist, so the *Guards Corps* postponed the attack until the next day. When it was discovered that the other attack division had not crossed the Steenbeek which was strongly held, the attack was further postponed until 20 April.

Ludendorff agreed with the commanders of the two attacking armies: neither had the resources to break through to Béthune, both were overstretched and in some places were holding dangerous tactical positions. Operation Georgette was closed down on *Sixth Army* front as was Tannenberg on *Fourth Army* front, but not before a final roll of the dice. The target on 25 April would be Kemmelberg, a position of natural strength. General Sixt von Arnim made preparations for the battle.

When the overall situation became clearer the next morning, Ludendorff cancelled the Ypres attack and ordered that all attacks be purely for local adjustment of the line. This released three relatively fresh divisions to assist at Kemmelberg. The total attacking force would be eleven divisions whose objective was Kemmelberg and the road from Poperinghe to Ypres, leading to the capture of Ypres.

The failure of the 18 April attacks was followed by what passed for a pronounced lull of six days, from 19 to 24 April. However, 'heavy shell-fire was a daily occurrence on the whole front but nowhere more so than in the Nieppe Forest and the Kemmel areas.'

The arrival of further French divisions allowed the British to relieve some of their divisions. These newly-arrived and fresh troops would face the attack of 25 April.

While both sides prepared, the British Dover Patrol attacked Zeebrugge. The raid involved three old cruisers, five cruisers, nine monitors and forty-four destroyers against Ostend on the night of 22/23 April and against Zeebrugge on 22 April. The Zeebrugge raid lasted an hour and cost 588 Royal Navy casualties, mainly in the 900 strong landing party that tried to storm the harbour mole. That raid's results were initially unclear, and the smaller attack upon Ostend was an unequivocal failure. Two old cruisers, intended as block ships, failed to reach the harbour entrance. A subsequent attempt made to cripple Ostend similarly failed on 9 May. Within three weeks of the raid, the canal was fully open.

The plan was for *XVIII.Reserve Corps* and *X.Reserve Corps* to reach a line from the southern end of Dickebusch Lake-Kemmelbeek-northern outskirts of Dranoutre-Haedoorne with a defensive flank on the right from the Ypres-Comines canal to Dickebusch Lake. Once secured, the divisions in the second line would push past the east end of Mount Kemmel towards the Poperinghe-Vlamertinghe road to cut off the Ypres salient. A second objective was set: Vlamertinghe-Brandhoek ridge-Reninghelst.

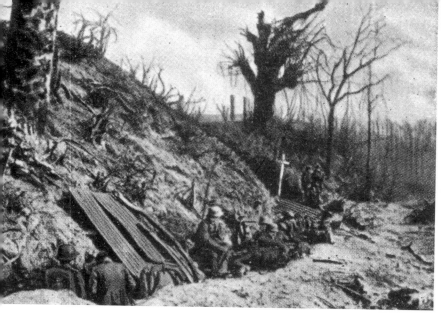

25 April 1918: soldiers resting on the newly-taken Mount Kemmel.

Over 300 aircraft would be available on the day; they would play an important part in the assault. Oberleutnant Loerzer, who finished the war with forty-four victories, was in charge of fourteen *Jagdstaffeln* that would provide air cover for the four *Schlachtgeschwader* and three *Jagdstaffeln* assigned to support the attacking ground force.

When aerial reconnaissance and prisoner reports made it clear that there would be an attack on Kemmel, all units were placed on the alert. At 0230 hours a high-explosive and gas (lachrymatory and mustard) bombardment commenced that followed the pattern of 21 March and 9 April. Luck was again with the attackers – there was fog, made worse by the smoke and dust. Moving through gaps, hiding in shell holes, firing flamethrowers, the attackers moved forward, in places very quickly. Everything went well. A few minutes after 0900 hours von Lossberg, Chief of Staff of *Fourth Army,* told Ludendorff that he intended to further develop the attack. New orders were issued. The corps were to continue their advance when they had consolidated their first objective and when they had sufficient artillery in position.

'At 0600 hours on April 25 the assault on Kemmel Hill marked the first large scale use of tactical aircraft from the outset of an offensive battle. The attacking German divisions were preceded by 16 *Schlachtstaffeln* flying in a long saw-tooth formation that swept over No Man's Land like a mowing machine. These 96 aircraft fired over 60,000 rounds of machine-gun ammunition and dropped 700 bombs; they then split up into units of two or three aircraft which proceeded independently, attacking targets of opportunity behind the British and French lines. Loerzer's fighter *Staffeln* maintained absolute control over the battlefield, shooting down four British aircraft for no losses of their own.' Only one *Fourth Army* plane was lost during the day.

By mid-day, despite brave resistance, Kemmelberg had been taken along with over 8,000 prisoners. 'Even the German airforce had joined in with 96 aircraft dropping 700 bombs and machine-gunning the French positions as the *Leib Regiment* of the élite *Alpine Corps* (in fact a division) stormed forward.' It would remain in German hands until the end of August when it was recaptured by the American 27 Division and British 34 Divisions.

The Kaiser was overjoyed and the *Guard Reserve Corps* was told to get ready for an

advance on Ypres. Ludendorff urged caution and troops were ordered not to push too far without adequate artillery support, even though it was felt that there would be no counter-attack in strength yet. Orders were given to prepare for a counter-attack and to bring the second-line divisions forward. The inevitability of a counter-attack was corroborated by French prisoners who told of reinforcements near Poperinghe, and by a deciphered British wireless message that mentioned holding the line La Clytte-Vierstraat until a counter-attack could be delivered.

On Kemmelberg the advance toward Scherpenberg slowed in the inevitable confusion that ensued during and directly after battle. The assault had met and surpassed its objectives. Dranoutre had been taken and the line pushed almost to Locre hospice, but on the right it had fallen far short of expectations. Suggestions to restart that evening had been rebutted because of the mix-up of units during the Kemmel battle. The attack would start again at 0800 hours, with the same divisions in the front and second lines.

The British counter-attack the next morning was initially successful in places, capturing many prisoners; those of *56 Division* were felt to be of poor morale but above average physical specimens. Regardless, preparations continued for the attack. However, as on other occasions, logistics began to play a key part. Infantry were still moving into position after the start time, the artillery did not open up and, when the fog lifted, men went to ground under the intense Allied fire. The Bavarian *Leib Regiment* blamed the lack of success not just on the inopportune French counter-attack but also on the fog which stopped artillery observation and reconnaissance. Another Bavarian unit, *1 Jäger Regiment* also blamed the fog, the lack of artillery fire and the Allied artillery which commenced when the fog lifted.

Unknown to von Lossberg with *Fourth Army,* whose troops had not broken through to Ypres, the day's fighting had severely stretched the British; so much so that Haig gave General Plumer the authority to abandon Ypres if necessary. 'Plumer also took steps to withdraw deeper into the Ypres salient during the afternoon, leaving only a thin outpost screen on the Pilckem Ridge.' New lines of defence were drawn up west of Poperinghe.

The attack was postponed until 27 April but one corps was unable to ready itself for a further two days. During this time, both sides moved divisions around and continued the artillery battle. The assault would be launched by eight divisions with five in close support. Increasing numbers of deserters indicated falling morale.

At 1815 hours the attack was postponed again, this time until 28 April, and finally until 29 April, on the condition that, if the situation changed, *Fourth Army* must attack at once. Although in the line for some time, most of the divisions were still in a good condition, although the *Alpine Corps* was short of officers. Two divisions desperately needed replacing and Rupprecht exchanged them for three new ones with the promise of more if the attack went well. Supply continued to be a problem: one division complained it had received no gas shell by the afternoon of the day preceding the attack.

At 0300 hours the bombardment commenced, mainly of gas with some high explosive. Then at 0540 hours the infantry began their advance. Their objective was the line Ypres-Vlamertinghe-Reninghelst-Westoutre-Mont Rouge. As before, the intention was to force the British to withdraw from the Ypres salient. There had been little Allied retaliation to the bombardment but, when the infantry advanced, they were hit by strong, well-directed fire from unsuspected locations in the Vlamertinghe-Reninghelst valley.

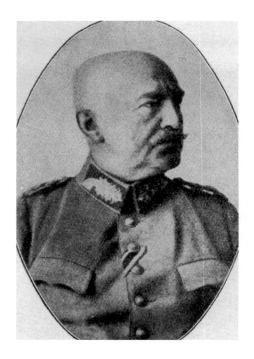

'Friedrich Karl "Fritz" von Lossberg (30 April 1868 – 4 May 1942) was a German colonel, and later general, of World War I. He was a strategic planner, especially of defence, who was Chief of Staff for the Second, Third and Fourth Armies'. Lossberg first put into practice the theory of elastic defence during the battle of Arras (April–May 1917), where it succeeded. At the subsequent battle of Passchendaele (June–November 1917) Lossberg carefully planned an elastic defence and again was successful. Lossberg's successes in battle proved the feasibility of defence in depth.

By 0700 hours stiff resistance was reported to *Fourth Army* headquarters and by 0945 Ludendorff was aware that the attack was not progressing as favourably as hoped – so unfavourably in fact that it was difficult to decide whether to continue. At 1100 hours he received a call from von Lossberg: 'Our attacking troops are everywhere encountering a very solid defence organized in depth, and particularly hard to overcome owing to the numerous machine-gun posts.'

Just before 1300 hours, in a reply to the Kaiser's request for news, 'von Lossberg reported that owing to the solid nature, and to the organization in depth, of defence, the attack this day was meeting far greater difficulties than had previously been experienced.' He would continue the attack later in the day against Millekruisse with three divisions. *233 Division* launched its attack at 1700 hours and made no progress, the *Alpine Corps* did not attack and the *Official Bavarian History* records that 'the offensive powers of the German troops was exhausted' when discussing the role of *4 Bavarian Division*.

It was a day of heavy fighting and severe losses. Both flank attacks made some progress but the centre fell into a British trap. The attack captured the minor height of Scherpenberg, between Kemmel and Ypres, but it was not enough. 'Georgette ground to a halt by 29 April with a furthest advance of 12 miles south of Ypres.' Ludendorff had decided 'that the offensive had irrevocably lost impetus and ordered that it should be closed down. Its results had been disappointing.' At 2220 hours *Fourth Army* ordered that the attack would not be resumed on 30 April, but minor operations could be undertaken as long as the present front was not compromised.

Taking stock of the situation the next day, von Lossberg concluded that to capture Mont Noir, Mont Rouge and Poperinghe, *Fourth Army* needed between ten and twelve fresh divisions. As these could not be made available, no further offensives would be possible. It was now essential to defend the Kemmel and Ypres sectors. Georgette was finished.

No great strategic movement had been achieved. The Channel ports had not been

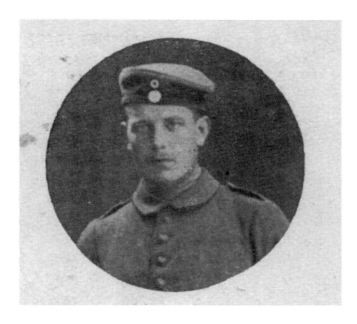

Anton Beck, holder of the Iron Cross Second Class, was nearly twenty-two when he was killed in action on 5 May 1918.

reached and on the left flank the troops were in an unfavourable situation. The hoped-for decision had not been achieved by the second great offensive. 'Fourth and Sixth Armies had exhausted their powers of attack. 'But before this, in the middle of April, Sixth Army had already warned Ludendorff of a serious problem: 'The troops will not attack, despite orders to do so. The offensive has come to a halt.' However, preparations were made for a further strike in Flanders – Operation Hagen.

'The cost had again been high in men and materiel. Between 1 and 30 April, "Sixth Army lost 63469 of its 361142 soldiers…Fourth Army 59209 of its 421221." In the course of the battle German artillery expended over three times the ammunition used during the Franco-Prussian War.'

The problem could be partly solved by withdrawing troops from the east and further combing-out at home, but both these strategies had problems. 'Replacements from the eastern front were a mixed blessing. Far too many of them had listened to the siren song of Bolshevism and were talking the socialist line of immediate peace without annexations or reparations. Other recruits from the homeland, taken from defence plants and resenting the loss of highly- paid jobs, had no desire to lose their lives in what they regarded as a senseless prosecution of the war.'

'While some senior officers cautioned an end to the offensives, Ludendorff disagreed. He did however accept that there was no longer the ability to fight two offensives at the same time. Instead of destroying the British forces, he decided to turn against the French in a series of smaller attacks that would separate them from the British.'

Ludendorff had failed to provide the breakthrough that would end the war, and both at home and among many of the troops there was a feeling of inevitability about the future; further attacks that would make initial gains but no breakthrough, allied counter-attacks, and all the time the butcher's bill was getting bigger.

On the home front, physical lethargy was breeding mental despair. There had been random acts of sabotage and strikes that had badly affected military production and jeop-ardised the planned offensives. People declared themselves 'tired of suffering'. What they wanted was the return of their sons and husbands.

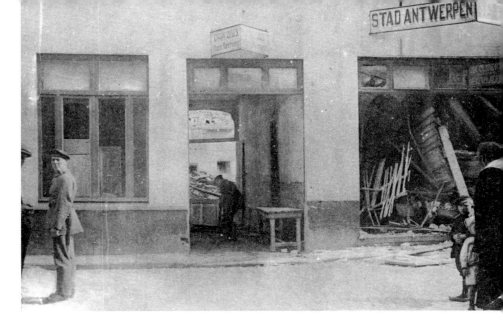

Taken on 16 May 1918, this photograph shows the effects of a British naval shell on the Rue Saint-Paul, Ostend.

The Russian Revolution had left its mark on many soldiers who had been on the Eastern Front. It was reported that a train bringing replacements for *2 Bavarian Division* had "Red Guards" painted on the carriages and that infractions of military discipline were becoming more common.

Ludendorff and Rupprecht thought that the causes of declining morale were war-weariness, the failure of the supply system, influenza, units being under-strength and reinforcements of indifferent morale. As well as a falling-off in the troops' ability to resist Allied attacks as ably as they had done in previous months, the British also noticed that their opponents 'had ceased to trouble about burying or removing the dead, or to make latrines.'

'Throughout April, May and June, a number of options for a "decisive" thrust after Operation Marneschütz-Reims were considered and discussed by Ludendorff, Hindenburg and the Army group Commanders.' The consensus was again to attack in Flanders. 'By 1 July, the plan was drawn up and preliminary orders issued to prepare for the new offensive.'

Before then there would two further smaller-scale operations. 'The two further offensives were being prepared by *Seventh Army* – Blücher and Goerz (a swashbuckling sixteenth-century mercenary famed for his comment – "Lick my arse!") by *First Army*. The Blücher offensive against the defences on the Ailette and Oise-Aisne canal crossed a marshy battlefield of water-filled shell craters. The conditions for Operation Goerz were similarly very difficult. This was to be followed by Operation Hammer Blow.

The battle would soon return to Flanders. Rupprecht's army group would take the leading role. General von Quast's *Sixth Army* would use two corps to strike against Hazebrouck, a vital road and rail junction, in the south. In the north five corps from General Sixt von Arnim's *Fourth Army* would attack between Meteren and Boesinghe, a thirty-seven kilometre front. Again the objective was to push the Allied forces back to the channel.

On 3 July *OHL* informed Rupprecht that the Hagen Offensive would be carried out and that preparations would be made for the Kurfürst offensive – despite the fact that the offensives so far had not significantly reduced the Allied strength in Flanders.

Relaxing in the July weather somewhere in Houthulst Forest. A card from Martin, serving in *Telephone Unit 421,* to his friend Heinrich Fink in *Reserve Infantry Regiment 40.*

Three days later Ludendorff informed Kohl, Rupprecht's chief of staff, that all Hagen preparations were approved but that there would be a diversionary attack before the real offensive. The last French troops left the Salient on 8 July, so the offensive would now be against the Belgians and the British.

A further German manpower crisis was resulting from Spanish flu – *Sixth Army* reported that 15,000 men had caught the illness. On 11 July, because of the number of influenza cases, Rupprecht seriously considered postponing the Hagen attacks. The shortage of men was so desperate that Ludendorff had arranged for *1* and *15 Austrian Divisions* to be sent to the Western Front in July and more were to follow in September. The war in the east was officially over, but garrison duties and continued Russian resistance against further German penetration tied down more than forty divisions; one division was transferred in June and broken up to provide reinforcements, and a further nine divisions were sent during September and October.

Unable to support a new effort by Rupprecht in Flanders, Ludendorff decided to focus on the weakly-held Rheims sector. The aim was to strengthen rear communications of *Seventh* Army and force the release of Allied troops from Flanders. Immediately after this all efforts, including flying squadrons, would be concentrated on the Flanders Front for an attack two weeks later.

The Marne offensive, launched on 15 July, did not go as planned. Even with this disaster and the launch of an Allied offensive three days later, the German High Command was still hopeful that it could launch the Flanders operation – Hagen had been rescheduled for early August. But the dire news of the situation on 18 July, at the morning meeting of Ludendorff, Rupprecht, army commanders and their staffs, caused a change of plan. Ludendorff cancelled the transfer of Bruchmuller's artillery to Flanders and sent the Flanders offensive divisions to assist on the Marne.

The British recapture of Meteren on 19 July caused another change in Ludendorff's thinking. The next day he informed Rupprecht that, due to the drain on troops caused by the Marne offensive, Operation Hagen would probably not take place. However, 'alternative plans, like an offensive on a reduced scale, known as Operation Klein-Hagen, were

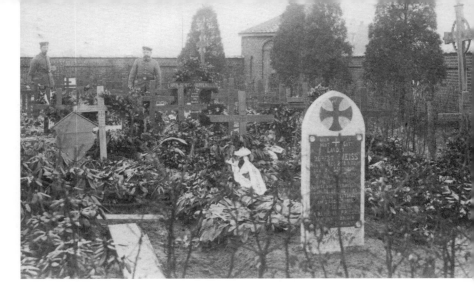

Isighem military cemetery during late summer 1918. The stone grave marker is a communal Landsturm grave and at the back is a large wreathed cross for an infantry captain.

put forward and actively considered until the end of the first week in August.' The launch of the 8 August offensive sealed the fate of any planned offensive – Operation Klein Hagen was cancelled.

No strategic goal had been achieved and the Allies had inflicted a serious defeat on the German Army. Operation Georgette's territorial gain put the army into a difficult position and had been achieved at considerable cost in life and resources. This failure, added to the other unsuccessful offensives, caused irreparable damage.

The army had suffered very serious losses over the four months of offensive action. Its artillery losses alone for the month of July were thirteen percent. Manpower was also dwindling, down from over 200 divisions to 141, of which over half were not fit for front-line service. While the Allies still had fewer divisions, all of them were at strength and fit for the front. There were also ever-increasing numbers of Americans arriving. In the air, the RAF held sway and on the ground British artillery now had tactical dominance.

Coupled with the losses came hunger. On 15 June army commanders were informed that there could be no more deliveries of corn or potato fodder for the horses, and negligible deliveries of potatoes for the troops until the next harvest – weeks away. 'The army was suffering from a vicious flu epidemic. Replacements were insufficient in quantity and lacking in quality, young recruits hungry and ill-clothed for three years, scarcely inflamed by the patriotic ardour of their predecessors, most of whom had been killed, wounded or captured; older men from other fronts; and repatriated prisoners who had had enough of war and wanted only to go home.' The future for the front line soldier looked bleak. They 'were no longer "jauchzend" (shouting hurrah!), but…had gone to the other extreme and were "zur Hölle betrübt" (depressed down to Hell).'

On 8 August, thirteen low-grade German infantry divisions were attacked by five Australian, four Canadian, four British and two French infantry divisions, assisted by 450 tanks and 2,000 artillery pieces. The German front collapsed and within hours 16,000 prisoners had been taken. Half the divisions were no longer effective units. Ludendorff ignored the disaster with a communiqué highlighting a minor (German) achievement in Flanders. 'On both sides of the Lys, we struck down partial English advances. To the north on the Somme, the enemy launched heavy attacks…They were repulsed.' The *Berliner Tageblatte* went as far as to lie to its readers, telling them that the enemy had been thrown

back by counter-attacks and had suffered heavy losses. Admiral Müller noted in his diary that the Kaiser was in very low spirits that evening.

The official German account acknowledged that it was the greatest defeat since the start of the war, with an estimated loss of up to 700 officers and 27,000 men, of whom about seventy per cent were POWs. It was not only the under-strength and tired divisions that failed to hold the enemy advance: at Hangard Wood, a fresh full-strength division collapsed when attacked by Canadian troops. After the war, the defeat was blamed on the unprepared defensive position which in some places amounted to no more than white tape on the ground.

The British attacks next day were not as successful and many of the senior commanders did not accept Ludendorff's black day scenario. It was clear that the men were recovering from the initial shock of the attack and that resistance was stiffening, with the effect that the British advance was slowing down.

By 10 August, Ludendorff knew that the war must stop. 'August 8th was the black day of the German Army in the history of this war', he wrote after the war. 'This was the worst experience…except for the events that, from September 15th onwards, took place on the Bulgarian front and sealed the fate of the Quadruple Alliance.'

Within a few days of the offensive, even the Kaiser was ready to concede that the war could no longer be sustained: 'We are at the end of our capabilities. The war must be ended.' Losses were high but many were not casualties; an estimated 50,000 were POWs. Within a week of the Allied attack, the number of unfit divisions had risen from 109 to 130.

In August, the British, French and American armies mounted a series of rolling attacks that ruptured the German defensive line. 'After 15 August "there were indications of an offensive between Arras and the Ancre, especially towards Bapaume. The *17th Army* was not to hold its front line but to give battle in a position three to four kilometres in rear; the front line was merely to be held by outposts who were to fall back on to the main position before the attack".'

'On August 21st the English attacked south of Arras between Boisleux and the Ancre; this was the first of a series of attacks on Crown Prince Rupprecht's sector which lasted almost uninterruptedly to the end of the war and made the heaviest demands on the Group Headquarters and their armies.' Five days later, after *17 Army* had

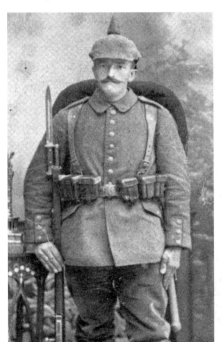

Josef Loibl, Iron Cross Second Class winner, was from Mitterleinbach and had served for four years at the front at the time of his death. He was killed in action during September 1918, at the age of thirty-eight, while serving with *26 Infantry Regiment*.

A scene that would not pass the censor in the British Army. Two happy officers 'sitting on the throne.' One is reading the latest news from home.

pulled back successfully 'the English offensive against the Arras-Cambrai road opened.'

The troops fell back according to plan but eventually the English reached the Wotan position. 'On September 2nd a strong assault by English tanks over-ran obstacles and trenches in this line and paved a way for their infantry.' As a result *17 Army* requested and were given permission to retire to a new line in front of the Arleux-Moeuvres Canal; during the night of 3 September it withdrew behind the canal. Such withdrawals short-ened the line and economised on manpower but only delayed the inevitable. They would arrive in Flanders before long.

During August the army lost 228,100 men, of which 110,000 were missing (deserted). As a result of the losses and shortfall in replacements, by the end of September there were only 125 divisions left of which only forty-seven were combat-worthy. Facing them were over 200 Allied divisions, with American replacements arriving daily. The only posi-tive note sounded was the forthcoming "class of 1900" which consisted of over 637,000 men, able to supply 300,000 new recruits.

At the front, this news raised no cheer. The majority were resigned to defeat and despair. However, many fought on with tenacity and withdrew in good order. The one positive thought was that each was a day nearer to the end. There were too few horses, little food, the field guns were worn out. The vaunted new troops were weak boys who could not carry a pack or look after themselves.

A month after the start of the Amiens battle, three Entente Army groups were ready to strike: the Americans in the south, the British in the north, and the French in the centre. However, it would not be a rout, even though there was a shortage of equip-ment, horses and men.

After 18 July, the Army was at the end of its physical and psychological capabilities.'Repeated Allied blows sent it reeling along the ropes like a punch-drunk boxer: Amiens, Meuse-Argonne, Flanders, Sambre, and Scheldt. The Allies stormed the Siegfried Line.'

'Shirking at the front became more prevalent, especially among men returning from home leave. Over-staying of leave increased, and the fighting line got thinner and thinner.'

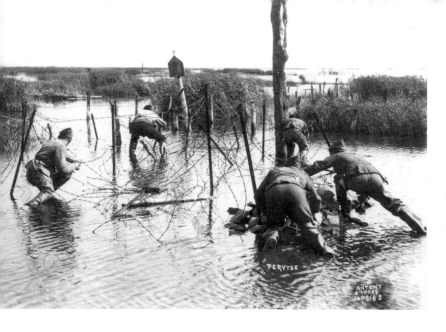

A posed photograph of Belgian soldiers moving through the inundations at Pervyse on 16 September 1918. As the floods stretch beyond the horizon there is no chance of them being spotted.

And while the Ministry for War was at last prepared to call up exempted men in greater numbers for the army, there were no other potential reserves on which to draw. All the useful men from the Eastern Front had been extracted long ago. There were no more replacements.

On the Home Front the situation was also deteriorating. 'Crown Prince Rupprecht, who was returning to the front from sick leave, recorded in his diary…In Nürnberg the inscription on a troop train…read "Slaughter cattle for Wilhelm & Sons".' Further withdrawals were planned to shorten the line.

In the retreat it was easy for men and artillery to get lost. 'Tens of thousands of German veterans deserted. Other tens of thousands simply went "missing"…"Slackers" and "shirkers" simply melted into the confusion of humanity in rear areas and in Belgium.' Official post-war estimates of the number of men who were shirking or slacking in their

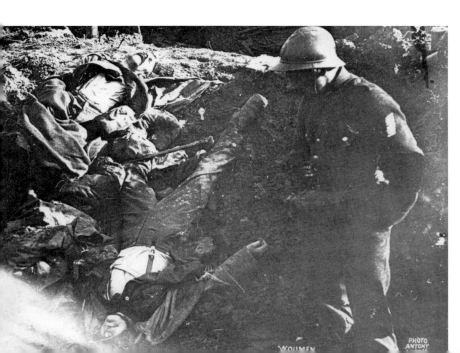

German dead after the Belgian attack on Woumen on 18 September 1918. A photo taken by Ypres' photographer Antony.

duty over the last two months of the war were between 750,000 and 1 million. Many just surrendered – as in an incident on 2 September. A British aircraft, looking for a counter-attack, sighted a large number of troops sheltering in a trench and sunken road. Returning fire, the British aircraft killed one and wounded three of the soldiers. When the plane turned to make a second attack the troops were waving a white flag. Throttling back, the plane descended to fifty feet and flew slowly past indicating with hand signals that they were to head towards the British lines with their hands up. They complied and were duly taken prisoner.

Deaths by "friendly-fire" further demoralised troops, many of whom were only looking out for themselves and looking for an escape route: 'Trains hauling the wounded back to base hospitals were often commandeered by rebellious troops.'

'As the allied attacks gathered momentum on several sectors throughout August and September, the army began to dissolve' – and Crown Prince Rupprecht noted in his diary at the end of September that it was unlikely that *Fourth Army* would stand up to a serious attack. To further emphasise the severity of the situation, at a meeting on 29 September at Spa, having given an account of the military situation, Ludendorff stated, according to Admiral Hintze, the Foreign Minister, that 'the situation of the Army demands an imme-diate armistice in order to save a catastrophe'. When the Chancellor arrived at the meeting, he was deeply perturbed by the request for an armistice. He tendered his resig-nation; it was accepted. On 1 October, Ludendorff asked Prince Max of Baden to form a government; otherwise Ludendorff himself would ask for an armistice. The next day Major von der Bussche, Ludendorff's liaison officer with the Reichstag, summarised the military situation to the party leaders, and told them that the war was lost, that every twenty-four hours would only worsen the situation.

However, the fighting continued. 'Allied artillery bombardments defied description. To move outside the trenches, even to a nearby crater-latrine, meant instant death.' Opium stopped bowel movements, but the easiest answer was to relieve yourself on a spade and throw it over the parapet.

'The gravity of the position became clear to the troops at the front when they received

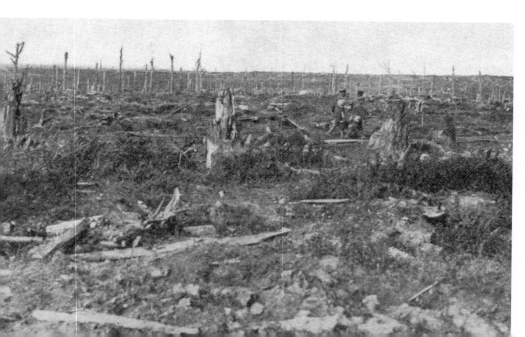

The remains of Hooge wood after the British attacks in October 1918.

the Order of the Day to the German Army and Navy, on 5 October, from the Kaiser. After describing their struggle against superior numbers and the collapse of the Macedonian Front, he ended thus: "Your front is unbroken and will remain so. In agreement with my Allies I have decided to offer peace once more to our enemies; but we will only stretch out our hands for an honourable peace." On the same day the new Chancellor "announced that a step had been made towards peace". On the Home Front "the Chancellor's armistice approach sent a wave of relief and hope through Germany".'

On 9 October, one day after the Siegfried Line had given way, Ludendorff confirmed Hindenburg's statement that the German borders were safe until early 1919. Five days later at a cabinet meeting in Berlin, he 'informed Prince Max that despite the collapsing Flanders front and the imminent fall of Lille, the army could carry out an orderly withdrawal.' All that was needed were more men. He asked for an immediate reinforcement of 600,000 to repair morale and a monthly replacement of 100,000. The replacements were not forthcoming.

Morale reached new lows when 'fresh units moving up to the front were greeted even by the venerable Prussian Guards with shouts of "strike breakers" and "war prolongers". There are few documented cases of open disobedience; the vast majority of those at the front were not prepared to take risks. However, by the end of October *Army Group Gallwitz* reported that thousands of its soldiers were refusing orders to fight. Rupprecht reported discipline problems in his army group. 'The morale of the troops has suffered seriously and their power of resistance diminishes daily. They surrender in hordes, whenever the enemy attacks, and thousands of plunderers infest the districts around the bases.'

The army pulled back under the continual pressure of Allied attacks in what the *MorgenPost* called 'a masterpiece in the history of war'. Militarily it was sensible to retire and, even if the withdrawal had to continue to the Siegfried positions or beyond, there was no need to be anxious. For many men it meant retiring over areas they had previously fought across, in some cases more than once. For the few 1914 men still serving in *16 Reserve Infantry Regiment* it was their third and final visit to the battlefields of Flanders. As for Hitler, not long after his arrival at Comines, he was gassed and sent to recover in Germany.

On 17 October Ludendorff was reported as having a nervous breakdown; on 26 October he resigned. General Groener, Ludendorff's successor, told his staff, at the end of October, 'that the army was disintegrating: between 200,000 and 1.5 million soldiers were either "missing" or had deserted; more than 40,000 "shirkers" were located at Maubeuge alone.' Coupled with this there was the effect of Spanish influenza which affected one in every six Germans in October. As a result of casualties, POWs, shirkers, slackers, missing and general disorganisation as the army broke down, *OHL* could barely muster 'a dozen fully-ready combat divisions between the Belgian Channel coast and the Upper Rhine.'

In late October Rupprecht wrote to the chancellor describing the true state of affairs on his front. 'Our troops are exhausted...In general the infantry of a division can be treated as equivalent to one or two battalions, and in certain cases as only equivalent to two or three companies.' There was a shortage of horses to move the guns and shells for heavy guns were in short supply. Fuel for the lorries was also in short supply and the likelihood of cessation of oil supplies from Romania would put an end to air support.

A German printed card of Leopold Square in Mons. The card was sent to Germany at the beginning of November, days before the British arrived at the town.

MONS Leopoldplatz

It was not just a shortage of men, guns and ammunition. He continued: 'we have no more prepared lines, and no more can be dug.' He concluded his concerns with three simple statements: 'I do not believe there is any possibility of holding out over December', that the 'situation is already exceedingly dangerous, and that under certain circumstances a catastrophe can occur overnight'…so 'we must obtain peace before the enemy breaks through into Germany'. He was also concerned about Ludendorff as the Commander-in-Chief, because he felt that he 'does not realize the whole seriousness of the situation'.

While the army retreated, mutiny broke out among the sailors at Kiel in response to orders to put to sea. The revolt spread quickly to Bremen, Cuxhaven, Hamburg and Lübeck, followed by riots in Coblenz, Cologne, Düsseldorf and Mainz; large numbers of army deserters arriving from the front helped fuel the flames of discontent.

On 23 October, during a debate in the Reichstag 'it was held that Ludendorff's suggestions were unsatisfactory' and that he should offer his resignation. In reply, on 25 October, Ludendorff issued an Order of the Day to the press but not to the government: 'Wilson's answer means military capitulation. It is therefore unacceptable to us soldiers…When the enemy realises that the German front is not broken through…he will be ready for a peace which ensures Germany's future.' The press regarded this as a stab in the back, an idea to be used later for different means.

Ludendorff then decided to go to Berlin, report to the Kaiser and demand that President Wilson's terms be rejected. 'The Chancellor now made up his mind that Ludendorff must be dismissed'. After a discussion with the Kaiser about the military and political situation Ludendorff offered his resignation, which was accepted, although Hindenburg's resignation was not. That evening Austria-Hungary asked Italy for an armistice. On 31 October, Turkey bowed out of the war.

'Towards the end of October evidence of the state of feeling in the Army, the Navy and the Homeland had become too obvious to ignore or conceal. On the 30th October the *18th Landwehr Division* had refused to go into the trenches in Lorraine, and there were signs of disaffection in other divisions; on the 2nd November the reinforcements from the Russian Front for the *Seventeenth Army* mutinied and had to be disarmed by a Storm

134

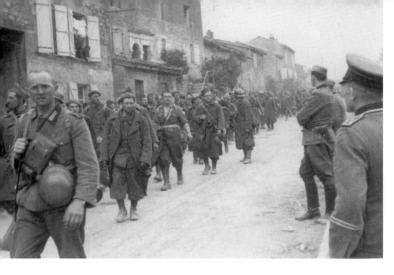

French POWs under very light guard as they march to the rear in May 1940.

battalion, and its Chief of Staff stated that it would not stand another attack. In the back areas wandered thousands of deserters and marauders'.

At home there was a naval rebellion and a population that wanted peace – peace at any price. But the Kaiser refused to abdicate. On 29 October he left Berlin for Spa in Belgium. He offered to march back to Berlin at the head of his troops to defuse any unrest in the capital. The response was not unified. Some wanted him to die honourably at the front leading his men; 'others hoped that he would lead the High Sea Fleet in a "death ride" against the Grand Fleet; and still others wanted him to place himself at the head of his troops and return to Berlin.'

Wilhelm II still believed that the army and the German people would rally to defend his throne. However, at an emergency meeting on 9 November of the fifty most senior commanders, General Groener raised the question of whether the troops would be loyal to the Kaiser, and if they would they fight against the Bolsheviks. Of the thirty-nine present, only one believed in a fight for King and Fatherland. The others rejected the ideas as viable possibilities.

The common response was: 'The troops are fully exhausted at the moment; only the

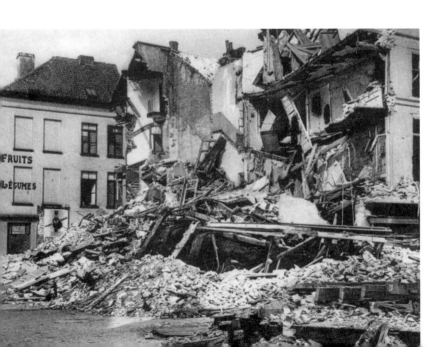

A repeat of the First World War. A 1940 photograph showing the damage to Ostend caused by the German attack.

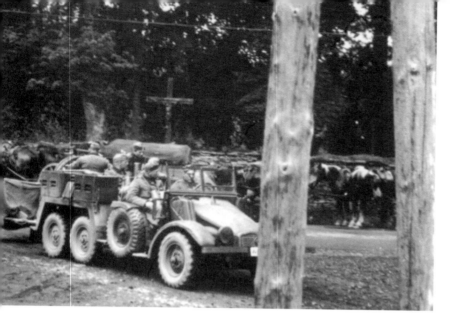

Horses still played an important part in the movement of the German Army through Belgium in 1940. Here a motorised vehicle is pulling a small field gun past resting horses.

ruins are on hand.' Food, rest and clothing were urgently needed. Later that day General Groener informed the Kaiser that 'the army will retire rapidly and orderly to the homeland under its leaders and commanding generals, but not under the command of Your Majesty, whom it no longer supports.' At home, there were mass marches and processions in Berlin and everywhere the cry was 'The Kaiser must go'. Within twenty-four hours, over 500 years of Hohenzollern rule ended when the imperial train carried Wilhelm II quietly across the Dutch border. When the Chancellor announced the Kaiser's abdication there was wild rejoicing in Berlin. Red flags replaced the traditional Hohenzollern flag.

By this time, Canadian cavalry were endeavouring to work round Mons to the south of the town and Third Army had captured Maubege. Both sides knew that the end was near, but the Allies were not relaxing the pressure on the retreating Germans. Similarly German troops were aware that certain towns had tactical importance and were prepared to defend them as long as possible.

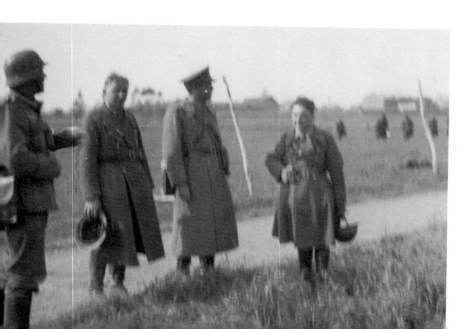

The Great War continued. British Staff Officers taken prisoner in Belgium during May 1940.

Mons was one of those towns: the site of the first battle with the British Army during the war. To the British it had symbolic significance; to the German Army its control was tactical: in their possession, 'the important roads leading from it to Beaumont, Charleroi, Brussels, and Ath could be protected. Hence their determination to make a fight for it.'

The local civilians knew that the Allies were close when on 1 November 'sappers began wiring bridges and tramways for demolition. On the morning of 6 November it became evident that the Germans had conducted a large scale overnight evacuation…later in the day Graf von Bernsdorff, the Head of the *Kommandantur*, and his staff left…to be replaced by an improvised Kommandantur under a Captain.' The Graf left behind a letter thanking the Mayor for his conduct throughout the occupation and for the sensible behaviour shown by the population.

German rearguards on the approaches stood fast and only retired after forcing their opponents to deploy. So stubborn were some of the defenders that, even on the penultimate day of the war, it needed a field gun at point blank range to stop them. To slow down the Allies, bridges had been blown and numerous machine-guns placed to control the roads.

On the far right of the line, guarding the coast, were the *Naval Corps* who also had to be evacuated, taking as much as they easily could transport for further use on the next and final defensive line. Decisions had to be quickly made, as the British were not far away. 'As regards the disposal of the *Naval Corps*, the following plan was arranged: those sections which could be employed in the field, viz. the regiments of able seamen and marines, as well as the transportable batteries of the marine artillery, were to be placed at the disposal of the Army; all the other men were to return to the Navy…Thus the *Naval Corps* in Flanders ceased to exist.'

On 11 November, Mons had been secured. By 0500 hours the town seemed sufficiently clear for the town notables to meet the first Canadian officers to arrive. However, not all the German soldiers had left the town. Some had hidden themselves in houses and were only found when the Allies paraded on the town square later in the day. They were arrested and locked up.

'The cost of defeat was high. In the last nine months of the war, over one million men had been lost and of these nearly 400,000 had been taken prisoner since 18 July.' On 11 November the war came to end with an armistice, and the Germans left the occupied territories, followed closely by their enemy.

A few days later many troops crossed the Dutch border in an eastward direction. Their arms and ammunition were taken away as they crossed over from Belgium. Thousands of troops marched across the Maastricht Corridor and returned to Germany. They were permitted to return to their home garrisons, often with their bands playing and flowers on their uniforms, as they had paraded in 1914.

The Great War was over. However, the seeds of the Second World War had been planted by the defeat. In May 1940 the Germans would once again arrive in Flanders.

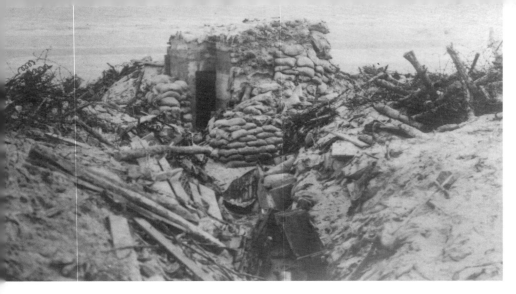

A destroyed British machine gun emplacement on the coast.

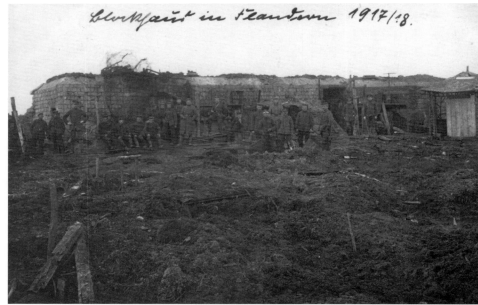

The rear of a soil-covered concrete blockhouse used for living quarters and as a HQ.

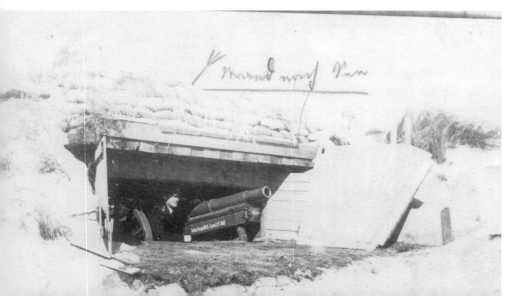

A small calibre naval field gun in the dunes. The wording on the gun is indistinct; ___Korps Artillery ___cm SK Battl.

A company duty office behind the front. The notices on the wall at the left are in French and Flemish.

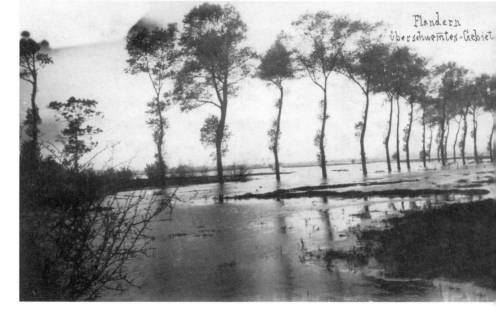

Flandern überschwemtes-Gebiet

Flanders flooding caused by artillery damage to the drainage system.

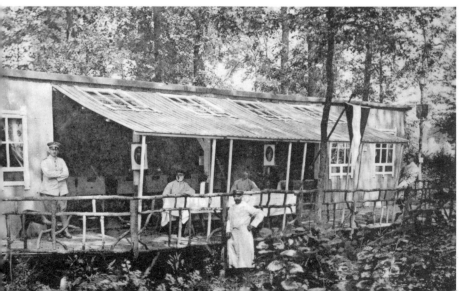

A recuperation facility in the safety of a Flanders wood.

Veerleplaats in Ghent. Well behind the front, the city and villages around it were used as a rest area.

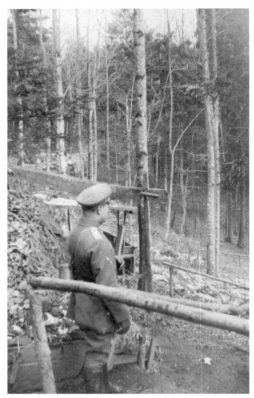

Leutnant Baumann, a machine gun officer, in Wevelgem Forest.

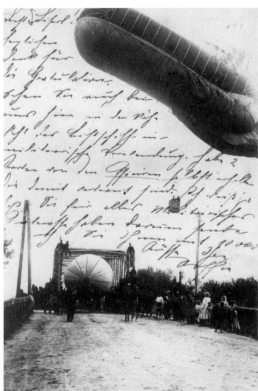

The movement and launching of an observation balloon was achieved using men, horses and wagons. Such balloons provided essential intelligence for the artillery and planners but were easy targets for Allied planes. The observers were provided with parachutes so that they could jump when attacked.

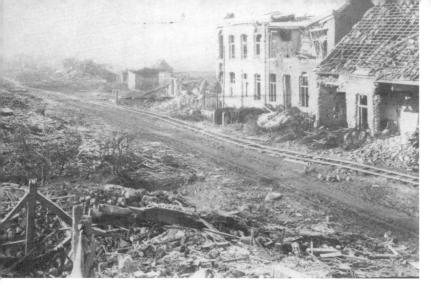

The centre of Moorslede during 1918. The road has been cleared for ease of movement and a narrow-gauge rail track constructed to allow the rapid transport of men and materials as close to the front as possible.

Ostend 1918: Flanders *Marine Corps* personnel in the remains of a trench after it was hit by a naval shell.

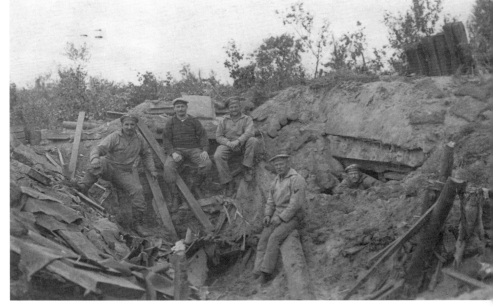

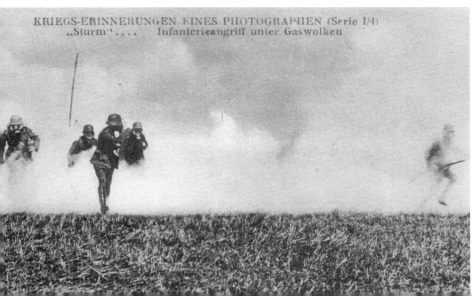

As part of the preparations for the Spring Offensive, many units received special training in movement warfare: this included moving through gas clouds.

Each battalion had its own regimental band. In many cases they would double as medical corps staff to deal with the wounded.

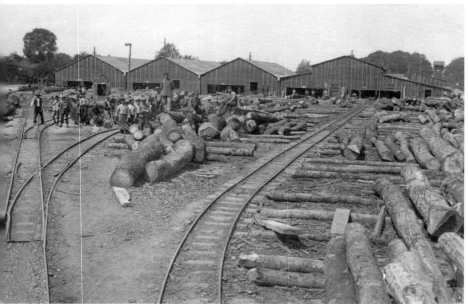

Constructing concrete dugouts and shoring up trenches required huge quantities of timber. As much as possible was taken from local sources to save space on the railways. Again, narrow-gauge rail tracks are in evidence.

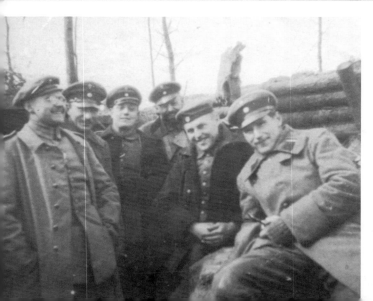

An officer and men relaxing in a communication trench in Flanders.

Wire entanglements as far as the eye can see. Just in case intruders manage to get through, cans are hung to make a sound when the wire is moved.

Resting in a timber dugout on the Ypres Front.

An aerial photograph of Zeebrugge docks after the raid. The ships sunk in the entrance can be clearly seen and there are craters caused by Royal Naval ships firing on the dock area.

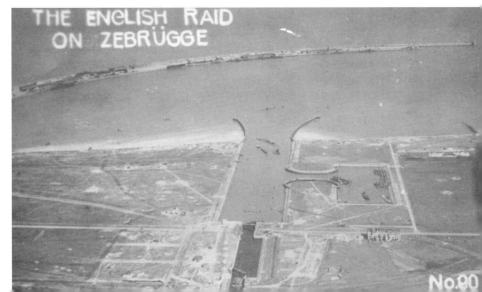

THE ENGLISH RAID ON ZEBRÜGGE

No.90

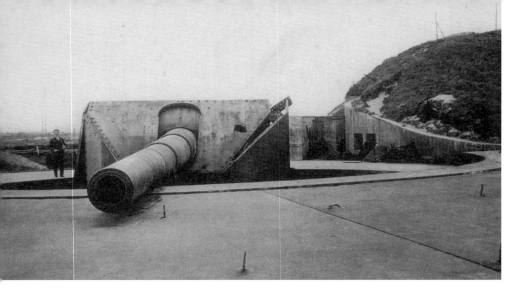

The guns at Knocke-sur-Mer. Batterie Wilhelm II had a maximum range of twenty-three miles.

Soldiers of *22 Bavarian Infantry Regiment* march past King Ludwig III of Bavaria in late February. The photo was taken near Verdun as the regiment were completing training for the attack on Mont Kemmel.

Heavily camouflaged defensive positions in Houthulst Forest. The camouflage effect is aided by the destruction caused by British shelling.

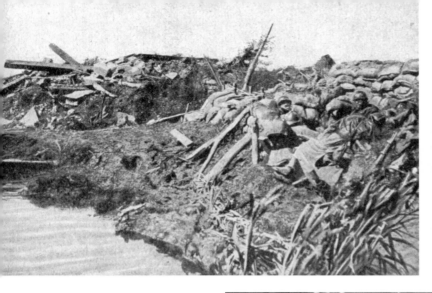

Positions captured north of Ypres by Belgian troops on 8-9 September 1918.

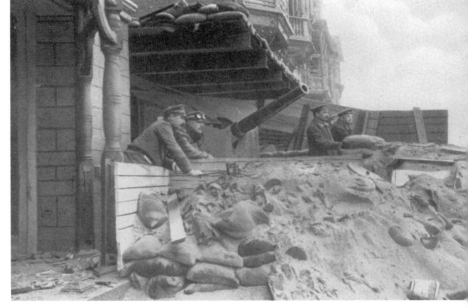

A small calibre coastal gun built into the side of house on the seafront at Ostend.

The sea front at Westende showing a gun emplacement and the damage caused by British naval shelling.

A concert in Roulers Market Square. No civilians are visible in the crowd.

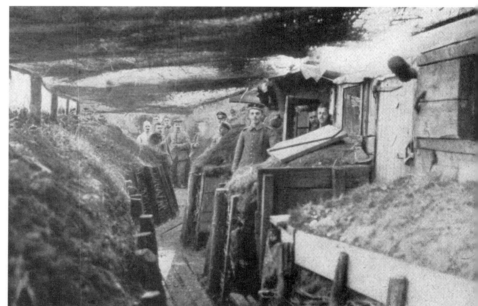

A well maintained concrete dugout with wooden walkways, doors and camouflage.

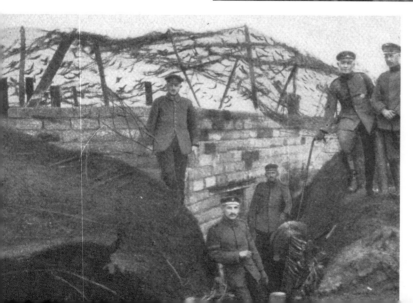

A camouflaged brick and concrete pillbox built into the side of a trench.

As many regiments spent considerable time at the front without being rested, it was essential to provide them with warm food as often as possible. One alternative to transporting food long distances by wagons was to have cookhouses closer to the front. This a concrete cookhouse near Frezenberg, capable of feeding four companies.

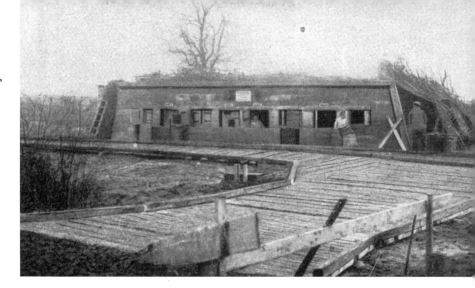

A small concrete cookhouse to feed one company.

A large communications centre built inside a wrecked farmhouse.

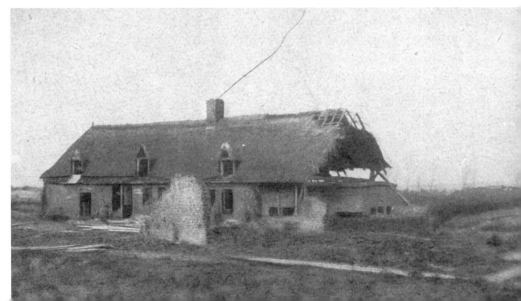

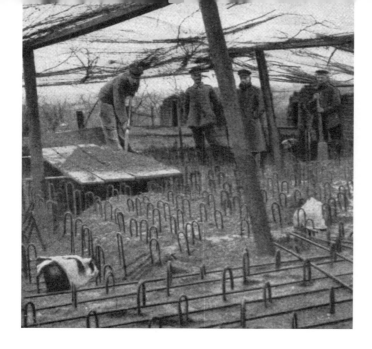

Laying the foundations of a concrete pillbox.

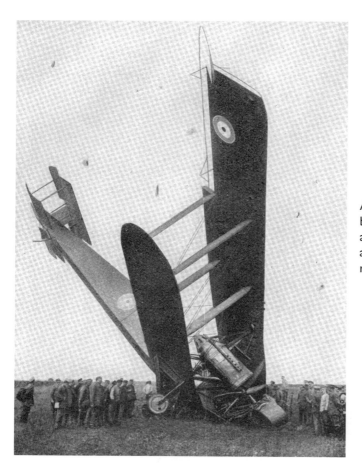

A Handley Page HP.12 0/100 bomber of the RFC. These aircraft usually operated singly at night, bombing docks and rear areas.

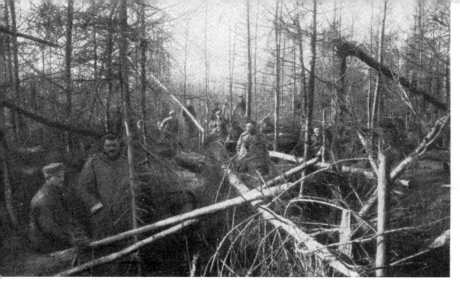

Even though the forest provided natural camouflage, these troops are attempting to hide their positions further.

The remains of a German field gun after a British counter-battery barrage.

Rear area dug-outs built into a hillock in the woods near Vlaa.

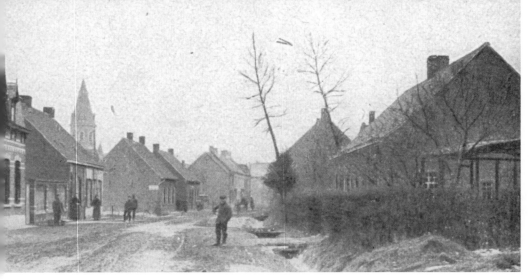

The main street of East Nukerke village during February 1917. A cosy billet in the rear areas that still housed some civilians.

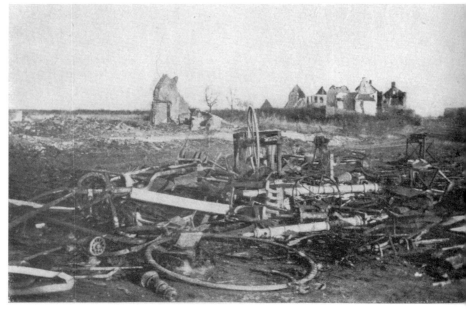

An unusual collection of metallic debris in No Man's Land somewhere in Flanders.

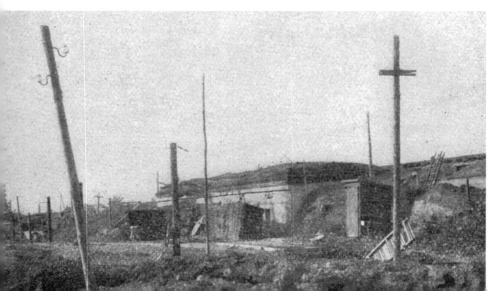

As well as buildings for headquarters, defensive positions and cookhouses, concrete was used to provide a relatively safe working environment for medical staff. This is a hospital dug-out at Wervik.

A view of the inundations from the German side, showing how little defensive work was needed to protect the front line.

Unlike the Allied Powers, the German Army quickly ran short of certain metals, making recycling very important. In this photo, troops have loaded spent artillery cases on to rail wagons for refilling or melting down depending on their condition.

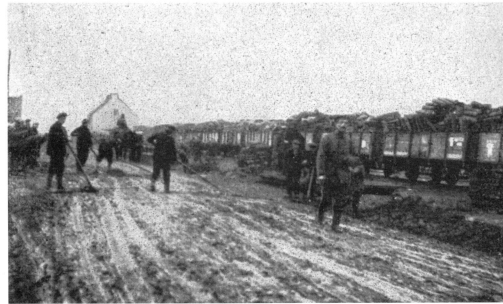

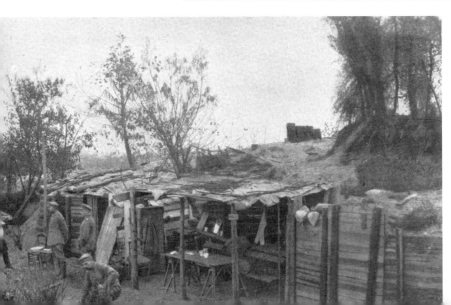

Well constructed and dry living quarters in the dunes.

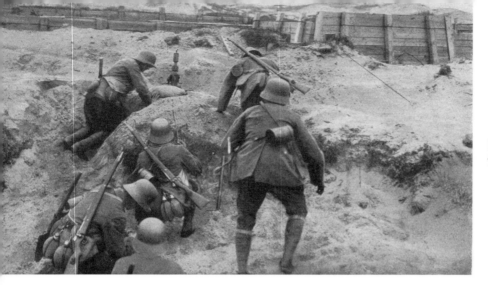

Marine infantry training for their next attack.

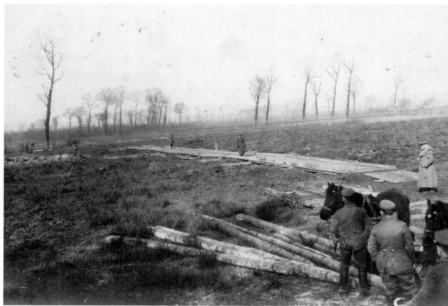

The damage to the drainage system caused by shelling made many areas difficult to traverse. Here a solution to the problem is about to be tried out. Horses and men wait to test the new structure.

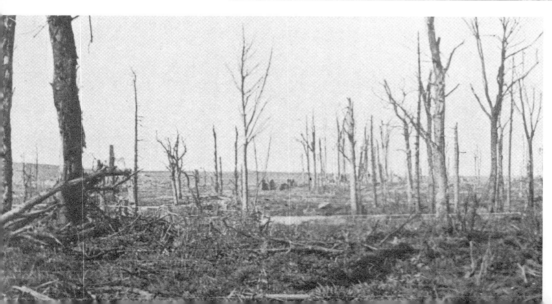

Mont Kemmel at the end of the war.

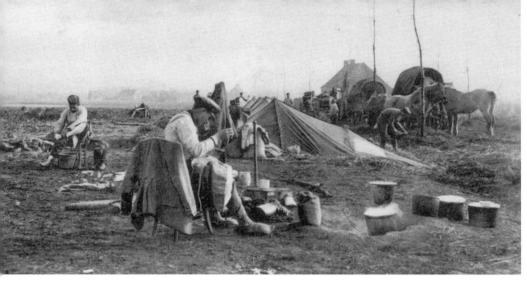

A postcard captioned 'Morning toilet with the baggage in Flanders'.

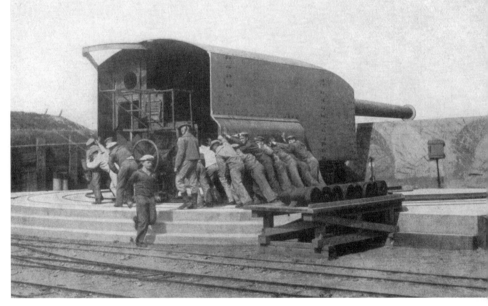

A large calibre turreted naval gun being manhandled into position.

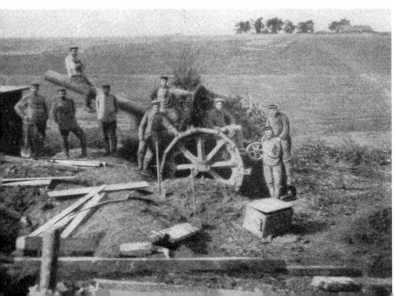

A field gun still in position after a British counter-barrage. The men are looking at the effects of a near miss on their position.

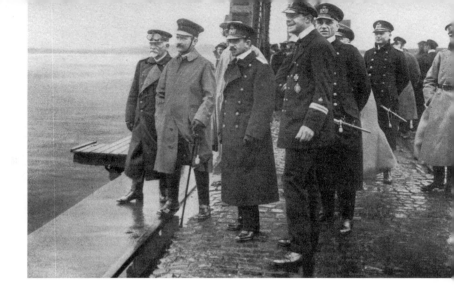

Reichschancellor Georg Michaelis inspecting the damage caused at Zeebrugge, on 28 April, by a Royal Navy landing party.

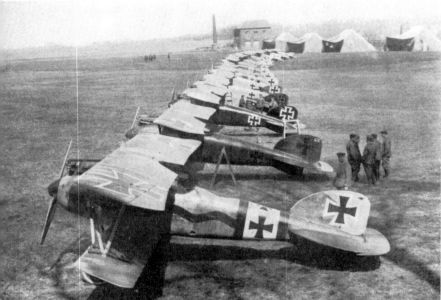

A squadron of Albatros D.Vs wait for the next patrol. The D.V was the final development of the Albatros D.I family, and the last Albatros fighter to see operational service.

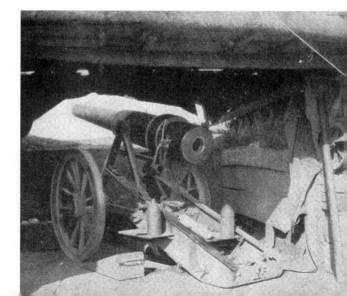

A field gun ('ring kanone' on the original caption) in its emplacement. Note the shells on the gun platform.

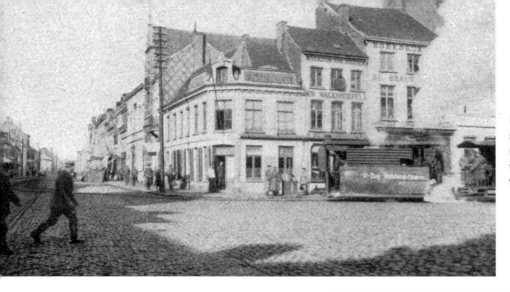

Roulers station with a narrow gauge train leaving for Ypres.

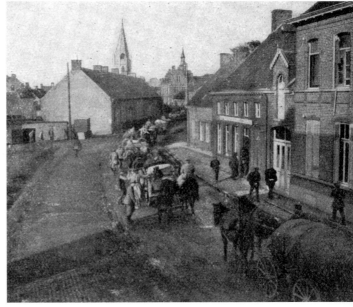

Somewhere in Flanders a supply column makes its way through an unscathed town on its way to divisional headquarters.

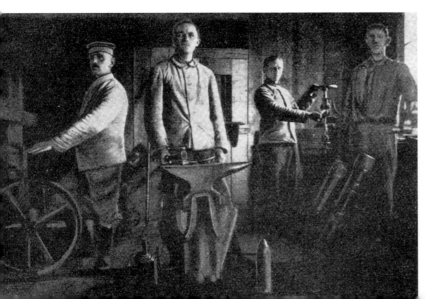

As resources became ever scarcer, repair and recycling increased in importance. If it could be mended, mend it. This is a brigade mortar repair depot putting a small trench mortar back in working order.

Everything had to be manhandled to the front and often in very difficult conditions. Here the base plate for a small trench mortar is being carried to a new position. As trench mortars were seen as an annoyance by both sides, they were often the target of controlled barrages once they were identified. This meant moving regularly, leaving the infantry to deal with the inevitable rain of shells.

The remains of a Flanders wood taken from the German front line.

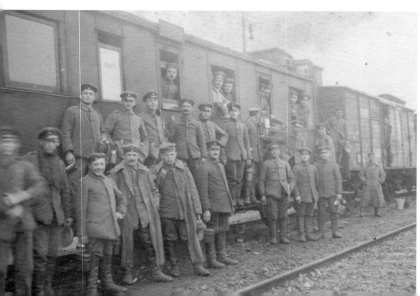

Returning from rest, soldiers pose before collecting their rations from a wayside stop.

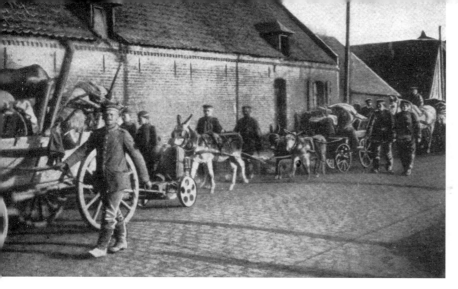

Troops leaving the combat area for a period of rest, refitting and further training. Any wagon that is able to carry equipment has been pressed into service, similarly any animal that can pull is pulling.

The sunken block-ships that were supposed to stop the harbour being used went down in the wrong place. Overall there was only minor stoppage to the use of Zeebrugge as an offensive port.

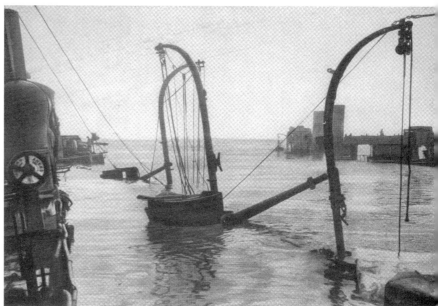

Chronology of the Flanders Front 1917 – 1918

1917

28 January	Crown Prince Rupprecht demands a voluntary retirement to the Siegfried Stellung as a result of the British pressure on the Ancre. Retirement vetoed by German *OHL*.
1 February	Army now has fifteen assault battalions and two companies of Stosstruppen. Each infantry company to receive three Bergmann Light Machine-guns. Infantry wearing winter white uniforms unsuccessfully raid British positions near Wytschaete. Temperature falls below zero degrees Fahrenheit.
4 February	Operation Alberich authorised by the Kaiser: retirement to the Siegfried Stellung between Soissons in the south and Arras in the north; 65 miles long with average depth of 19 miles; whole area to be given the scorched earth treatment. Objective: release thirteen divisions in to the reserve and shorten the front by twenty-five miles.
9 February	Operation Alberich begins on the Somme: demolitions and programmed removal of material and remaining civilian population.
15 February	Trench raids on British positions west of Messines and north east of Ypres.
19 February	British trench raid east of Ypres results in 114 men being taken prisoner.
22 February	Retirement to Siegfried Stellung accelerated due to British pressure, with a preliminary withdrawal of three miles on a fifteen- mile frontage.
25 February	General Sixt von Arnim takes over command of *Fourth Army* from Duke

	Albrecht of Württemburg who now commands an army group in Flanders.
1 March	*Fourth Army* on Belgian coast becomes part of *Rupprecht's Army Group* while units on left of *Rupprecht's Army Group* join newly formed *Albrecht Army Group. Seventh Army*, from *Rupprecht's Army Group* leaves to join *Crown Prince's Army Group.*
8 March	Five raids on British trenches north of Wulverghem.
16 March	Synchronised retreat to Siegfried Stellung begun by thirty-five divisions.
21 May	British begin bombardment of Messines Ridge with over 2000 guns.
26 May	First American troops disembark in France.
31 May	Start of week of artillery duels round Wytschaete and Ypres.
1 June	BEF has taken 76,067 POWs during Flanders offensive. In response to British threat Rupprecht transfers ten divisions from the quieter sector from Lens to Lille.
3 June	British artillery at Messines begin a feint creeping barrage that draws German guns for counter-battery retaliation.
7 June	British attack at Messines Ridge on a nine mile front captures the Messines-Wytschaete ridge after exploding seventeen mines under the ridge (two of the planned nineteen mines failed to explode). Commander of *Gruppe Wytschaete* sacked as a result and over 6000 men captured.
8 June	British repulse counter-attacks east of Messines Ridge forcing withdrawal to a new line running through Warneton.
14 June	Counter-attack south-east of Ypres repulsed by British troops.
21 June	British begin operations on the Flanders coast.
27 June	'Long Max' 15 inch gun at Luegenboom fires fifty-five shells at Dunkirk.
5 July	Slight British advance south of Ypres.
6 July	French Yser bridgeheads taken over by British troops who are shelled with 300,000 shells of high explosive and gas.
9 July	Slight British advance in Messines sector.

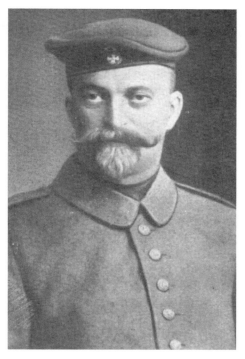

Gefretier Georg Michlbauer, of a Bavarian Reserve Infantry Regiment, had been a farmer before the war. He was thirty-six when he was killed by artillery fire on 13 May 1917.

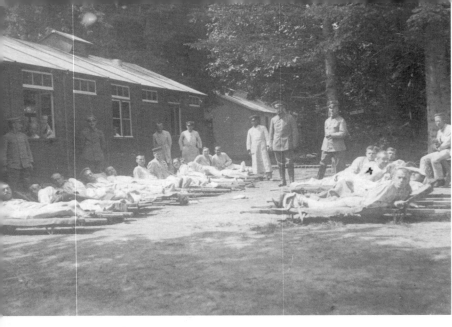

With the number of casualties during the British offensive in Flanders, many had to be sent to field hospitals in other sectors. Here lightly wounded men enjoy the sun at Mérignies.

10 July	Fifteen battalions attack on Nieuport, and marines advance near Lombaertzyde on a 1400 yard front east of the Yser mouth, taking over 1000 POWs. Some attacks repulsed.
12 July	First mustard gas attack on Ypres – 50,000 rounds fired, gassing nearly 2,500 but killing under 100.
14 July	Over the following three weeks, British positions between Nieuport and Armentières are shelled with one million rounds of mustard gas.
17 July	Start of British bombardment using 3,000 guns which expended four and a quarter million shells over the following ten days, of which 100,000 were gas shells. Given such an onslaught the *Fourth Army*, led by Arnim, fully expected an imminent offensive: the element of surprise was entirely absent.
19 July	British positions around Nieuport attacked.
21 July	Artillery duels along the front.
27 July	British occupy 3,000 yards of front-line trench and beat off all counter-attacks.
29 July	Artillery duels along the front.
31 July	When the attack is launched across an 18 kilometre front, *Fourth Army* was in place to hold off the main British advance around the Menin Road, and restricted the Allies to fairly small gains to the left of the line around Pilckem Ridge. Similarly the French were halted further north by the *Fifth Army* under Gallwitz.
1 August	St. Julien recaptured from British and further gains made near Ypres-Roulers rail line but French not held on west bank of Yser Canal.
2 August	British retake positions on Ypres-Roulers rail line. Battle for Pilckem Ridge ends after British have advanced 3000 yards. Waterlogged shell holes begin to appear.
3 August	British recapture St. Julien after heavy losses. *2 Guard Reserve Division* reduced to just over 1600 men fit for duty.

5 August	Initial assault on British positions at Hollebeke successful but troops are unable to hold against counter-attacks.
8 August	Heavy rain throughout the day. French gain ground northwest of Bixschoote.
10 August	Start of second major attack resulting in the loss of Westhoek, Glencorse Wood and Inverness Copse to the British, while the French advanced east and north of Bixschoote.
11 August	Counter-attack recaptures part of Glencorse Wood.
16 August	British advance on a nine mile front north of the Ypres-Menin road and cross the River Steenbeek during the Battle of Langemarck. Counter-attacks push British back a little but Irish divisions pushed back to their start line. Drie Grachten bridgehead on the Yser canal taken by a French Marine battalion.
17 August	French attack east of Bixschoote successful.
19 August	Twelve-tank attack on positions on the Ypres-Poelcapelle road successful, capturing pillboxes at St. Julien; retaken by counter-attack but troops unable to hold positions against further British attacks.
20 August	General Kuhl, Chief of Staff to Rupprecht reports that since 31 July seventeen divisions are 'verbraucht' (used up). Further British attacks using tanks.
22 August	British capture and hold Glencorse Wood but other attacks using tanks are held, with attacking troops gaining only a few hundred yards for heavy losses.
23 August	Some minor British successes.
31 August	British shell Menin Road Ridge defences. Some advanced British posts north of St. Julien – Poelcapelle road captured.
3 September	Slight British advance near St. Julien.
6 September	Successful counter-attack against British at Frezenberg.
13 September	Unsuccessful attack on British positions near Langemarck.
15 September	Strongpoint north of Inverness Copse lost to British attack.
20 September	Large scale British assault with tanks and eight-hour creeping barrage on the Passchendaele-Gheluvelt line in an attempt to take the high ground between Ypres and Roulers-Menin railway. In spite of eleven counter-attacks, Inverness Copse, Glencorse Wood, Veldhoek and part of Polygon Wood are taken.
21 September	British take over two thousand POWs over the first two days of the

Thirty-five year old Unteroffizier Xaver Peter was a carpenter before the war. He was killed in Flanders on 5 August 1917 while serving with a trench mortar detachment.

	attack. British repulse attacks on Tower Hamlets Ridge.
25 September	After initial successful penetration of British positions in Tower Hamlets and Polygon Wood, troops retire.
26 September	British attack, with tanks, on Polygon Wood, takes all planned positions and smashes three Eingreif (intervention) divisions in four counter-attacks, taking over 1,500 POWs.
27 September	Australian troops recapture Polygon Wood and seven counter-attacks fail to push the British out of lost positions east of Ypres.
29 September	First tank unit formed with 113 men and five A7Vs, but captured British tanks preferred.
30 September	British positions between Tower Hamlets and Polygon Wood attacked with flame-throwers. British claim to

Georg Eberl was an NCO in *Bavarian Reserve Infantry Regiment 2*. He had served at the front for three years when he was killed on 11 September 1917.

	have taken 5,296 POWs and eleven artillery pieces during the month.
1 October	Army strength in the west now 147 divisions with 12,432 artillery pieces. Five counter-attacks against British positions in the Ypres salient between 1 and 5 October are unsuccessful and result in over 4,400 men being taken POW.
2 October	Artillery duels along the front.
3 October	Fighting at Polygon Wood ends.
4 October	Using twelve tanks which helped take Poelcapelle, British troops attacked (in drizzle, without a warning bombardment) Broodseinde Ridge on an eight mile front gaining on average less than half a mile. Heavy losses defending the ridge resulted in a change of tactics for defence; fewer troops in the front line and an advanced zone of mobile troops positioned in 'No Man's Land' to slow down advancing enemy infantry and provide the artillery with easier targets. British troops reach the crest of Ypres Ridge.
7 October	British positions near Reutel attacked.
9 October	British gain crest of Broodseinde Ridge on a six mile front and reach the south edge of Houthulst Forest taking 2,000 POWs. Rain breaks drainage system on Passchendaele Heights. British positions south of

	the Ypres-Staden rail line attacked on a 2,000 yard front.
10 October	French attack up Corverbeck Valley.
11 October	Counter-attack on French positions east of Dreibank repulsed. Rupprecht informs *OHL* that it may be necessary to withdraw so far back that the enemy artillery would have to be completely redeployed.
12 October	Anzac Corps attacks Passchendaele, north east of Ypres, on a six mile front in heavy rain and deep mud. Twelve divisions, moved from the Eastern Front to Italy, diverted to Flanders to replace losses.
13 October	Artillery duels along the front.
20 October	Australians replaced by Canadians in the salient.
22 October	Anglo-French advance, on 2½ mile front, astride Ypres-Staden railway. *Seventh Army* counter-attacks in Ypres Salient. Southern end of Houthulst Forest lost along with 200 POWs.
23 October	*Seventh Army* counter-attacks continue. Part of Houthulst Forest retaken.
24 October	Southern end of Houthulst Forest lost to counter-attack.
26 October	Heavy fighting in the Passchendaele sector with the enemy's main thrust against Houthulst Forest and Poelcapelle. The attacks, carried out in the rain, gain 1,000 yards on a 2,800 yard front towards Beclaere,

Twenty-two year old Wilhelm Widmann was a musician before the war. He was killed in action on 26 October 1917.

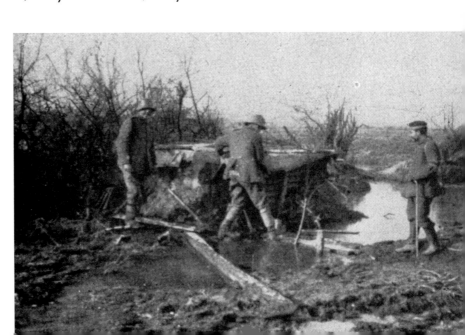

Attempting to cross the mud of the Becelaere battlefield in October 1917. The sinking building is a concrete blockhouse. Many men slipped and disappeared in such conditions.

	Passchendaele, Gheluvelt and Zandvorde including the rising ground south west of Passchendaele.
27 October	Belgian and French troops penetrate up to 1¾ miles on Ypres-Dixmude Road.
30 October	Passchendaele entered but after five counter-attacks most of the town is retaken.
4 November	Trench raids along the front.
6 November	A day of losses: Goudberg and Mosselmarkts, Passchendaele captured by Canadian troops and Merckem captured by the French.
10 November	Despite three counter-attacks, Canadian troops advance 500 yards along main ridge east of Passchendaele. Allied advance since 31 July amounts to 4½ miles.
13 November	All bombardment and assaults on Allied positions in the Ypres Salient fail. Belgians raid trenches to the south east of Nieuport.
14 November	North west of Passchendaele, British consolidate their positions, and counter-attacks against their positions to the north of Menin Road and north east of Passchendaele are repulsed.
16 November	Artillery duels along the front.
17 November	Anglo-French trench raids across the Flanders Front.
19 November	Trench raids on the British sector.

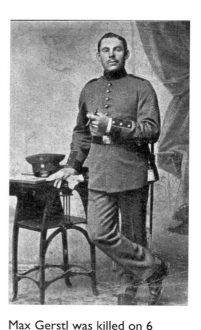

Max Gerstl was killed on 6 November 1917 during an artillery barrage.

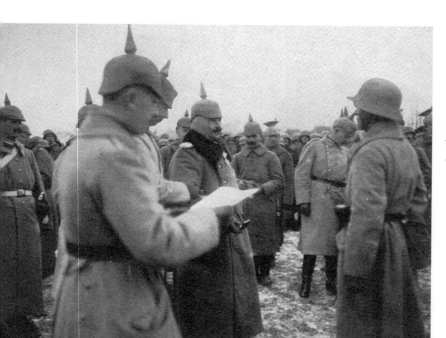

Flanders, 23 December 1917. The Kaiser is presenting Iron Crosses.

26 November	Artillery duels around Ypres.
30 November	Casualties since start of Allied offensive on 31 July around 400,000.
3 December	Some British gains south of Polygon Wood.
13 December	Skirmishing in places along the front.
14 December	Part of the British front trench near Polderhoek Château captured.
15 December	Ludendorff urged to continue with his scheme for a Flanders offensive by Kuhl.
20 December	In fog, British advanced post west of Messines is captured.
22 December	Some British advanced posts are stormed on the Ypres-Staden rail line.

Michael Stegbauer, serving in a Bavarian infantry regiment, was nineteen when he died of a head wound. He was an underage soldier when he went to the front in 1914.

1918

10 January	Trenches around Ypres raided by the British.
21 January	Spring offensive decision taken by Ludendorff with a start date of 14 March.
23 January	After storming French positions east of Nieuport, the positions are lost to a counter-attack.
1 February	Captain Bomschlegel restores thirty British tanks captured at Cambrai to operational status.
10 February	Thirty-three POWs lost to a strong Australian trench raid on Warneton.
12 February	Some skirmishing around Passchendaele.
13 February	Ludendorff promises victory to the Kaiser.
22 February	Trench raid on British positions on the Ypres-Staden line.
28 February	Western Front strength now 180 divisions and general training over.
1 March	Final preparations begin with advance parties moving up.
3 March	Trench raids in Flanders.
5 March	New highly secure five-letter cipher introduced prior to offensive. Belgian counter-attack north of Pervyse.
6 March	Night raid on Belgian positions near Ramscapelle is repulsed.
9 March	British front line, from Ypres to St. Quentin, bombarded with 1,000 tons of mustard and Phosgene gas.
10 March	Operation Michael ordered by Hindenburg.
13 March	British capture strong point south east of Polygon Wood and Australians raid positions near the Ypres-Comines Canal.

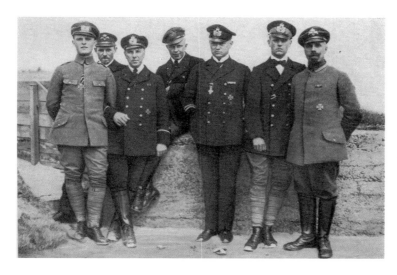

Officers of the Zeebrugge garrison pose confidently the day after the British attack.

18 March	Belgians repulse the three heavy local attacks on the Yser front.
19 March	190 divisions now available on the Western Front.
21 March	Operation Michael commences. In the Artois region, British fire fifty-seven tons of Phosgene shells on positions near Lens.
8 April	Whole British front in Flanders shelled.
9 April	Georgette offensive against British with the aim of opening up the way to Calais. After 4½ hour hurricane shelling, fourteen divisions of the *Sixth Army* attack on a ten mile front at 0845 hours. Portuguese 2 Division overwhelmed and 6,000 POWs taken, driving a wedge 3½ miles deep into the British lines. British take some POWs.
10 April	Messines Ridge recaptured.
11 April	Large numbers of British POWs taken throughout the day. Hill 63 taken from British.
12 April	Offensive slackens a few miles from Hazebrouck. Two days after the capture of Armentières, the Kaiser visits the town in readiness for the victory in Flanders.
13 April	Ludendorff sacks *II.Bavarian Corps* commander after his unit's failure in the Flanders offensive.
14 April	Massed attacks on Australian positions fail, as do seven attacks near Merville.
15 April	*Alpenkorps* and two other divisions capture Bailleul and Wulverghem. British pull troops from Passchendaele Ridge.
16 April	Passchendaele reoccupied and Meteren and Wytschaete taken with over 1,000 New Zealand POWs, but retaken by Allied troops later in the day.
17 April	Flanders offensive continued but, despite capture of Meteren and Wytschaete, the fighting is inconclusive. Start of a two day battle for Kemmel Ridge. Belgians take 700 POWs north west of Dixmude.
19 April	A lull in the Flanders attacks with only minor actions during the day.

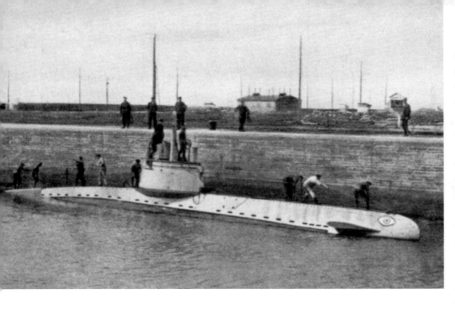

UB1 type mine-laying submarine. This is thought to be UB16 which was ordered in November 1914 and laid down in Bremen in February 1915. *UB-16* was a little under 92 feet (28 m) in length and displaced between 127 and 141 metric tons (140 and 155 short tons), depending on whether surfaced or submerged. She carried two torpedoes for her two bow torpedo tubes and was also armed with a deck-mounted machine gun. *UB-16* was broken into sections and shipped by rail to Antwerp for reassembly, being launched in April 1915 and commissioned as SM *UB-16* in May.

20 April	Allied positions on the Kemmel – Ypres sector bombarded with various types of gas totalling nine million rounds by the end of the shelling.
23 April	Zeebrugge raid by British Dover Patrol.
25 April	French positions on Kemmel Hill captured in just five hours by seven divisions.
26 April	Attacks on Allied positions at Voormezeele to the south of Ypres repulsed; French lose Locre village to the west of Kemmel but counter-attack and retake the village.
28 April	French hold Locre village against counter-attack and assault on Belgian positions at Langemarck is repulsed.
29 April	Thirteen-division attack on a ten-mile front captures Scherpenburg (knoll two miles north west of Mt. Kemmel) from the French and a two mile stretch of the British-held Salient outpost line three miles south of Ypres, but offensive suspended at 2200 hours.
30 April	Operation Georgette, the Flanders offensive, halted and put on hold to await the results of the a major diversionary offensive (Operation Goerz) against the French to draw Allied reserves away from Flanders. If successful Ludendorff plans a heavy attack on the British in the salient.
1 May	Now 204 divisions on the Western Front. Ludendorff orders Aisne attack. The French make small gains near Locre and repulse a raid to the south.
4 May	Allied positions in Locre and south of Ypres heavily shelled.
5 May	Artillery duels and widespread skirmishing along the Flanders front.
6 May	French positions south of Locre raided.
9 May	Allied positions in La Cytte-Voormezeele sector attacked. British naval raid on Ostend.

19 May	French attack near Locre takes 400 POWs, and British raid trenches south-west of Meteren.
24 May	British positions in the Nieppe Forest (French Flanders) shelled with gas.
29 May	Attack on French near Mt. Kemmel repulsed.
1 June	Between 1,000 and 2,000 flu cases per division recorded a month.
26 June	British active in French Flanders.
28 June	Substantial British raid in French Flanders advances a mile on a three mile front.
30 June	1919 class of recruits almost used up as reinforcements.
3 July	OHL informs Rupprecht that The Hagen Offensive will be carried out and that the Kurfürst offensive will be got ready.
6 July	Ludendorff informs Kohl, Rupprecht's chief of staff, that all Hagen preparations are approved but there will be a diversionary attack before the real offensive.
8 July	Last French troops leave the Salient.
11 July	Because of the number of influenza cases, Rupprecht seriously considers postponing the Hagen attacks.
18 July	Morning conference between Ludendorff, Rupprecht, army commanders and their staffs about the final offensive. Hagen, now scheduled for early August, is thrown into confusion by news of serious problems on the Marne. Ludendorff cancels transfer of Bruchmuller's artillery to Flanders and sends Flanders offensive divisions to assist on the Marne.
19 July	British recapture Meteren.
20 July	Ludendorff informs Rupprecht that, because of the drain on troops caused by the Marne offensive, Operation Hagen 'will probably never come into operation.'
8 August	British major offensive at Amiens.
9 August	British advance in French Flanders.
11 August	Ludendorff offers his resignation to the Kaiser (who refuses it), and tells him that Germany has nearly reached the peak of its ability to resist and that 'the war must be ended'.
14 August	Crown Council decides victory in the field now most improbable. Ludendorff recommends immediate peace negotiations.
15 August	Rupprecht warns Prince Max of Baden that the military situation has deteriorated so rapidly that the army may not hold out over the winter and could collapse even sooner.
18 August	Further British advances in French Flanders.
31 August	Mount Kemmel evacuated.
1 September	British capture Neuve Église and Wulverghem. Ludendorff issues order for 2nd phased retirement to the Hindenburg position.
4 September	British capture Hill 63 and Ploegsteert.
6 September	Evacuation of Lys Salient completed. Hindenburg stresses gravity of the situation at an OHL conference. General Boehn recommends a forty-

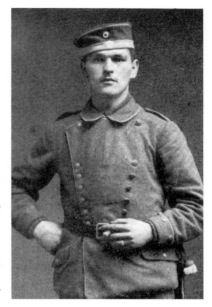

five mile withdrawal to the Antwerp-Meuse position but the decision was made to halt, if necessary, on the Hermann-Hunding-Brunhild line, only twenty miles back.

7 September	Skirmishing in French Flanders.
15 September	Construction of Hermann Line begins behind *Army Group Boehm* and *Army Group Rupprecht*.
18 September	Ludendorff warns Admiral Scheer of the plans to abandon the Flanders coast.
28 September	Hindenburg and Ludendorff agree that Germany must request an immediate armistice. Allied Flanders Group of twenty-eight divisions (twelve Belgian, ten BEF and six French) advances on a twenty-three mile front after a three hour barrage taking Houthulst Forest and Wytschaete. BEF attack results in the capture of Gheluvelt and Messines and a general advance of up to six miles in places.

Johann Seibold, a Gefreiter in *8 Bavarian Chevaulier Regiment,* was the holder of the Iron Cross and Bavarian Military Service Cross. He had served at the front for thirty-six months before his death on 9 September 1917.

29 September	Kaiser approves Hindenburg's and Ludendorff's request for an armistice. Although evacuated the next day, the defenders beat off nine Belgian attacks on Westroosebeke, but Belgians capture Dixmude.
30 September	British continue to advance towards Menin.
1 October	Ludendorff cables government to transmit peace offer. Parts of French Flanders evacuated.
2 October	Reichstag party leaders informed that the constant Allied attacks make it impossible to form any reserves and that the losses can no longer be made good. The army is still able to inflict heavy losses on the enemy but cannot win the war. Every day reduces the likelihood of acceptable peace terms, especially if they follow a scorched earth policy. In Flanders the Allied offensive stops short of its key objectives – Menin and Roulers Junction.

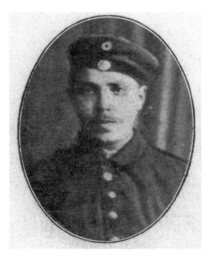

Infantryman Michael Bergbauer was a cottager's son from Windsprach in Bavaria. He was nineteen when he was killed fighting in West Flanders on 1 October 1918.

Lorenz Böck, Iron Cross Second Class and Faithful Service Cross winner, was killed in action on 6 October 1918 at the age of twenty. He was serving with *6 Company* of *3 Bavarian Reserve Infantry Regiment* in *1 Bavarian Reserve Division* on the Roulers sector.

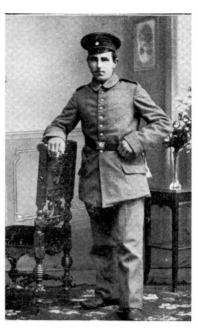

7 October	Coastal guns start being moved back to new positions.
10 October	Battle of Flanders Ridge ends.
11 October	Pressure on flanks forces army into a general withdrawal between the Rivers Oise and Meuse to take up positions in the Hunding-Brunhild Line. Army and Marine troops hasten evacuation of coastal bases and defences with ships and aircraft leaving.
12 October	Hindenburg warns troops that favourable armistice terms depend upon their continued and successful resistance.
14 October	Allied troops renew their offensive between Dixmude and the River Lys taking 12,000 POWs and advancing eighteen miles. Roulers Junction taken by French troops assisted by tanks.
15 October	Allied troops reach Menin.
16 October	Dunkirk shelled for the last time during the war. Lance Corporal Hitler wounded by a British gas shell.
17 October	Belgians reoccupy Ostend. Ludendorff demands a fight to the finish, denouncing Wilson's second note and stating that an Allied breakthrough is unlikely; he points out that there is only a month of campaigning weather left. With reinforcements and a withdrawal to the Antwerp-Meuse Line, the army would be ready in the spring to continue the war.
19 October	Belgians take Bruges and Zeebrugge.
20 October	Belgian coast now in Allied hands and Belgian troops on Dutch frontier.

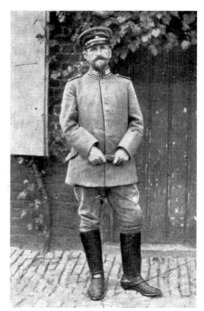

Anton Paintner, a veterinary reserve officer, was wounded during a bombing attack on 10 November and died of his wounds on 15 November 1918.

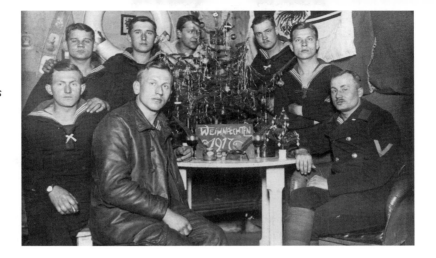

Sailors of the *Flanders Naval Corps* pose formally during the Christmas 1917 celebrations.

25 October	British take Ooteghem.
26 October	Ludendorff resigns and is succeeded by Gröner. Hindenburg's resignation is refused by the Kaiser.
31 October	British take 1,000 POWs at Tieghem. Since 14 October British have taken 19,000 POWs and advanced thirty-one miles.
3 November	Belgians reach outskirts of Ghent.
5 November	*OHL* orders general retirement to Antwerp-Meuse positions and general retreat from the Meuse to Condé on the Scheldt begins.
8 November	Armistice delegation, led by Erzberger, sees Foch at 0900 hours and refers terms to Berlin at 1300 hours. Senior commanders tell Chancellor that army cannot be relied upon to suppress uprising at home. Troops retire from Oudenarde-Tournai-Condé (the Hermann position). British patrols cross the abandoned bridgehead west of Antoing-Tournai and cross the river.
9 November	Kaiser abdicates after being informed that the army will march back home under its own generals in good order but not under his leadership.
10 November	Chancellor radios Armistice delegation after 1800 hours to sign. Belgians reoccupy Ghent.
11 November	Armistice signed.
13 November	Troops begin retreating from Belgium through Dutch Limburg.
14 November	Retreating troops blow up an ammunition dump at Jamioulx, south of Namur.
18 November	Brussels reoccupied by the Belgians. Retreating troops, although warned by Foch that such occurrences must not happen, blow up an ammunition dump at Beez, east of Namur.
19 November	Antwerp reoccupied by Belgians.
26 November	Last troops cross Belgian border back into Germany.
30 November	Belgians occupy Aix-la-Chapelle (Aachen) and set-up their HQ before moving on in the next few days to occupy Julich, Crefeld, and München Gladbach.
19 December	Dutch Foreign Minister reports to parliament that 70,300 German soldiers have passed through south Holland since the Armistice and that each was disarmed and all baggage was searched for war material.

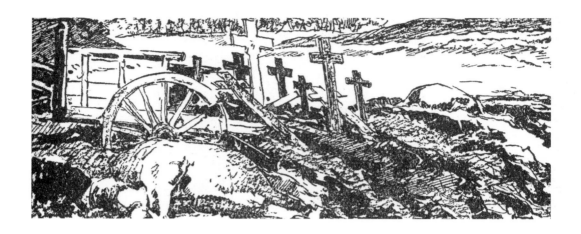

Histories of the Divisions that fought in Flanders

Military history is mostly written about the movement of units, some large, some small, with personal experience added where relevant, but rarely dealing with the history and origin of the troops involved.

With a population of over sixty-five million, the army was able to expand rapidly initially from ninety-two divisions at the start of the war to over 200 by the armistice. A brief history of those divisions that fought in Flanders is detailed below. This record details both the transient and permanent divisions on the Flanders Front.

1917

Bavarian Ersatz
Originally formed from Bavarian replacements in August 1914, it later became a mixed unit with troops from Baden and Württemberg, as well as Bavaria.

It arrived from France on 1 September and was engaged on both sides of the Ypres-Menin Road until 25 September; one battalion was almost totally destroyed in the fighting on 20 September. At the beginning of October the division was sent to Russia.

1 and 2 Naval
In April 1917, the three naval infantry regiments were withdrawn from *1* and *2 Naval Divisions* to organise a new division, *3 Naval Division*. These regiments had already formed

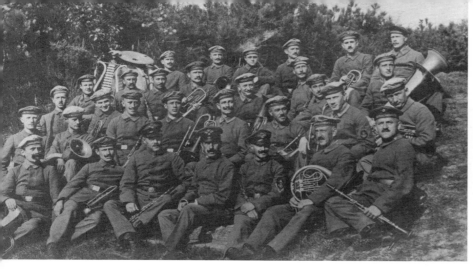

October 1917 - Greetings from Flanders sent home by a marine regiment band member.

a provisional division, from the end of September 1916 to January 1917, when they were engaged on the Somme.

1 Guard Reserve

After fighting in France it returned to Flanders on 1 June. A week later it relieved *3 Bavarian Division* before being pulled out of the line on 12 June for a period of rest.

It was regarded as an average division and not to be feared. By this period, the personnel were of a lower fighting quality than at the beginning of the war, consisting partly of Landwehr troops while many were Polish conscripts.

2 Guard Reserve

At the beginning of June the division returned to Flanders and by the start of July was in the line at Staden. On 31 July, elements of the division were surprised during formation and later reassembled on the western border of Houthulst Forest from where they counter-attacked in the direction of Bixschoote, suffering heavy losses. Up until this point the division, recruited in Westphalia and Hanover, had been considered excellent by Allied intelligence but during this period it showed only mediocre fighting quality and, during the 31 July attack on Bixschoote, many men remained in the rear. For the rest of the year their attitude was classed as passive.

After a further eight days in the sector the division was sent to rest in the Gand district until early September, when it was sent into the line west of Passchendaele, southeast of St. Julien. At the end of the month the division moved into positions southeast of Armentieres, where it remained until it reappeared in the Passchendaele area in December.

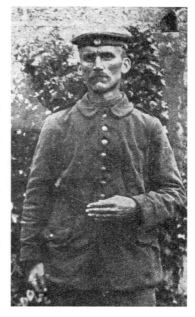

Thirty-four year-old Simon Günzkofer was killed during the fighting on 10 September 1917. He was a Landsturmmann serving with *Reserve Infantry Regiment 15* in *2 Garde Reserve Division*.

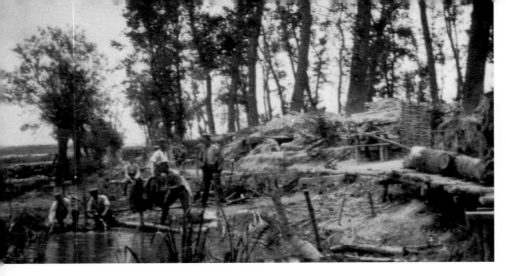

Soldiers washing clothes during a quiet period behind the line. Behind them is their dug-out, built into the bank of the stream.

2 Infantry

From Oriental Prussia, with 1 Division, it formed *I.Army Corps* on the Eastern Front. In February it entrained for the Western front, arriving in Belgium five days later in the Oodenarde area where it rested until the end of March. During this period it received reinforcements of various classes: wounded, convalescents and class of 1917 reservists.

The division occupied the Wytschaete sector from 25 March until the beginning of June, receiving drafts from the class of 1918 on three separate occasions, totalling nearly 4,500 men. The last group on 15 May had only received three months' training. On one day, 7 June, the division had nearly 3,000 men taken prisoner by the British. Three days later the division was sent to rest before leaving for the Eastern Front. Rated as third class but capable of holding its positions.

3 Bavarian

A regular Bavarian division that formed part of *II.Bavarian Army Corps* in *Sixth Army*. It fought in France and had been heavily engaged at Arras in April. Arriving in Flanders on 5 June, it relieved *40 Division* in the Messines sector. During this relief the British attacked and the division was unable to hold both the village and the summit, suffering heavy losses, including over 1,500 POWs. On 8 June the division was withdrawn and sent to Lorraine to receive reinforcements. Although originally classed as one of the best divisions during 1917, Allied Military Intelligence felt that its fighting value had diminished.

3 Guard

Having served briefly in Belgium during August 1914 the division went to the Eastern Front, returning to France in April 1916. It arrived in Flanders during June, resting until 29 July. Its first combat in the sector coincided with the British offensive on 31 July; it lost 1,000 prisoners while attempting to relieve *23 Reserve Division* in the Pilckem sector.

Relieved during the night of 5–6 August, it went into rest in Alsace for two months, returning to the northeast of Zonnebeke in early October. After a month at the front it was sent to Ghent to rest before moving to Cambrai in late November. It was rated as one of the best divisions and was used extensively in the 1918 offensives.

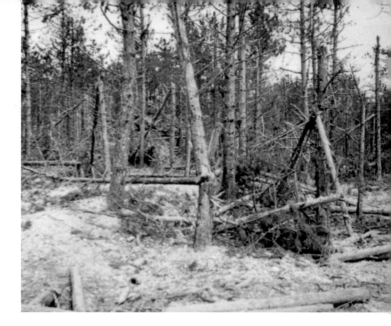

Houthulst Forest before the start of the British offensive.

3 Naval

On their return to Flanders the three regiments that had fought on the Somme were formed into *3 Naval* in April 1917, fighting east of Ypres from August through November: Lombartzyde and then Poelcappelle. After a rest it was put into the line at Lombartzyde in December.

The naval troops were classified as Imperial troops and regarded as high quality soldiers whose recruiting standard had not fallen during the war.

3 Reserve

Originating in Pomerania, *3 Reserve* formed part of *Eighth Army* and fought on the Eastern Front until May when it entrained for the Western Front, arriving at Bruges on 18 May. After resting it went to France for Western Front experience.

Arriving back in the Ypres area at the end of July, it was rested for a few days and then sent into the Battle of Frezenberg on 4 August where it suffered casualties to artillery. Withdrawn on 18 August, it went into rest at Tournai and then the Moorslede district before returning to active service south of Zonnebeke, at Polygon Wood, on 23 September. Once again it suffered heavy losses during fighting on 26 September.

Intelligence reports indicated morale was mediocre. One of its component regiments, *49 Reserve,* had very heavy losses and a considerable number of desertions; as a result it was placed in the rear after 18 August. On 26 September, *8 Company* of *49 RIR* refused to take part in the attack – replacements were older soldiers of the Landsturm. Having lost 6,000 men in Flanders, the division was sent to Alsace.

4 Bavarian

Mobilised with *3 Bavarian Division,* the divisions formed *2.Bavarian Army Corps* in *Sixth Army.* Throughout the war it drew its recruits from Bavaria and Lower Franconia.

In June, while still in the line in front of Bois de Ploegsteert, it was subjected to the British attack against Messines ridge, and suffered especially from the artillery prepara-tions, losing 200 prisoners. On 17 June, the division was sent to rest in the Oudenaarde

Fully revetted trench in Flanders using interwoven twigs to stop the sides collapsing. The card was sent by a soldier in *7 Bavarian Infantry Regiment (Prinz Leopold)* while he was serving on the Artois front. The caption reads 'Trench in Flanders with bullet defence'.

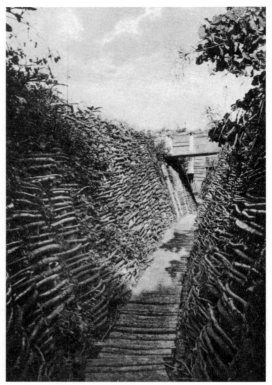

area until 7 July. By 9 July it was engaged at Armentières and then in mid-September returned to the Ypres area, where it went into the line between Zonnebeke and Passchendaele from 26 September to 27 October, during which time it suffered heavy losses – around thirty per cent of its strength. A few days later it left Flanders for Lorraine.

Classed as a good division. Allied intelligence stated that the division had gone through 'some very severe offensive and defensive fights and had come through them with honours. Captured personnel gave proof of vigour, if not intelligence.' Losses had been so severe that it was still under strength in February 1918.

4 Guards

After service on the Somme, punctuated by a month's rest north of Ypres, the division moved to the Lens Front in March. Over the next five months it suffered considerable losses. It was sent to Flanders on 23 and 24 September where it became a reserve division before going into the line east of Zonnebeke on 27 September. British artillery fire stopped a regimental attack on 22 October but, after replacements had been obtained, the attack was renewed on 4 November in order to regain the heights lost on 26 September. As the British attacked at the same time, the unit became demoralised and fled in disorder to Becelaere; losses were so heavy the division was relieved over the next two days and sent to France. After the Ypres fighting, the division was no longer classed as an excellent combat unit by Allied Military Intelligence.

4 Infantry

At the beginning of the war, the division fought in France before moving to the Ypres front in November. It was then sent to Russia until September 1915 when it returned to France. At the end of October 1917, it entrained for the Poelcapelle sector that it held until 24 November when it moved to French Flanders.

The division was recruited from Pomerania, an area with a small population. As a result

it often received men from different districts. More as an attempt to maintain the provincial composition rather than improve its quality, many replacements came from Landwehr depots and Landsturm battalions. Prior to this Allied Intelligence had rated the division as very good, showing very fine military qualities in all the battles in which it took part.

5 Bavarian

Recruited in Upper and Middle Franconia, with *6 Bavarian Division,* it was part of *III.Bavarian Army Corps.* The division had previously fought in France before being sent to rest near the Belgian-Dutch front. After a period of training, it left for the front around 6 August and by 10 August was holding the sector south of St. Julien, east of Ypres. Here it suffered heavy losses in the fighting of 15 August and the days following. It was relieved on 24 August and after a period of rest returned to the line on 8 September in a quiet sector south of the Lys.

It was classed by Allied intelligence as a good combat unit, doing well on the Arras and Ypres fronts where it suffered heavy losses.

5 Bavarian Reserve

Forming part of *I.Bavarian Reserve Corps* in *Sixth Army,* it was recruited in the Upper Palatinate and Upper and Middle Franconia. After fighting in France, the division was reconstituted and sent to Flanders where it was put in the line on 12 October near the Ypres-Roulers railway at Zonnebeke but by November was in Artois.

It was classed as a good division that fought with great tenacity.

6 Bavarian

Recruited from the Upper Palatinate and part of Lower Bavaria, along with *5 Bavarian* it constituted *III.Bavarian Army Corps* and was part of *Sixth Army.* After service in France, the division arrived in Flanders and went into the line northeast of Langemarck on 29 September. The British attack on 4 October caused it heavy losses and it lost Poelcappelle. On 8 October it was relieved, sent to rest and reorganised.

'The morale of the division was good...it always reacted quickly against attacks, but it seems it could easily be persuaded to adopt a more passive attitude.'

6 Bavarian Reserve

Formed in September 1914, the division fought near Ypres before moving south into France. After constant service in France, the division returned to the Ypres area at the end of June.

At the front southeast of Ypres on 18 July, it lost heavily

After sixteen months' service, farmer's son, Joseph Panzer, was killed in action on 28 August 1918. Awarded the Iron Cross Second Class for bravery, the nineteen-year-old was an infantryman with *11 Infantry Regiment.*

from the British artillery preparation and was relieved before the British attack and sent to Alsace, its morale having been weakened by the artillery barrage.

7 Infantry

The division was recruited in the Province of Prussian Saxony, and with *8 Division* formed *IV.Army Corps* based in Magdeburg. It had previously been in Belgium for a very short period in September 1914.

During the winter the division suffered from British raids. Towards the end of May it was sent to the Hollebeke-Wytschaete sector. At the beginning of July the division was sent to Alsace. The division returned to La Bassée in late September for a short spell before moving to the Ypres sector. On 29 October it was in the line between Becelaere and Gheluvelt, a sector it held until February 1918.

8 Infantry

Part of *IV.Army* Corps, it fought in Belgium in August 1914 before moving into France. It was recruited in Prussian Saxony, the Duchy of Anhalt and part of Thuringia.

The division arrived in Belgium on 18 September. After a rest it went into the line west of Becelaere on 4 October, moving on 9 October to positions south of Hollebeke.

8 Bavarian Reserve

Formed in 1915, with personnel from across the whole of Bavaria, as a mountain warfare division. The division fought in the Alsace, Galicia, Somme and Romania where it had seen little fighting since August 1916. Its losses on the Eastern Front were few.

The division was reviewed by the Emperor on 27 September and then brought up to strength (with men of the 1918 Class with under four months' training being sent to *22 Reserve Infantry Regiment*) for service on the Western Front. On 26 October the division took over the Aschhoop sector near Dixmude where it remained until late January 1918.

9 Bavarian Reserve

Formed in France during October 1916, it fought there before arriving in Belgium. It was placed in reserve in the Staden-Zarren sector from 9 to 16 August. During the fighting on 17 August it lost heavily and was taken out of the line after three days. After two months near St. Mihiel, it was sent to rest near Bruges and Ostend. From 22 November until the beginning of December, it was in the line near Lombartzyde and then moved to Cambrai.

The division was raised with recruits from the Upper Palatinate, and Upper and Lower Franconia. It had defended well against French attacks and was rated as a good division.

9 Reserve

The division was part of *V.Reserve Corps* and had previously fought in Flanders in late 1914. It was recruited in the Province of Posen, with a few units from other districts, to reduce the number of Poles.

Moving from the Somme to Artois in quick succession, the division arrived near Ghent at the beginning of July for a rest. From 10 August to 25 September the division was in the line on the Ypres road at Menin, suffering heavily during the fighting of 20 September.

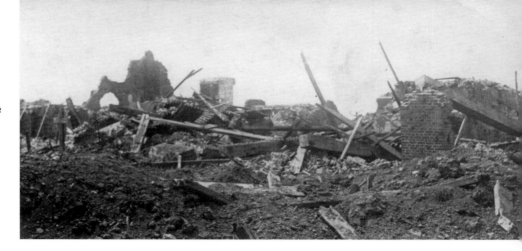

Messines after the battle had moved on.

During the Menin Road battles, *11 Company* of *6 Reserve Infantry* was reduced to twenty men and *12 Company* to twenty seven men, with *19 Reserve Infantry Regiment* suffering losses at the same level. *3 Company* of *395 Infantry* lost half of its men. After reorganisation the division moved to the Cambrai front.

10 Bavarian Reserve
This division was formed at the beginning of October 1916 using drafts from already existing divisions. It was originally recruited from Lower Bavaria and the Bavarian Palatinate. The division fought well during the French attacks in April 1917.

An October 1917 report noted the division as composed of young men. Although it had not sustained any casualties for a long time, its morale was shaky. During its move from St. Quentin to Ypres, the officers of *16 Infantry Regiment* had difficulty in preventing a mutiny.

On 1 August, the division left Lorraine for Flanders. It detrained at Roulers and was placed in reserve in the region Staden-Zarren from 9 to 16 August. It fought at Bixschoote-Langemarck on 17 August, where it suffered heavy casualties. Taken out of the line three days later it was sent to Lorraine. In October it returned to Flanders and was rested in the vicinity of Bruges and Ostend until about 22 November, when it went into the line in the sector of Lombartzyde. In early December it moved to France.

10 Ersatz
Organised in August 1914, the division was recruited in Westphalia and Thuringia but by 1917 included troops from the Rhine Provinces. It fought against the French until near the end of September 1917 when it was engaged near Poelcapelle suffering heavy losses. Withdrawn after two weeks, it was sent to Galicia. It was rated as having only moderate value as a fighting unit.

11 Infantry
Recruited in Silesia and forming part of *VI.Army Corps,* the division fought in France until April 1917. It was reorganised and received replacements from the newly disbanded *623 Infantry Regiment.* At the beginning of June it was in support on the Wytschaete-Messines sector when the British attacked. It suffered heavy casualties on 8 and 9 June but held the sector until 28 June. After a short rest it went to France. The division returned to

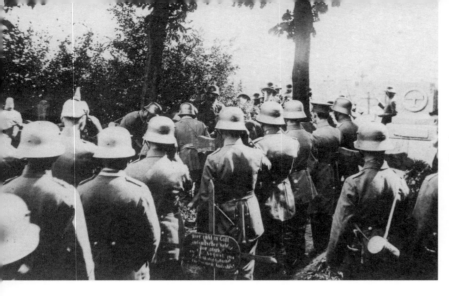

The funeral of an officer in a cemetery, first used in August 1914.

Flanders at the end of October where it served for two months near Passchendaele and then went into rest before proceeding to the Champagne region.

The division was recruited in the regions of Breslau, Glatz and Schweidnitz from the German population. A small number of Silesian Poles also served in the division. Its value, according to intelligence reports, was diminished by the presence of the Poles who were generally ready to desert when they had a chance.

11 Reserve

Raised in Silesia as part of *VI.Reserve Corps*, the division fought in France before it was reconstituted in Flanders. It then returned to France. In November it was sent to the Passchendaele area, where it alternated in the line with *12 Reserve Division* until January 1918.

To reduce the number of Poles serving in the division, it received drafts of replacements from other military areas.

11 Bavarian

Organised in April 1915 in Galicia, the division was part of Mackensen's army during the offensive in Galicia. Arriving in France in February 1916, it fought at Verdun and then in Russia and Romania. In the middle of October it entrained for Flanders, going into the line near Passchendaele on 22 October. On 26 October it suffered badly during the British attack and was withdrawn for reorganisation. It went back into the line on 2 November for eight days, was rested and sent to France.

12 Infantry

A Silesian division that, as part of *VI.Army Corps,* had fought in France and Russia. It went to Flanders via France in May 1917 and from early June to 1 August it was a reserve division on the Wytschaete-Messines Front. It then relieved *22 Reserve Division* east of Klein-Zillebeke after the Franco-British attack. Although not engaged in battle, the division suffered greatly from artillery bombardments. So much so, that, on 20 August it was relieved and transferred to Alsace for reorganisation and rest.

Considered to be a good division.

12 Reserve

A sister division to *12 Infantry*, it left France on 7 August for Flanders where it went into reserve near Passchendaele. A few of the elements of the division engaged in battle at Langemarck on 17 August. It was in line for four days during the heavy fighting in the St. Julien sector on 20 August. After rest it returned to France.

15 Infantry

Recruited in the Rhine Provinces, the division had fought in France since August 1914. On 7 October it was transferred to the Ypres sector until 13 November during which time it suffered heavily. Sent to rest around Bruges, it returned to the line east of Passchendaele about 18 December.

In spite of its lack of success, it was a good division. It was composed, for the most part, of young and well trained elements and two of its regiments fought particularly well in June. Recruited in a very populous district it was able to maintain its regional homogeneity throughout the year.

16 Infantry

A Rhine Province division. It fought in France from the start of the war until it was sent to Flanders at the beginning of June. After resting at Wambrechies for twelve days it went into the line at Warneton on 28 June. It suffered few casualties as a result of the British attack on 31 July.

About 23 September the division was rested near Bruges and returned to the Ypres Front in early October. Some elements were engaged on 3 and 4 October against the British attacks east of Vonnebeke. On 6 October it took up positions southeast of Poelcapelle where it supported a local attack against British troops between 9 and 12 October. After the battle it remained in support until 24 November when it returned to the front, holding positions at Becelaere and Passchendaele.

Known as the 'Iron Division'. At Warneton and at Ypres it fought stubbornly in spite of its heavy losses.

17 Infantry

Raised in Mecklenburg and the Hanseatic cities of northern Germany it had first entered Belgium on 3 August 1914. A month later it was in France where it fought until 9 June 1917 when it was transferred to Roulers.

Placed in the line north of Hooge, it was withdrawn three days before the British attack on 27 July after suffering heavy losses from the bombardment. Rested in France, the division returned on 23 September. Used in the counter-attack against British positions in the Polygon Wood sector on 26 September, it lost heavily for no gain and was withdrawn: *75 Infantry Regiment* lost thirty officers and around 1,000 men. Relieved on September 28 from the Flanders front, the division was sent to France on 17 October.

17 Infantry was part of the highly rated *IX Corps*; 'a formidable adversary.' As a unit it was seen to be more intellectually able at all levels than most other divisions. Allied Intelligence put this down to its recruitment base. High losses in July and September perceptibly diminished its fighting ability. However, the division gave a good account of itself in the course of its battles.

17 Reserve

Recruited in Schleswig-Holstein and the Hanseatic cities, the division guarded the coast until leaving for Belgium on 23 August. It moved to France in September 1914. In the middle of November 1917 the division took over the Becelaere sector. Engaged against the British attack on 3 December, it lost heavily. After further attacks the division was withdrawn to France.

The division was 'not one of the best in the German Army and its morale is mediocre'; however, it was seen as being capable of offering serious resistance in defence.

18 Infantry

At the outbreak of the war, the division was sent to Liège. It went into action at Tirlemont on 18 August and at Mons five days later. On 25 August it entered France where it fought until 27 August 1917 when it entrained for Flanders. During a period in army reserve it was reorganised with troops from the Russian front.

It went into the line north of Passchendaele in the middle of September. During the Franco-British offensive of 9 October it took serious losses and was relieved on 14 October. Having transferred to the Russian front, it returned to Alsace before the end of November.

From Schleswig-Holstein, the majority of the men were Prussians or Danes with a small number of Poles. Although classed as good division, it did not perform well in Flanders. This was put down to the intensity of the bombardment, the state of the terrain and the poor quality of the soldiers in the line during the attack.

18 Reserve

The division was on the Pilckem sector until the end of March. After a short rest at Roulers it was sent to the Arras sector. As a result of the British offensive, the division suffered heavily and was relieved, rested and returned to Flanders.

Arriving about 16 June the division was in reserve behind the Messines front. On 3 July it was in action west of Houthem, again suffering severe losses as a result of local actions

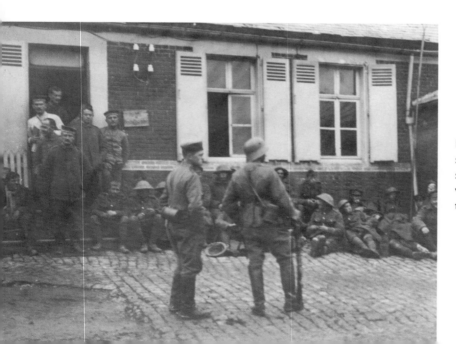

During the offensive both sides took prisoners. Here some of the British POWs wait, under guard, before they are sent further back.

and bombardments. Relieved on 8 August and sent to rest in France, it returned to the line near the Ypres-Menin railroad on 28 October.

During 1917, all serving Mecklenburgers were transferred to their national regiment in the division – *90 Reserve Infantry Regiment*. A mediocre division with passable morale.

19 Reserve

After service in France and Russia, the division returned to Flanders between 20 and 24 September where by 28 September it had taken up positions in Polygon Wood.

Recruited in Hanover, Oldenburg and Brunswick, the attitude of the men was generally good. The division's leadership was energetic and intelligent. However, its losses on the Aisne, its stay in Russia and the low quality of the replacements it received diminished its fighting value. The presence of Poles and Alsatians had considerably reduced its combat effectiveness. The division reported sixty-seven deserters from *73 Reserve Regiment* on 28 September and on 29 September.

As a result of the heavy losses sustained during the British attack of 4 October, *12 Company* of *92 Reserve Regiment* had only eight officers and eighty-six men. It was immediately relieved and sent to rest in France.

20 Infantry

The division briefly fought in Belgium in August 1914. It spent the next three years on both the Eastern and Western Fronts before arriving in Roulers on 27 September. On 4 October it went into action north of Zonnebeke. Relieved almost immediately, it was sent to the Artois region.

Recruited in the Province of Hanover and Duchy of Brunswick, the division was not highly rated, due to the high losses it had previously sustained, but it remained capable in defence.

21 Landwehr

The division was formed in April by the addition of *435 Regiment* to the two existing regiments of *11 Landwehr Brigade*. This independent brigade had come to Belgium on 2 August 1914, fought near Ypres in November and December of that year, and then formed the Brussels and Antwerp garrison. At the end of December 1915 it returned to the front line between Dixmude and Ypres. In May 1917 the division entrained for the Russian Front. The unit was used in the service of supplies for most of its time in Belgium.

22 Reserve

With *7 Reserve Division*, it formed *IV. Reserve Corps*, part of *First Army* that fought in Belgium in August and September 1914.

After fighting in France for over thirty months, it went into the line near Warneton on 14 June. At the end of the month it was rested and on its return to the front faced the British attack of 31 July, suffering very heavily. Rested immediately afterwards, the division was sent to Bullecourt. From 5 October it was in the Becelaere sector as a counter-attacking division supporting *4 Guard Division*. It suffered heavily from bombardments between 5 and 21 October. By November it was in Lorraine.

The division was recruited in the Electorate of Hesse and Thuringia. It could not always

replace losses and received replacements from the Eastern Front, men from the Service of Supplies, convalescents or men of mediocre physical quality. As a result it was classed as a mediocre division.

23 Reserve

After passing through Belgium briefly in August 1914, the division, part of *Third Army*, fought continuously in France where it had a good reputation. In March 1917 it was sent to the Bruges area. Given a two week rest, it was sent to a quiet sector near Ypres for a month.

Placed in reserve, it returned to the front between the railroad from Ypres to Staden and the Ypres-Roulers Railroad. On 31 July, during its relief it suffered heavily from the British bombardment that preceded the attack.

The division again suffered heavy losses during the Passchendaele fighting between 22 and 26 September – *2 Company* of *100 Reserve Infantry Regiment* was reduced to twenty five men. After only five days in the line, the division was relieved and sent to Russia.

23 Reserve Division was a purely Saxon division. The replacements received after its heavy losses in July and September were elderly men and returned convalescents so it was not highly regarded by the Allies.

24 Infantry

After garrisoning the trenches between the Comines Canal and the Douvre river until April, the division was withdrawn. On 7 June it returned to the front with *179 Infantry Regiment* going into action east of Wytschaete the next day. The division occupied the Hollebeke sector until 27 June. During this period of service in the line it suffered heavily. After further service on the Ypres front the division was sent to France at the end of October.

The Allied opinion of the division was good. They regarded the Saxons as courageous adversaries.

25 Infantry

The *Hessian Grand Ducal Division* fought in Luxemburg and France until September 1917 when it was sent to Flanders. After a short period in the line north of Zandvoorde it was sent to rest in the Ghent area. From the middle of November until February 1918 it held a sector on the Passchendaele front. Allied Intelligence had no real opinion of the division.

26 Infantry

After heavy fighting in France the division was rested at the end of July. From 16 August to 14 September it held the sector north of Langemarck where the artillery caused it heavy losses. After a brief rest it was sent to the Italian Front.

26 Württemberg Division was classed as good by British Intelligence with some reservations after its Flanders experience. At Poelcapelle in August, some units mutinied and left the front line vacant because the relief did not arrive quickly enough. However, due to its previous conduct it was felt that this was temporary and that with rest it would have the same fighting capabilities as shown before August.

Cutting wood for the fire in November 1917. The men are standing outside the communications bunker of *124 (6 Württemberg) König Wilhelm I Infantry Regiment*, part of *27 Infantry Division*. The picture was taken near Ypres just before the division moved to Alsace.

26 Reserve

This Württemburg division, with *28 Reserve Division*, formed *XIV.Army Corps*. As part of *7 Army*, it fought in France from the beginning of the war until August 1917, when it spent a month in the line north of Langemarck. Rested for a month, it returned to the front north of Ypres about 17 October. After barely a week in the line, the division was again rested, then sent to a quieter area and put in reserve. In the middle of November, the division took over the calm sector of Merckem for a month, was rested and returned to the line.

Allied Intelligence rated *26 Reserve Division* as a very good unit equal to the majority of the regular divisions. Having been thoroughly rested on the Flanders front, its morale was considered to have remained unimpaired.

27 Infantry

With *26 Infantry*, the division formed *XIII (Royal Württemberg) Corps* and fought in Lorraine and the Argonne during 1914, spending 1915 in the Argonne. In December of that year *XIII.Army Corps* was reformed when *26 Infantry* returned from Serbia. Until the end of July 1916 the division served in Flanders when it was moved to the Somme. After heavy fighting it returned to Flanders and was put in the line near Wytschaete. In the middle of November the division returned to the Somme.

During 1917 the division fought in France until the end of August. It went into action on 26 August southeast of St. Julien. Although it did not take part in any major engagement it suffered heavily from artillery fire. Rested for a month, it returned to the line northeast of Ypres on 11 October. There it remained until 11 November, when on relief it was sent to the Alsace.

The division had fought well since the start of the war. At the end of the year Allied Intelligence noted that even though its morale was slightly weakened by the heavy losses of the year, it was still a very good division.

31 Infantry

On mobilisation in 1914, the division, along with *42 Division*, formed *XXI.Army Corps*. It

fought in France and Russia until December 1917 when it was given a few days' rest and sent to Flanders. It did not enter the line until early 1918.

Originally recruited in Lorraine, Lower Alsace and the Rhine Province, by 1917 most of the replacements came from Westphalia. Having spent nearly three years on the Eastern Front, it was classed as a mediocre division.

32 Infantry

Upon the declaration of war, the division, along with *23 Division,* formed *XII. Army Corps (1 Saxon Corps).* The division entered Belgium on 13 August 1914. Two weeks later it was in France where it remained until June 1917 when it entrained for Belgium. After a brief rest it was put in the line near the Ypres-Menin road. At the beginning of September it was withdrawn, rested and then moved to the Warneton-Messines sector until the middle of January.

34 Infantry

With *33 Division,* it formed *XVI. Army Corps* based at Metz. Recruited in Lorraine, the division fought in France from August 1914 to July 1917. In reserve until 12 August, it went into action near the Ypres-Menin road, suffering heavy casualties. It left Flanders on 24 August.

Although designated as a Lorraine division, recruitment difficulties in the region were overcome by using drafts from Westphalia and the Rhine Province. By late 1917, many of the replacements were from the Landsturm, withdrawn from Russia and retrained in Germany before being sent to the Western Front.

35 Infantry

A West Prussian division that fought on the Eastern Front until October 1915 when it was sent to France. On 31 May it held positions along the banks of the Ypres-Comines Canal. It lost heavily during the fighting of 7 June – between 5,000 to 6,000 men, of whom

Out of the line many troops were happy to help in any way they could on the farms where they were billeted. A photo taken in August 1917 and sent home in September, by the soldier on the left, Everhard Haendler.

1,272 were prisoners. Reorganised and made up to strength with convalescents and returned wounded, it went into a quiet part of the line until around 22 October when it reappeared in the Houthulst Wood sector. It lost heavily during the fighting between 22 and 25 October but remained in the line until being relieved on 22 January 1918.

In June 1916 many replacements came from Silesia so the division contained a considerable number of Poles. Because of this and the numbers of young soldiers, the division was regarded as mediocre and morale poor in some units.

36 Infantry

Raised in West Prussia as part of *XVII.Army Corps,* the division fought in Russia until the end of September 1915. As a result of the Allied offensives the division was withdrawn and sent to France. Relieved from the Oppy-Gavrelle sector at the end of August, it went into the line near Poelcapelle on 10/11 September. By 23 September, as a result of heavy losses from the British attacks, the division was no longer fit to hold the front and was sent to recuperate near St. Quentin.

Rated as an excellent combat division. In Flanders it was not as energetic as it had been, because British artillery had reduced the number of front-line soldiers by half.

36 Reserve Infantry

In 1914, the division fought with *I Reserve Division* in East Prussia and Russia as part of *I.Reserve Corps* At the end of May 1917 it was transferred to France. By October it was manning positions east of Ypres.

36 Reserve Division was recruited in West Prussia and Eastern Pomerania. During its service on the Western Front it had a large number of Alsace-Lorrainers in its ranks.

38 Infantry

The division returned to Flanders in early June 1917 after heavy losses during the Arras offensives. Initially in reserve on the Messines front, it entered the line on 27 July east of Hooge. Suffering heavy casualties prior to and during the British attack of 31 July, it was relieved on 1 August and sent to Antwerp for rest and reorganisation. It was then sent to the Artois.

At the beginning of November, it took over the lines north of Ypres from 19 to 25 November, then north of Passchendaele, where on 3 December, a British attack inflicted heavy losses. The division was then relieved and rested in the Bruges area.

The division was initially recruited from the Thuringian States but by the beginning of 1917 included a large number of men from Baden. It was classed as a good division that generally gave a good account of itself. Replacements for the losses in Flanders came from the 1918 class and did not have a good effect on the division.

39 Infantry

On mobilisation, the division, along with *30 Division* formed *V.Corps* based in Strasbourg and recruited across the Rhine district. The division fought in France before moving to Flanders in October 1917. From the end of October to the end of November it held the line at Passchendaele and then Becelaere. It then returned to France.

40 Infantry

With *24 Division,* it formed *XIX.Corps,* part of *Third Army.* After fighting in Flanders the division went to France in 1915. In November 1916 it returned to the Messines sector. Towards the end of March 1917 the division moved Renaix for a period of rest, returning to the same sector a month later. It was subjected to the British artillery preparation for the battle of Messines and suffered heavy losses: its *104 Infantry Regiment* recorded 224 men lost as POWs.

On 7 June it was withdrawn and rested for over a month near Bruges. It returned to the line north of Ypres on 22 July and again suffered during the bombardment in the attack of 31 July. It was rested and reorganised in France, receiving 2,300 men as replacements. Many came from the Russian Front but some were Saxons, withdrawn from *428 Infantry Regiment* and *8 Landsturm Regiment.*

The division returned to Flanders on 12 October and between 17 and 27 October it occupied the Langewaade-Zevecoten sector, northeast of Bixschoote. During the 27 October attack it suffered heavy casualties. A month later it was sent to Russia.

A purely Saxon unit, it was rated as a passive division in attack. During the fighting, 22 to 28 July, men of *104 Infantry Regiment* scattered under fire, sometimes with their NCOs, and fled eight kilometres behind the front. This happened again during October. On 24 October, half of *6 Company, 134 Infantry Regiment,* left the front line.

41 Infantry

At the outbreak of hostilities the division formed part of *XX.Army Corps,* fighting in Russia and Romania. In February 1917 it was transferred to France and in November to the Flanders front where it alternated with *38 Division* in the vicinity of Staden and Houthulst Wood. It was not involved in any major battles.

The division was recruited from West Prussia, an area with a relatively small population. To maintain full strength the division recruited men from other districts, particularly Alsace-Lorraine during its time in Russia. It was classed as a mediocre division.

44 Reserve Infantry

Formed between August and October 1914, the division initially fought on the Belgian coast where it suffered heavy losses; *3 Battalion 205 Reserve Infantry Regiment* was reduced to 153 men. In June 1915 it was transferred to the Eastern Front where it fought in Russia and Serbia. In January 1916 it entrained for France where it fought until November 1917 when it arrived in the Passchendaele sector. After a month it was sent to Neuve Chapelle.

Initally recruited from Brandenburg and Hanover, by 1917 it had become a Brandenburg division. Although designated as an assault division, it did not show any great military value during 1917.

45 Reserve Infantry

The division arrived from France in late September and went into the line as a counter-attack division in the Zonnebeke sector. 'Elements of the division were engaged on October 1 (Polygon Wood), on the 4th (Zonnebeke), and from the 9th to the 12th as reinforcements on the Passchendaele front. After the British attack of October 12 the division, very much exhausted by these battles, was relieved.' It was transferred to France.

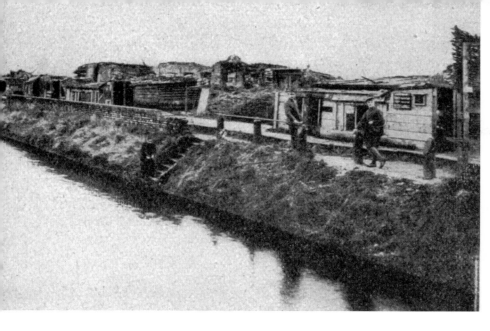

German positions on the Yser showing the developing comfort of the area: wooden shacks and walk ways where soldiers could walk safely.

A mixed Hanseatic and Pomeranian division at the start of the war, by 1917 it received replacements only from Pomerania, many of whom were classed as elderly. Although it had a good reputation, *212 Reserve Infantry Regiment* refused to attack on 30 September.

49 Reserve Infantry

Recruited in Prussian Saxony and Thuringia, the division fought in Russia and Romania until the middle of January 1917 when it moved to France, losing heavily at Arras. Its replacements were mainly new recruits, many of whom were only eighteen.

It was rested and reorganised near Tournai in Belgium before going into the line near Bixschoote. During the artillery barrage that preceded the Franco-British attack of 21 July, it suffered heavy losses and was withdrawn before the main attack. After a period of reorganisation, it returned to a sector south of the Ypres-Menin road at the end of October, where it served until 21 November, when it was transferred to France.

The division was considered to be of good quality. It had fought well in Artois but under artillery fire near Ypres the first line troops scattered and fled while the remnants of the advanced elements deserted – thirty men in total. On 25 July *226 Reserve Infantry Regiment* received between 500 and 700 men, principally from the 1918 class.

50 Reserve Division

Formed shortly after the outbreak of the war, the division, as part of *XXV.Reserve Corps* was sent to fight in Poland. After the corps was dissolved in September 1915, the division was transferred to the Western Front.

Towards the middle of June 1917 it was transferred to the Ypres front in anticipation of a British attack and was kept in reserve until 24 July. On 31 July it 'went into action in St. Julien and suffered heavy losses while fighting for the possession of the village between 1 and 2 August. Relieved on August 10, it was sent to rest in the vicinity of Mons and went back into line on September 20, was engaged on the 26th in the vicinity of Gheluvelt, and left Flanders on October 3, after serious losses – the *1st Company* of the *231st Reserve Infantry Regiment* was reduced to 15 men after September 21, the *6th Company* to 28.'

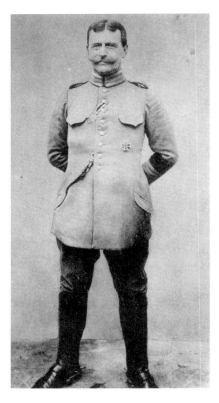

A 1918 postcard of General Waldorf, commander of *52 Reserve Infantry Division*. This division fought in Flanders on six separate occasions, distinguishing itself in the final months of the war during the fighting near Courtrai.

Originally recruited from Prussian Saxony and Silesia, by 1916 most replacements came from Hanover and Brunswick. Although its morale was shaken by its losses, it was thought to have fought quite well in Flanders.

52 Reserve

As part of *XXVI.Reserve Corps* it was engaged in the first battle of Ypres, fighting near Langemarck and Passchendaele. *240 Reserve Infantry Regiment* listed casualties of 28 officers and 1,360 men for the period of 18 to 28 October.

After two years in Flanders, the division moved to the Champagne region before returning to the Ypres front at the end of July. It went into action on the Ypres-Menin road on the first day of the British offensive, suffering heavy casualties. Further heavy losses were suffered during the British attacks on 10 August. By the time of its relief, *238 Reserve Infantry Regiment* had lost a third of its effectives. Shortly after, the division returned to the Champagne region.

Originally a mixed Rhenish and Baden division, by 1917 it was entirely Rhenish. It was rated a good division even after its heavy losses.

54 Infantry

Raised using troops from Schleswig-Holstein, Mecklenburg and Prussian Saxony in March 1915 by removing regiments from three divisions fighting in France. The division fought in the Champagne, was transferred to Russia and returned to France in the space of seven months.

After heavy fighting during 1916 and 1917, the division moved to Belgium for a rest. In action east of Ypres, it suffered during the British attacks in August with one company being reduced to one officer and four men. At the end of the month it returned to France.

The division held some of the most active sectors on the Western Front and proved itself in resistance. However, British intelligence felt that its desertion rate indicated a weakened morale after the Ypres battles.

54 Reserve

Formed at the beginning of the war from Württemberg and Saxon reserves. It was involved in the first Ypres battles when it suffered heavy casualties. The division remained

in Flanders until March 1916 when it left for the Artois region. It returned to Flanders in late October 1917 and held positions in the Dixmude sector until March 1918 when it moved to Picardy.

By 1917 it had become a purely Württemberg unit. Although heavily involved during the year, it lost few men as prisoners.

58 Infantry
In March 1915, surplus regiments from two divisions were used to form the mixed Saxon and Württemberg *58 Infantry Division*. By the end of 1916 it had become a purely Saxon unit.

After fighting in France and Russia, the division arrived in Belgium in the second week of October 1917. On 17 October it took over the sector south of Houthulst wood. It was relieved after the British attack of 22 October and rested for ten days. After a month in the same sector, it spent December in the vicinity of Bruges.

The division was not rated highly by British Intelligence. It did not show any high combat value and frequent cases of abandoning the front line were reported.

79 Reserve
Formed in 1915 from battalions of the *Prussian Guard,* all personnel in *261* and *262 Reserve Regiments* were specially selected. The third regiment, *263 Reserve,* was recruited in Prussian Saxony and was a Magdeburg unit. It fought on the Eastern Front until December 1916. After serving at Arras it was transferred and rested near Bruges.

At the beginning of the British offensive at Ypres on 31 July it was brought to the Langemarck sector as a counter-attack division. It suffered heavy losses on 6 August and abandoned Langemarck during the attack on 16 August. Having lost seventy-five per cent of its strength, it was relieved and sent to rest.

As a result of the Ypres combat, British Intelligence regarded two regiments, *261* and *262 Reserve Infantry,* as completely demoralised because they fled to the rear during the Ypres fighting. This was due to the high numbers of the 1918 class replacements who lacked 'combat spirit'.

80 Reserve
The division was formed with recruits from Prussian Saxony, Thuringia, the Grand Duchies of Mecklenberg and Pomerania during 1915. It fought on the Eastern Front until January 1917 when it was transferred to France. Suffering heavily at Arras, it was sent to rest in Flanders. It held the line from Boesinghe to Wieltje and took no part in any active operations. In July it was sent to France.

111 Infantry
When existing divisions were triangularised in 1915, the surplus regiments were formed into new divisions. After formation it moved to France.

After suffering heavy losses in the Arras offensive, it was rested and then sent to the Ypres front between 25 and 26 July. Within two days of the first troops arriving, it was engaged on the Boesinghe-Steenstraat sector. It lost heavily during the artillery preparation for and during the British attack of 31 July and was relieved that night and sent to Lorraine.

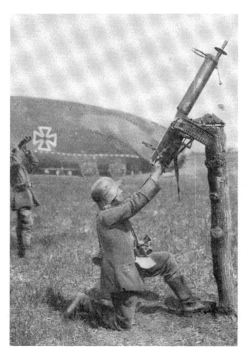

Infantry often created their own anti-aircraft guns using machine guns fitted on poles or other wooden structures.

In the middle of October it returned to Flanders. After detraining at Aalst it moved into the Poelcappelle sector where it was engaged from 22 to 26 before being relieved on 4 November. After being rested, the division moved to France

Considered a good division it was composed of young men, some of whom had experience in active sectors. However, at the start of the July offensive many men left their formations under bombardment or on going into the line.

119 Infantry

Formed in 1915 from regiments of *Fifth Army,* the division fought in Russia until May when it was sent to the Western Front. On arrival in Flanders, during May, it was rested for a month before going into the line near Ypres. After a month in the trenches, it was relieved and rested before moving to the Bixschoote sector at the beginning of August. It suffered serious losses on 16 August; *9 Company* of *58 Infantry Regiment* being reduced to thirty-eight men. Relieved from the front after further action on 9 and 10 October, it was sent to rest at Gand before moving to France.

Originating in Silesia, the division contained a large number of Poles. To dilute their numbers, replacements often came from two other districts. At the time of its induction to Western front conditions, over twenty per cent of the division were from the 1917 class.

121 Infantry

Formed in Lorraine from the surplus of three divisions during April 1915. After fighting on the French and Russian Fronts, it arrived at Elsegem in Belgium on 25 May 1917. It immediately moved to France before being brought back to Flanders.

On arrival in the trenches south of the Roulers-Ypres railway on 19 August, it was shelled and took heavy losses. Its casualties were also heavy during the British attack of 20 September. Before this battle, *12 Company* of *56 Reserve Regiment* 'was reduced to sixty-five men of whom about forty were men of the class of 1918.' Its *9 Company* was entirely destroyed or captured. Relieved in the night of 21 September, the division was sent to France to rest and reorganise. British Intelligence thought that it had fought well.

While resting, it received over 2,000 replacements, men previously wounded. To dilute the large number of Poles on the division, replacements came from Westphalia, Hanover, Baden and Magdeburg.

183 Infantry

Originally formed in May 1915, the division was restructured in late 1916. From its formation to August 1917 it fought in France. After moving to Flanders it went immediately into action at St. Julien. On 20 August it was relieved and sent to France. British Intelligence recorded that the division had fought well before arriving in Flanders.

185 Infantry

Created from Rhine Province regiments in May 1915, the division fought in France until February 1917, when it occupied a sector north of Ypres. Towards the end of April, it moved to Artois and then La Bassée. Transferred to Belgium at the end of October, it took over a sector west of Houthulst Forest between 6–7 November before leaving in December. The 'division gave a good account of itself in all the battles in which it took part.'

187 Infantry

The division served in Alsace and Romania after being formed in May 1915. In May it went to France before moving to Belgium in September 1917. It faced the British attack on Poelcappelle, was partially relieved and sent to counter-attack north of Langemarck on 10 October. The division suffered heavily and was sent to rest north of Bruges between 12 October and November when it returned to the front near Blankaart, south of Dixmude.

Recruits for the division came from three different provinces, Prussian Saxony, Brandenburg and Schleswig-Holstein. Equipped as a mountain warfare division, the division was made up of young men who were well trained.

195 Infantry

Organised from three existing regiments, in July 1916, the division fought in Galicia until transferred to France at the end of April 1917. It spent the next three months in the line at Ypres and Wytschaete before moving to St. Quentin. After resting during August it returned to Flanders and fought in the Passchendaele sector between 3 and 12 October. On its relief a constituent regiment, *233 Reserve,* was reduced to 800 men. The division then transferred to France.

Classed as a good division that had been severely tested by the October fighting. The average age of its men was twenty-five.

Two soldiers pick their way through the heavily shelled ground near Becelaere.

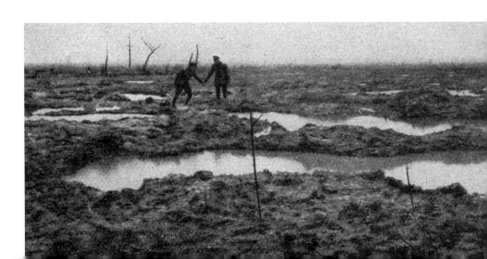

199 Infantry

Formed in August 1916 on the Eastern Front with troops from the Western Front. At the end of November it was sent to France. Suffering heavy losses at Arras, it moved in June to Ostend to rest and was sent into the line in the Nieuport-Lombartzyde sector in July. After a month it was again rested at Ostend until the middle of September, when it returned to the Nieuport sector until 24 October. On November 10, after a short rest, it was put in the line to the north of Passchendaele. Except for brief rest periods, it held the sector until February 1918 when it went to France.

204 (Württemberg) Infantry

The division was formed in June 1916. British Second Army Intelligence summary suggested it consisted of fair quality troops. Only *120 Reserve Infantry Regiment* had much experience of fighting. Apart from two short periods in France, the division was in Flanders for the year.

207 Infantry

The division had been organised in Belgium during September 1916 by taking regiments from existing divisions. It went into the line near Ypres at the end of November. After brief service in Artois during May it returned to Messines at the beginning of June, moving to Ypres in August. In October it moved to Lens.

The division was rated by Allied Intelligence as having only a moderate fighting value.

208 Infantry

The division was organised in France with regiments from older divisions in September 1916. It fought on the Eastern Front and in France until December when it moved to Ghent. After a six week rest, it took over the Ypres-Comines canal sector, moving to France for five months. It lost heavily during the British assault on 20 September with *1* and *3* Companies of *185 Infantry Regiment* entirely destroyed or captured; the remainder of '*1* Battalion was reduced to a handful of men.' At the end of the month the division moved to Lorraine. The number of young recruits weakened its fighting spirit but intelligence reports indicated that it generally did well in action.

214 Infantry

Formed in Lorraine during September 1916 using replacement troops and a brigade from *10 Division*. The division fought in France until August 1917 when it went into the line in the Bixschoote-Langemarck sector where it fought against the French. *50 Regiment* was

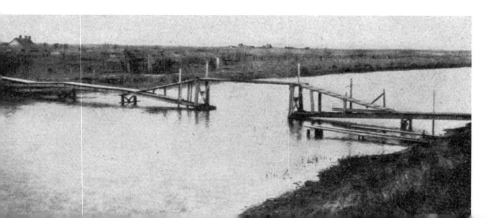

A German-held bridge over the Yser in 1917.

rated the worst of the division's three regiments due to the large number of the Polish troops in its ranks. Overall the division was rated as a good division by Allied Intelligence.

220 Infantry
At the end of 1916 the division was formed from regiments serving on the Somme and at Arras. It served east of Zonnebeke during October and then returned to France. It was not rated as having any great offensive value.

221 Infantry
Using men from a mixture of infantry, Landwehr and ersatz units, the division was formed in the Ardennes during October 1916. It served in France until July 1917 when it went into reserve near St. Eloi. On 1 August it launched a counter-attack during which it lost heavily. Shortly after it was sent to Champagne to rest and refit. It was classed as a good fighting division with good morale. Its commanding officer and the major commanding *41 Infantry Regiment* both received the 'Pour le Merite'.

227 Infantry
The division, formed in March 1917, was composed of newly-formed regiments using drafts from other divisions. It arrived in Flanders at the start of October and was heavily engaged during the fighting near Poelcappelle. After a brief rest in Ghent it went to the Champagne region to refit. It was classed as a mediocre division.

233 Infantry
Composed of returned wounded and very young soldiers, the division was formed in January 1917. It trained in Belgium before serving in a quiet sector in France. Sent into the line at Ypres in late May, it suffered heavily during the British artillery preparations towards the end of July. In nine weeks' service in Flanders, one regiment lost 900 men, more than half of whom were killed. After a two week rest, it moved to St. Quentin, returning to Flanders at the beginning of October. Engaged during the British attacks of 6 and 9 October, it again lost heavily. It was withdrawn from Flanders on 12 October and moved to France. Classed as a fairly good division by the Allies, the German view was that the men in the division were too young to have the great endurance needed for trench warfare.

234 Infantry
Like *233 Infantry Division*, it was composed of newly-formed regiments using men from the 1918 class and returning wounded. After service in France, the division moved to Flanders where it counter-attacked the British on 20 September near St. Julien. Exhausted after further fighting of 27 September, the division moved to Cambrai. Intelligence reports suggested that its losses had an effect on its morale.

235 Infantry
Composed of the 1918 class, returned sick and wounded and men withdrawn from the front, the division was formed in January 1917 and sent to the Somme region when trained. After replacing its severe losses it moved to Flanders. It entered the line near

Both sides relied on pigeons to carry important messages quickly to rear headquarters. Each division was provided with a carrier pigeon unit by the end of the war. Although the birds could be quick, battlefield conditions often meant that they got lost or did not fly at all.

Wieltje suffering heavy losses from the British preparatory bombardment for the Third Ypres assault. After a week's rest, it left for France. It was classed by intelligence as being of mediocre value.

236 Infantry

Formed at the end of 1916 using returned wounded and the 1918 class, it fought in France from April to September 1917 when it became a Flanders counter-attack division. It opposed the British attacks between Polygon Wood and Zonnebeke, suffering heavily from the bombardment. At the end of September it returned to France. British Intelligence rated it as a mediocre division.

238 Infantry

After formation in January 1917 and training it moved to France. On 13 October it went into the line near Passchendaele and suffered heavy casualties during the British attack of 30 October. Relieved the next day, it was sent to St. Quentin. Although rated as mediocre, it was regarded as better than most of the later war-raised divisions. It was nicknamed 'The Division of the First Communicants' because of the number of young recruits.

239 Infantry

As with all the divisions in the series 231 to 242, it was composed mainly of the 1918 class. Raised in January 1917, it fought in France until late October when it entered the line near Poelcappelle. During the British attack of 26 October, it lost heavily but was not rested for a month, after which it went to France. It was rated as one of the best divisions in the series.

240 Infantry

Recruited in Baden and Alsace, it received a large contingent of the 1918 class on formation in January 1917. Upon completion of training, it moved to France. Arriving in Flanders at the beginning of October, it suffered heavily in the British attacks near Poelcappelle and was relieved shortly afterwards and returned to France. It was rated as a mediocre division.

1918

Alpine Corps
Formed in April 1915, the division fought in Italy, France, Serbia, and Romania before it participated in the Lys battles, After nearly a month in action, during which time it suffered heavy casualties, it was withdrawn, rested and sent to France and then the Balkans. It was an élite body and considered one of the best German units.

Guard Ersatz
Created from replacement battalions in 1914, the division had fought in France and Russia and was rated as a good division. It arrived in Flanders, near Roulers, in October and fought stubbornly until relieved on 7 November.

1 Bavarian Reserve
The division fought from August 1914 to October 1917 in France. It took over the Zandvoorde sector on 8 October and in March 1918 moved to Dixmude. Serving on the Arras front for Operation Mars, it returned to Flanders for the Lys offensive. It suffered heavily during 9/10 April and was withdrawn on 18 April. After a rest, the division returned to Flanders in October. It remained in Flanders for the remainder of the war. As it took part in little fighting, it was classed as third-rate division.

1 Landwehr
Raised in 1914 as *Jacobi's Division*, it fought on the Eastern Front. Unusually, by 1918 it comprised men from many regions, including Alsace-Lorrainers who were not rated as reliable troops on the Western Front. After three months on the Western Front, it was rated by Military Intelligence as a mediocre division composed of old men and others that had little military value.

On arrival on the Western Front it spent time in reserve until March. By 26 April it was in the Hooge-St.Julien sector where it suffered exceedingly high losses during an unsuccessful attack. Three months later, it was sent to the Vosges to rest.

1st, 2nd and 3rd Naval
1 Naval Division was out of the line until May and from that date until 4 November held the extreme right of the line, which was a quiet front until the last month. Its fighting ability was classed as the lowest possible – fourth class.

3 Naval Division was relieved north of St. Georges about 1 March and moved to France. The division was classed as good when it left Belgium and replacements were of a high standard, but it performed poorly in France during the rest of the year.

Observation post built into the side of a pillbox with its own communication trench.

2 Guard

Rated as a first-class division, it fought in France and Russia before appearing briefly in Flanders at the end of the war.

2 Guard Reserve

The division remained in the Passchendaele sector until withdrawn for a rest around 9 January. It was in and out of the line until March when it went into training for two weeks. The division then left Flanders.

3 Guard

A much travelled and highly rated division. After brief service in Flanders during 1917 when it suffered heavy casualties, it returned to take part in the Lys offensive, again suffering heavy losses. By the middle of May, the division was in the line in Lorraine.

3 Reserve

Withdrawn from France about 27 September and sent to Belgium, it entered the line near Dixmude on 29 September. Apart from a period of rest from 16 to 23 October, the division stayed in the line at Dixmude until the armistice. Its morale was poor, the Polish troops deserted freely and British Intelligence rated it as having limited fighting value.

4 Bavarian

After six months in Lorraine the division took part in the Kemmel attack on 23 April, suffering heavy losses. Apart from a rest at Tourcoing it did not fight in Belgium again. It was rated a high quality division; aggressive in attack and tenacious in defence.

4 Infantry

The division left the Somme to participate in the Lys offensive between 23 April and 14 May. After rest and reconstitution, it moved to Loos and then Sailly-sur-la-Lys, returning to cover the Lys withdrawal. It was rated highly by Allied Intelligence.

A concrete dug-out in the trenches at St. Julien in the autumn of 1917.

4 Ersatz

Organised in August 1914, the division had fought in Belgium from September 1914 to September 1916. It returned for the Battle of the Lys. On 9 April it had 700 prisoners amongst its many losses. It was relieved on 19–20 April and did not return to Flanders. A third-class division.

6 Bavarian

After service in France, it returned to Dixmude where, with some elements of adjoining units, it was to make a very elaborate attack against the Belgians. The attack failed completely with the Belgians taking many prisoners. After being rested near Ruddervoorde, the division left Flanders.

Rated as one of the forty-five best divisions in the German Army. 'It suffered extremely heavy losses, but since it always fought well – though not brilliantly, during 1918 – the German High Command sent in as many replacements as it could. The morale has always been good, but quite anti-Prussian.'

6 Bavarian Reserve

The division returned to Messines in September after service in France. It received replacements from disbanded Bavarian divisions and remained in the area until the armistice. It withdrew through Wytschaete-Houthem-Comines-Marcke-Ooteghem and Krinstraat. It was regarded as a second-rate division.

6 Cavalry (Dismounted)

Formed in 1918, it moved from Alsace to Ypres in July. After a month in the line it moved to Cambrai, returning to Ypres at the start of October. After a week in action it was rested, returned to the line two weeks later and was then in action for a few days before going into *Fourth Army* reserve. It was rated as a fourth-class division.

7 Infantry

After resting in the Eecloo area, it returned to the Becelaere sector in March. It was engaged in the Battle of the Lys from 9 April to 1 May. It was then rested and sent to France.

7 Cavalry (Dismounted)

The division did not exist before 1918. It fought in Belgium during October before going into reserve. Intelligence rated it as a fourth-class unit.

8 Infantry

It was engaged in the Lys battle on 11 April and captured Merville. On 23 April it was rested until 15 May when it moved to the Ypres sector. Alternating between action and rest periods, the division remained in Belgium until the armistice. Even though it was composed of mainly younger men, it was rated as a first-class division.

8 Bavarian Reserve

Prior to the Lys battle, the division had held a quiet section of the line near Becelaere. Having lost fifty per cent of its infantry during the battle, it was relieved and sent to France. The morale of the division was good and it was rated as first-class by the Allies.

10 Ersatz

Its losses, including 700 prisoners, were heavy during its engagement in the Lys battles between 9 and 24 April. After resting the division moved south to La Bassée Canal. It was a sector-holding division and not rated highly by Allied Intelligence.

11 Reserve

The division was to the south of Passchendaele in January. On relief it trained for open warfare. It suffered heavily during the Lys fighting. By June it was near Kemmel where it fought until the end of the war. Graded as a second-class division by the Allies.

11 Bavarian

After reconstitution, the division moved into the line east of Boesinghe. It took part in the retirement losing more than 500 prisoners. The division reinforced the front near Beveren and was still in the line when the armistice was signed. It was a first-class division that fought well during 1918.

12 Bavarian

After its formation in the summer of 1916, it fought in Romania until the end of April 1918 when it moved to France. It arrived in Flanders in late August and went into the line near Ypres. The British attack of 28 September pushed the division back with the loss of 3,000 prisoners. The division went back into the line near Herseaux after a brief rest. It was rated as a third-class division.

12 Infantry

After suffering heavy losses during the Lys battles, the division was rested. On its return to the line near Meteren, it lost 300 prisoners in a local operation. At the end of August it went to France. Although it had done well in the spring offensive, it was only rated as second-class by the Allies.

12 Reserve

After serving south of Passchendaele from November 1917 to the middle of February 1918 the division moved to Lens. It was involved in the Lys battles before returning to Lens. This second-class division did not return to Belgium.

13 Reserve

The division had fought in France since August 1914. It arrived in Flanders during April and was used in the attacks on Voormezeele on 25 April and Merris on 28 May. The division stayed in the line, with periods of rest, until the armistice and was praised for its good work in an official communiqué. It was a first-class division that played a prominent role in the defence of Belgium.

15 Infantry

After serving in the Zonnebeke sector for five months, the division moved to France. Rated as good in 1917, by 1918 it was second-class.

16 Bavarian

The division fought in France until late September 1918 when it became a reserve formation in Belgium. It was engaged at Westroosebeke shortly after its arrival, suffering heavy losses. With periods of rest the division fought in Belgium until the armistice. A second-class division.

16 Infantry

Relieved in the middle of January and rested until March. After being engaged east of Passchendaele, the division took part in the Lys battles. During May it moved to France. A second-class division.

17 Reserve

During the attack on Messines during 9–10 April the division gained considerable ground at a heavy cost, including the loss of two battalion commanders. It left Belgium in June. Although it contained a considerable number of men from the 1918 and 1919 classes, it was rated as first-class.

18 Reserve

While on rest in January, the division was trained in open warfare. During February and March it held the line near Gheluvelt and then moved to La Bassée. A second-class division.

19 Reserve

After serving in France, the division returned to the line at Dixmude on 17 April. It fought in the Ypres area until 1 May when it was relieved after losing forty per cent of its effectives. By 10 May it was in the Champagne region. Allied intelligence rated the division as first class, but it was mainly a defensive division, having only attacked in the Lys battles during April.

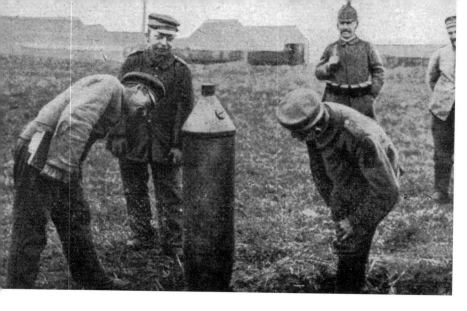

A certain percentage of shells and bombs did not explode for one reason or another. Here troops examine an unexploded 100 kilogram aerial bomb.

21 Infantry

As part of *Fourth Army,* it fought in Belgium in August 1914. Transferred to *Second Army,* it fought in France and spent a short period in Russia during 1917 before returning to France. The division arrived in Belgium in October 1918 where it was engaged until the armistice. Although by this time its morale was low, it was still considered to be first-class.

22 Reserve

The division left Alsace to take part in the Lys offensive, fighting at Kemmel. Upon relief it moved to Verdun. Rated a second-class division.

23 Infantry

After brief service in Belgium in August 1914, the division fought in France until late September when it went into the line near Bixschoote. Losing 800 prisoners, the division was withdrawn, rested and returned to the line. It stayed in the area until the end of the war. A third-class division.

23 Reserve

The division served briefly in Belgium during October and November. Rated as third-class but good defensively.

26 Reserve

The division left Flanders during March for service at Arras. A dependable first-class division.

28 Infantry

The division fought in Belgium during the last few days of the war. It spent most of its time on quiet fronts and was rated second-class.

29 Infantry

Until its engagement at Kemmel during the Lys battles, the division had only fought in France. It moved to Langemarck before returning to France. The division was rated as first-class.

31 Infantry

After serving in the line in the Moorslede sector, the division took part in the Lys offensive, fighting at Bois de Ploegsteert. For its actions at the start of the battle the division was mentioned in an official communiqué. Its losses at Kemmel were heavy, with one battalion losing seventy per cent of its combatants. Rested and reconstituted, it returned to Kemmel and faced a French attack, again suffering heavily and losing many as POWs. Relieved and rested, it moved to the Ypres front before moving to a quiet sector in France.

32 Infantry

From service in the line between Warneton and Messines, it moved south to take part in the Lys offensive on 9 April. After a week in action, it received a draft of 450 men as replacements. Alternating combat and rest, the division was involved on the Lys until the end of June when it moved to Lorraine.

35 Infantry

The division was engaged at Merckem before moving south to fight in the Lys offensive. It was reviewed by the Kaiser in May. After further fighting, it returned to the Merckem sector before leaving for France.

36 Reserve

On 10 April the division supported an assault division before going into action the next day. After suffering heavy losses, it was retired and moved to the Ploegsteert area. Alternating active service and rest periods, the division moved to France in June. It returned to Flanders at the beginning of October and fought at Roulers, Thielt, Deynze and Ecke. It was a third class division that achieved little during the Lys battles.

Cosy accommodation in Flanders for the officers of *Landwehr Infantry Regiment 78* - slippers under the bed, pictures on the wall and a rifle ready in case of attack.

38 Infantry

During the Lys battles the division served in the line at Meteren for three weeks and then transferred to France. It returned to Belgium on 29 October, and served in the line until 8 November. Its constant use during the last three months of the war showed that it was an effective defensive unit.

38 Landwehr

The division was used to relieve more active units and regularly moved sector. It was in Flanders for the whole of the year. Although composed of men over forty, it distinguished itself in the November fighting.

39 Infantry

The division was not heavily involved in the Lys battles and moved south in July to France. Arriving back in Flanders in October, it distinguished itself in action near Menin. At the end of October it went into the line near Nukerke and stayed there until the armistice. Rated as second-class.

40 Infantry

The division came to Flanders from Russia via France in September. After losing nearly 1,300 prisoners while serving near Wervicq, it was rested. It then went into the line near Menin and later at Roubaix. During 1918, Allied Intelligence noted that Saxon units were not fighting as well as previously and rated this division as third-class.

41 Infantry

Relieved from the Ypres sector at the end of January, it was rested and provided with new artillery. A month later it went back into the line at Westroosebeke before moving to the Arras region. It was considered a second-class division.

42 Infantry

Arriving from the Eastern Front in January, the division fought during the Lys battles for a week. It was sent to a quiet sector near Lens because it had sustained fifty per cent casualties. It did not return. Although it had a large percentage of younger men, it was a defensive division that was rated third-class.

49 Reserve

Returning to the line on 11 April, it launched an attack on Messines. Alternating between rest and active periods, the division was in the Ypres sector until late August when it moved to France. Classed as a second-class holding division.

52 Reserve

After nine months in France, the division moved into the line southeast of Ypres. It suffered heavy losses fighting at Dickebusch during May. Rested, it moved to Locre and after fighting at Kemmel in August it went to France. Although trained as a shock unit it was not used in an offensive and was rated as a weak second-rate division.

56 Infantry
After spending three years in France with a spell in Galicia, the division went into the line on 25 March and captured Kemmel. It remained in the sector until May when it was relieved. Rated as second-class division, it fought in Belgium until the end of the war.

58 Infantry
Rated as second-class, the division was noted for being strong in defence. During the Lys offensive it held sectors near Ypres and Locre. It left Flanders in August to fight in France and returned in early November.

79 Reserve
After fighting in France, the division arrived in Flanders during April. Rested for five weeks, it spent a month in the line, was rested and left for France. Rated a third-class defensive division.

81 Reserve
The division served on the Eastern Front from May 1915 to December 1917. After a period of relative quiet, it attacked near Meteren during the Lys battles. It suffered heavy losses and was relieved. During May it returned to Meteren before moving to Lorraine. Rated a mediocre third-class division.

83 Infantry
Raised in early 1915, the division did not appear on the Western Front until April 1918 where it held the Ypres sector until July. It then left for France. Rated as a fourth-class unit with a high percentage of older men.

117 Infantry
Composed of men from Upper Silesia, it was used as a mountain division on occasion. It had previously fought in Flanders but came from Lorraine to fight in the Lys battles. To replace its losses, a regiment was disbanded and replaced by one from Macedonia. During June it moved to France. Intelligence rated it as a second-class holding division.

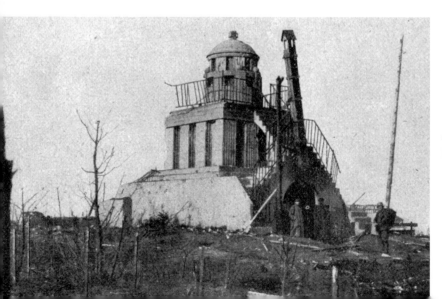

Mausoleum in the cemetery at Terhand in November 1917.

119 Infantry

Suffering heavy losses in the Somme offensive, the division was sent to Flanders to partic-ipate in the Lys offensive. After being engaged for ten days it was relieved, rested and returned to the Somme. Although rated as second-class, it was used as an attack division.

121 Infantry

The division comprised a reliable core of Third Ypres veterans; the remainder were of inferior fighting value. Arriving from France in April to garrison positions at Dranoutre and Locre, it returned in August. A third-class division with no particular power of resistance.

204 Infantry

On 28 February, after just over three months in Flanders, the division went to France. It was a third-class division,

207 Infantry

In October this second-class division was sent to Belgium after heavy losses at Cambrai. It spent a short period in the line before becoming a reserve unit during November. By October its morale was indifferent.

214 Infantry

In the line near Dixmude for the first months of the year, it moved south for the Lys offensive. After being engaged near Ploegsteert and Locre, it moved to Arras in mid-May. A lack-lustre second-class division.

216 Infantry

Formed on the Eastern Front during July 1916, it did not arrive in the west until mid-April 1918. It served on the Kemmel front for a month and then moved to France. A third-class division.

233 Infantry

From 20 January to 24 February the division received special training in the warfare of movement. Rated as a fairly good division initially, but only third-class by the armistice. It sustained heavy losses during the battle of Mount Kemmel and was transferred to France.

236 Infantry

The division entered the line at Passchendaele on 6 April. On 22 June it was rested, before returning to the front near Ypres. It left for Lorraine in September. A third-class division.

Bibliography

Asprey, R. The German High Command at War. William Morrow & Co. 1991.

Baer. C H. Der Völkerkrieg – Siebenter Band. Julius Hoffmann. 1916.

Baer. C H. Der Völkerkrieg – Zehnter Band. Julius Hoffmann. 1916.

Baer. C H. Der Völkerkrieg – Dreiundzwanzigster Band. Julius Hoffmann. 1920.

Baker, C. The Battle for Flanders. Pen & Sword. 2011.

Becke, Major A.F. Military Operations France & Belgium, 1918 volume 1. Macmillan & Co. 1935.

Bilton, D. The German Army at Arras 1914–1918. Pen & Sword. 2008.

Binding, R. A Fatalist at war. George Allen & Unwin. 1933.

Bull, S. German Assault troops of the First World War. Spellmount. 2007.

Chickering, R. Imperial Germany and the Great War, 1914–1918. Cambridge University Press, 2005.

Clayton, A. Paths of Glory. Cassell. 2003.

Edmonds, Brigadier General Sir James, CB, CMG. Military Operations 1917 France & Belgium, volume 2 Messines and 3rd Ypres. HMSO. 1948.

Edmonds, Brigadier General Sir James, CB, CMG. Military Operations France & Belgium 1918, volume 2. Macmillan & Co. 1937.

Edmonds, Brigadier General Sir James, CB, CMG. Military Operations France & Belgium 1918, volume 3. Macmillan & Co. 1939.

Edmonds, Brigadier General Sir James, CB, CMG. Military Operations France & Belgium 1918, volume 4. HMSO. 1947.

Edmonds, Brigadier General Sir James, CB, CMG. Military Operations France & Belgium 1918, volume 5. HMSO. 1947.

Falls, Captain C. Military Operations France & Belgium 1917. The German retreat to the Hindenburg line and the battle of Arras. Macmillan. 1940.

Farr, D. Mons 1914–1918. The beginning and the end. Helion & Company. 2008.

Foley, R. German strategy and the path to Verdun. University Press Cambridge. 2005.

Fredette, Major R. H. (USAF), The First Battle of Britain 1917–1918. Cassell. 1966.

Görlitz, W(ed). The Kaiser and his court (the First World War diaries of Admiral Georg von Müller). Macdonald. 1961.

Gray, R & Argyle, C. Chronicle of the First World War Volume 1, 1914 – 1916. Facts on File. 1991.

Gray, R & Argyle, C. Chronicle of the First World War Volume 2, 1917 – 1921. Facts on File. 1991.

Groom, W. A Storm in Flanders. Cassell. 2003.

Herwig, H. The First World War, Germany and Austria 1914–1918. Arnold, Headline Group. 1997.

Herman van Kuhl home.Comcast.net

http://www.greatwar.co.uk/westfront/ypsalient/cemeteries/gecemyp.htm

http://www.greatwar.co.uk/ypres-salient/battles-ypres-salient.htm

http://www.kaiserscross.com/41902/108001.html

http://www.webmatters.net/belgium/ww1_lys_4.htm

Humphries, M O & Maker, J. (editors) Germany's Western Front: Translations from the German Official History of the Great War. Wilfrid Laurier University Press. 2010.

Jackson, R. Air War Flanders–1918. Airlife Publishing Ltd. 1998.

Junger. E. Storm of Steel. Chatto & Windus. 1929.

Keegan, J. Passchendaele, Volume 6 History of the First World War. Purnell. 1971.

Keegan, J. The "Ludendorff Offensive" Phase 2 Lys. Volume 7 History of the First World War. Purnell. 1971.

Kitchen, M. The German Offensives of 1918. Tempus, 2005.

Ludendorff, General. My War Memories 1914–1918 volume 1 & 2. Hutchinson (No Date).

Michelin & Cie. Ypres and the battles for Ypres 1914–1918. Michelin & Cie. 1920.

Miller, T.G. The air battle over Lys. Volume 7 History of the First World War. Purnell. 1971.

Nash, D.B. Imperial German Army Handbook. Ian Allan. 1980.

Palmer, A. The Salient – Ypres, 1914–18. Constable. 2007.

Palmer, S & Wallis, S. A War in Words. Simon & Schuster. 2003.

Passingham, I. All the Kaiser's Men. Sutton Publishing. 2003.

Passingham, I. Pillars of Fire. Sutton Publishing. 1998.

Passingham, I. The German offensives of 1918. Pen&Sword Military. 2008.

Prior, R. & Wilson, T. Passchendaele – the untold story. Yale University Press. 1996.

Scheer, Admiral R. Germany's High Sea Fleet in the World War. Cassel & Co. 1920.

Sheldon, J. The German Army at Passchendaele. Pen & Sword. 2007.

Scott, M. The Ypres Salient. Gliddon books. 1992.

Sulzbach, H. With the German guns. Leo Cooper. 1973.

The Times. Documentary History of the War. Volume 8. The Times Publishing Company. 1919.

Thoumin, R. The First World War. Secker & Warburg. 1963.

Weber, T. Hitler's First War. Oxford University Press. 2010.

Westman, S. Surgeon with the Kaiser's Army. William Kimber. 1968.

Wikipedia.org SM UB-16.

Williams, J.F. Corporal Hitler and the Great War 1914 – 1918. Frank Cass. 2005.

Witkop, P (Ed.). German students' war letters. Pine Street Books. 2002.